THROUGH THE LENS

NATIONAL GEOGRAPHIC GREATEST PHOTOGRAPHS

THROUGH THE LENS

Introduction

by Paul Martin

The 40 million readers of Nᴀᴛɪᴏɴᴀʟ Gᴇᴏɢʀᴀᴘʜɪᴄ are an incredibly varied lot. Residing in every country, they represent a true United Nations of languages, cultures, and worldviews. Yet despite their diversity, they share an abiding appreciation of photography. Indeed, whether we're Manhattanites or Muscovites, the photographic image speaks eloquently to us all. An early editor of Nᴀᴛɪᴏɴᴀʟ Gᴇᴏɢʀᴀᴘʜɪᴄ, John Oliver La Gorce, stated that the communicative power of photography makes it a universal language. And for the past 113 years, few publications have contributed as much to the language of the photograph as the familiar yellow-bordered magazine.

Today, the photographic archive of the National Geographic Society encompasses a staggering 10.5 million images, both published and unpublished. These images span the history of the photographic medium, from rare glass Autochromes to film negatives and transparencies to cutting-edge digital photographs. And they offer an unparalleled record of the world over the past century—its achievements in medicine, science, and exploration; its dramatic cultural changes; its wars and natural disasters.

MARIA STENZEL | 1996

So imagine the challenge of sorting through these priceless images and attempting to select a sample of the best photographs the National Geographic Society has ever produced. That is the lofty goal the editors of this volume set for themselves.

Within these pages you'll view the world through the lenses of legendary GEOGRAPHIC photographers such as William Albert Allard and James L. Stanfield. You'll see landmark historical photographs, like those that documented the polar expeditions of Adm. Richard E. Byrd. And you will see images captured by nonprofessional photographers, like the astronauts who gazed in wonder through the windows of their spacecraft as they orbited high above the Earth or circled the distant moon.

The photographs in this book combine intimate moments and grand spectacle. Like a magic carpet, these images plunge you into deserts, forests, and jungles, take you beneath the sea, even whisk you to the stars. Many of the photographs examine details of everyday life—subjects that GEOGRAPHIC photographers have devotedly and consistently covered. "Taking pictures on assignment gets you closer to people," observes photographer George Steinmetz. "Not only does it give you an entrée

that you wouldn't have as a normal traveler, but it makes you look at things differently, more analytically than experientially. It forces you to extend yourself, to insinuate yourself into situations."

The organization of the book is geographical, which mirrors NATIONAL GEOGRAPHIC magazine's working method and mission as well as the Society's photographic archive. Each of the six chapters opens with an essay that helps put the photographs within that chapter into perspective. Written by experts whose backgrounds range from novelist to scientist, these essays reflect the unique perspectives and interests of their authors.

Chapter One focuses on Europe, one of the richest subject areas of the Society's photographic collection. Covering rural and urban life from the turn of the 20th century right up to today, the pictures paint a cultural portrait touching on a wide number of nations. Highlights include profiles of women and children, with interesting contrasts between today and years past—from Barcelona children frolicking amid bubbles at a party to a 1929 image of Dutch children in wooden shoes. Classic landscapes and cityscapes and images of people at work and play round out the chapter.

NATIONAL GEOGRAPHIC GREATEST PHOTOGRAPHS

NATIONAL GEOGRAPHIC

WASHINGTON, D.C.

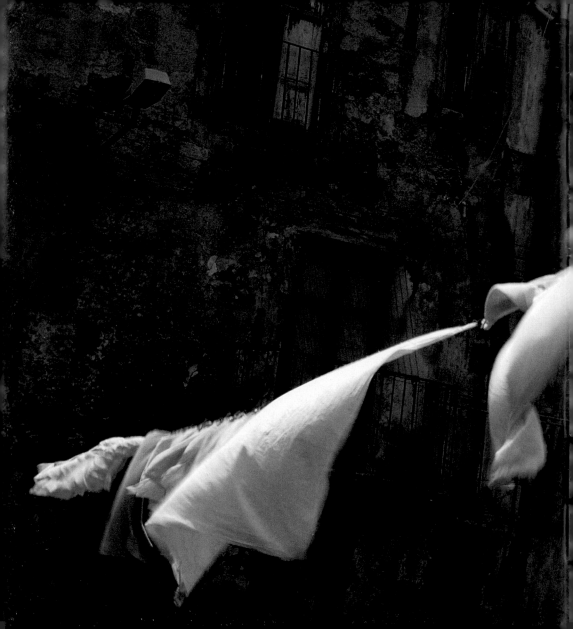

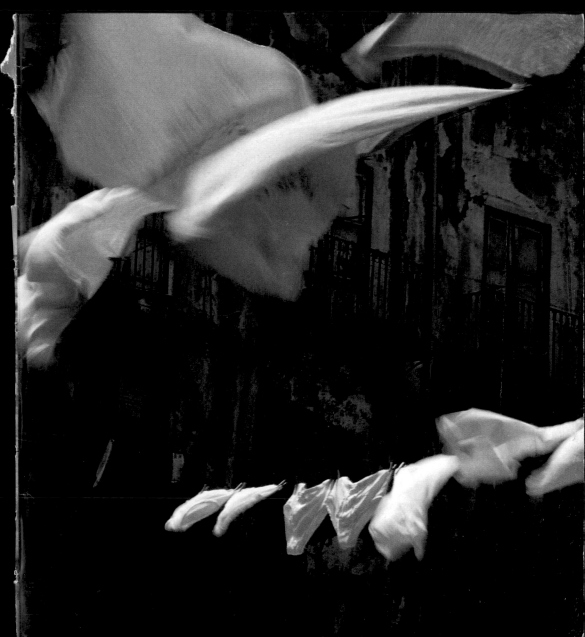

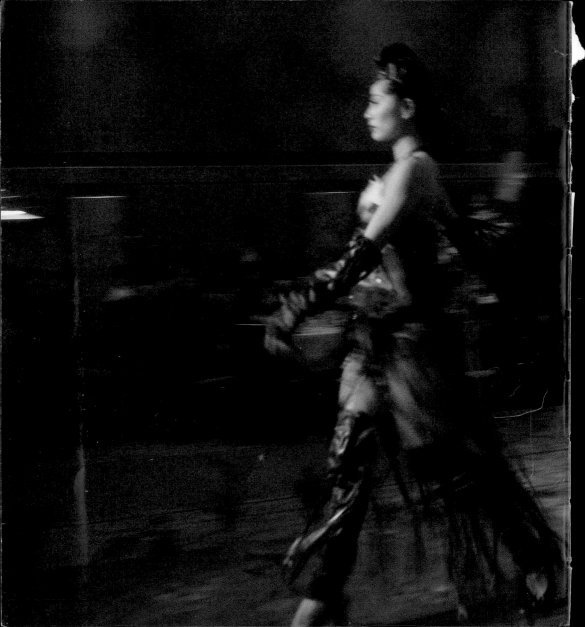

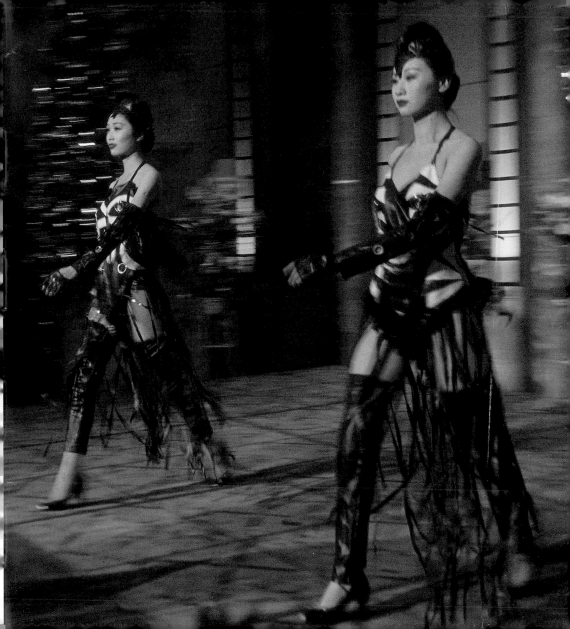

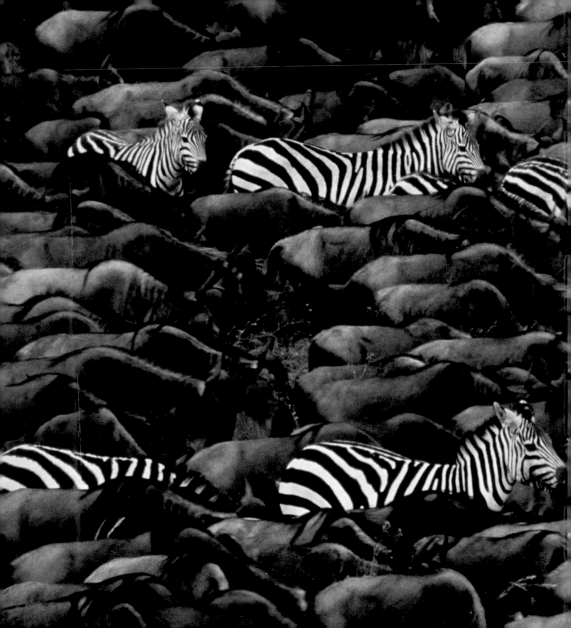

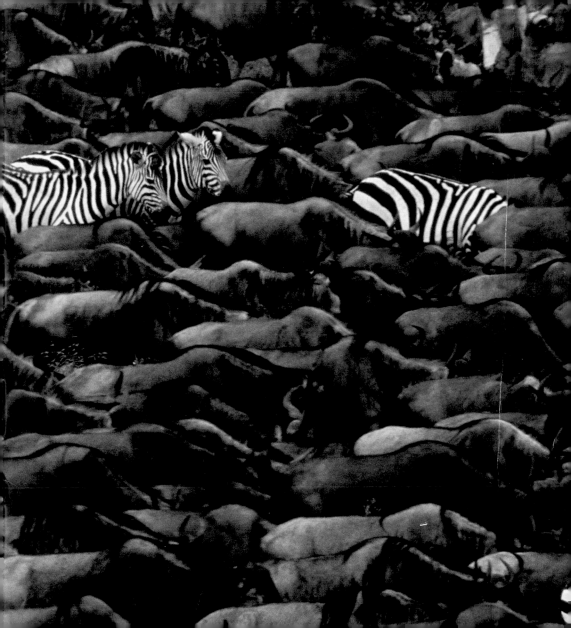

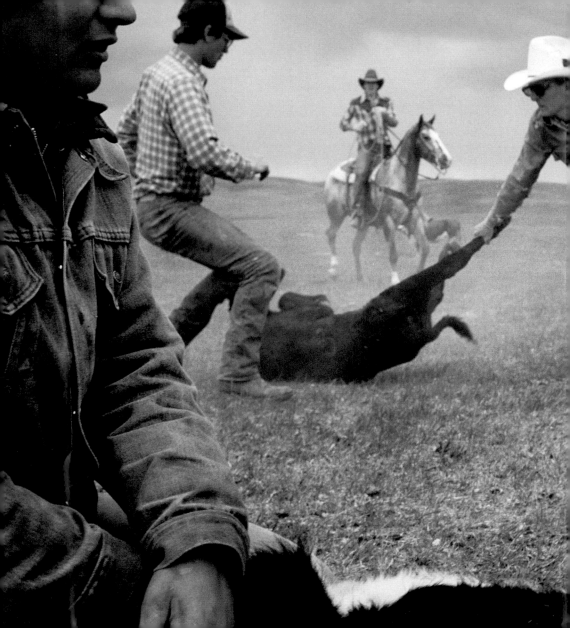

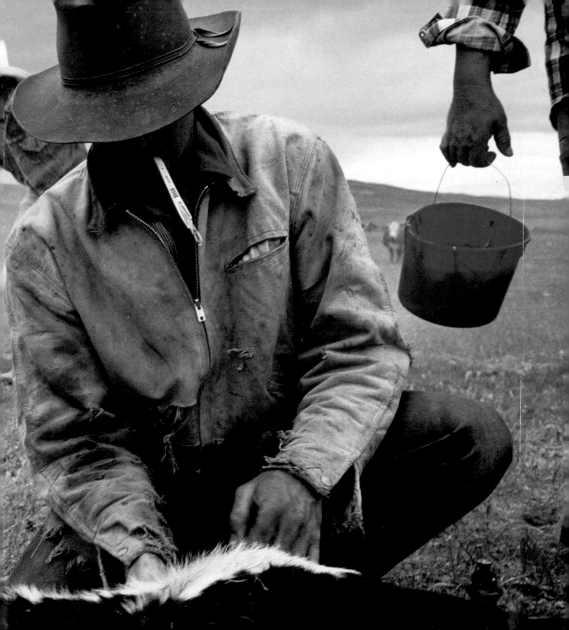

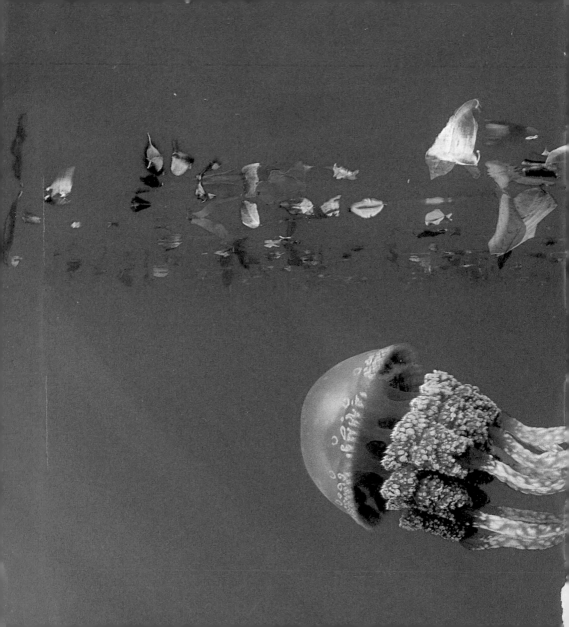

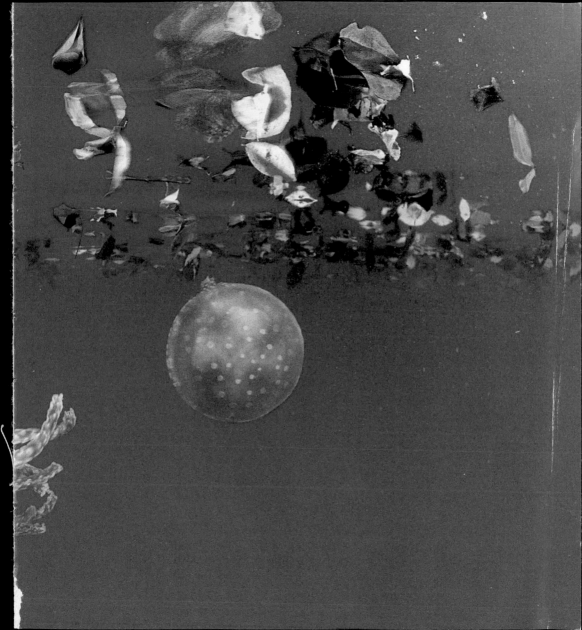

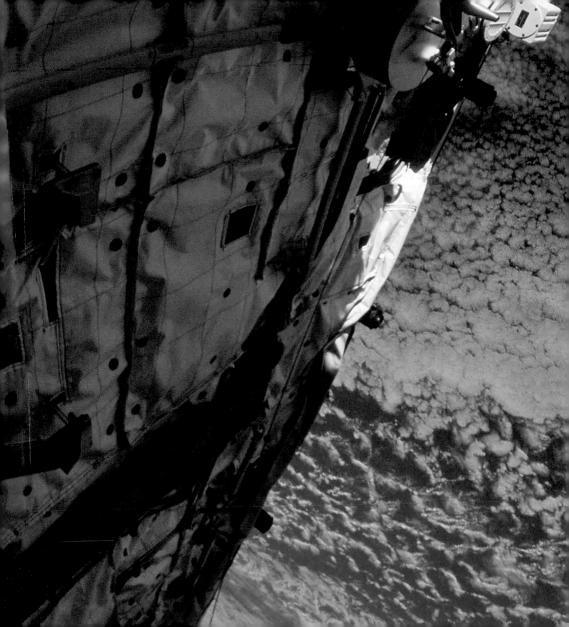

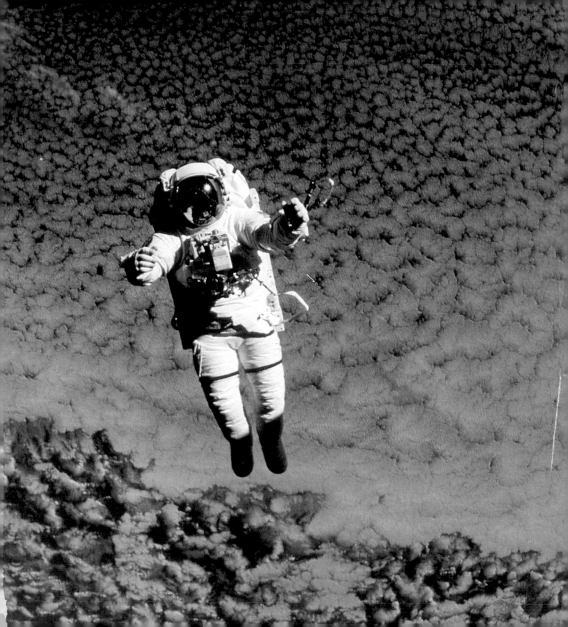

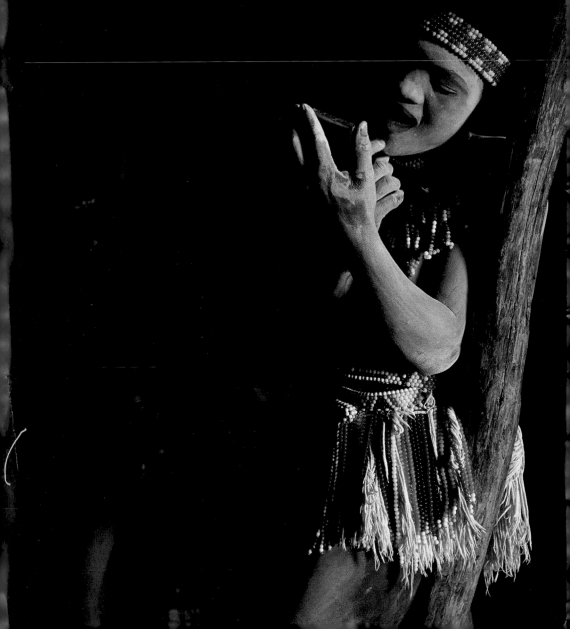

CONTENTS

COVER: Jodi Cobb/1995–Geisha in Japan; PAGES 4-5: William Albert Allard/1995–Laundry in Sicily; PAGES 6-7: Michael S. Yamashita/1997–Fashion models in China; PAGES 8-9: Mitsuaki Iwago/1986–Zebras and wildebeests in Africa; PAGES 10-11: Sam Abell/1984–Cowboys in Montana; PAGES 12-13: David Doubilet/2000–Jellyfish in Pacific lagoon; PAGES 14-15: NASA/1994–Astronaut Mark Lee on spacewalk; LEFT: Chris Johns/1996–Zulu in South Africa.

erhaps the most interesting and exciting part of my job is to occasionally join NATIONAL GEOGRAPHIC's world-renowned photographers on assignment. I've shared adventures in Cuba with longtime contributor David Alan Harvey. I've journeyed to Africa with senior editor Chris Johns. On such occasions, it's always a privilege to witness the dedication and ability of fine photographers such as these.

Professionals like Harvey and Johns uphold a defining tradition of excellence at NATIONAL GEOGRAPHIC. Not long after the Society started its official journal in October 1888—for a total of 165 members—photographs found a place in the pages of the magazine. The first was an image of Herald Island, published in July 1890. However, the real mandate to include photographs as a storytelling element came in 1902. That was when Society President Alexander Graham Bell and his managing editor (and son-in-law), Gilbert H. Grosvenor, agreed that Grosvenor should travel to the Caribbean island of Martinique to document a devastating volcanic eruption. Bell encouraged him to bring back "details of

Foreword

by John M. Fahey, Jr.
President and Chief Executive Officer

living interest beautifully illustrated by photographs." A century after Grosvenor's groundbreaking assignment, Bell's admonition still sums up the goal of NATIONAL GEOGRAPHIC.

If your family is like mine, you know that the simple ritual of delving into the latest NATIONAL GEOGRAPHIC represents a lifelong addiction. As children, we are introduced by the images to new cultures, dazzling landscapes, and the myriad species with which we share our planet. Even as adults, we continue to marvel at the discoveries we read about in the magazine, all brought to life with images that fairly leap off the page.

That's why I am so excited about this book, which contains some of the most fascinating photographs the Society has ever published. I hope you share the same feelings of discovery and recognition that I first felt as I flipped through these pages. What you hold in your hands is an open invitation to examine the world through the lenses of some of the finest photographers of the past century. Enjoy the view.

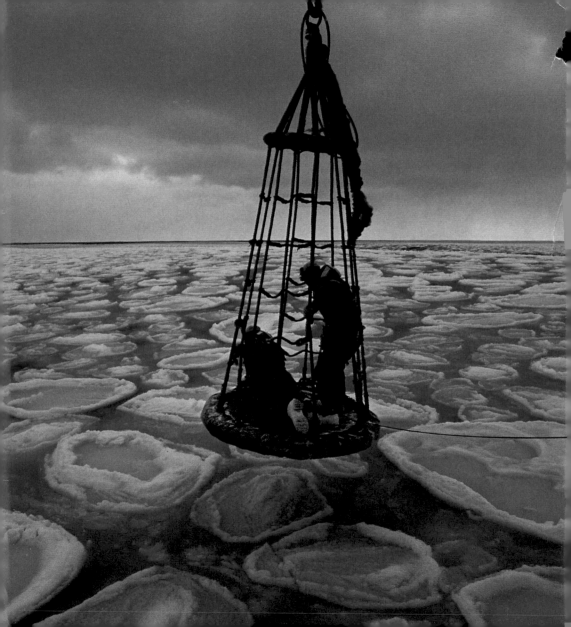

BYRD ANTARCTIC EXPEDITION | 1930

PAGE 24: Dressed in a caribou skin suit, Adm. Richard E. Byrd poses with his pet terrier, Igloo, who accompanied Byrd on his historic flight over the South Pole in November 1929.

Chapter Two covers Asia, Earth's most populous continent—home to some 3.8 billion people. Lands of rapid change amid enduring traditions, the nations of Asia embrace both the futuristic skyline of Shanghai and the timeless temples of Angkor. Photographer John Scofield's vibrant Hong Kong streetscape provides telling counterpoint to O. Louis Mazzatenta's image of 2,200-year-old terra-cotta warriors near Xi'an, China. And memorable then-and-now portraits are seen in Bruce Dale's shot of women in a Shanghai beauty parlor and John Claude White's 1920 photograph of a group of Nepalese ladies dressed in their finery.

Chapter Three encompasses Africa and the Middle East. Among the highlights are some of the dramatic wildlife photographs that National Geographic is famous for, including Chris Johns's shots of a magnificent group of cheetahs and a giraffe moving through an eerie forest. Extensive coverage is given to culture, seen through the prisms of work, daily life, and traditions. Portraits depict a nimble hunter chasing cane rats in South Africa, burka-shrouded women waiting to vote in the capital of Yemen, a coin-bedecked girl of the Ouled Nails tribe of North Africa, and gold miners toiling in Gabon's Minkébé forest.

Chapter Four profiles the immense stretch of land that makes up the Americas—two realms whose similarities in topography are as striking as their differences in cultural makeup. Imbued with the spirit of Spain and Portugal, Latin America presents a far different face than the predominantly Anglo-French cultures of the United States and Canada. The images here are as exotic as a trio of young Kayapo Indian women in Brazil and as quintessentially Yankee as a Pittsburgh laborer proudly displaying the Stars and Stripes from his front porch. Wildlife photography includes remarkable images of wolves, grizzly bears, jaguars, and quetzals.

Chapter Five explores the world beneath the sea, along with islands and their cultures. Through the years, the Society has supported renowned undersea adventurers such as Emory Kristof, who was on the team that gave the world its first glimpse of the wreck of the *Titanic*. Photographer David Doubilet, whose work is represented here, says, "We've come from the sea, and because of this there is an elemental feeling in making images underwater." Equally fascinating are the lands surrounded by the sea, and images document wonders from Iceland's steaming thermal springs to creatures like the tuatara, a "living fossil" in New Zealand.

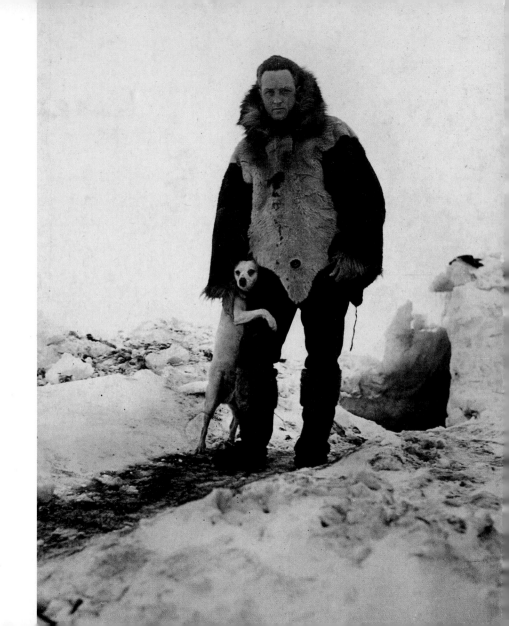

Chapter Six presents an overview of man's exploration of the heavens. Several images result from NATIONAL GEOGRAPHIC's long association with NASA, including photographs of the Apollo lunar missions and the space shuttle. Dramatic images captured by Voyager and the Hubble Space Telescope reveal the colorful spectacle of distant planets and galaxies, a fitting finale for this book's photographic journey.

As you peruse these six chapters, you'll see photographs whose power is undiminished long after the details of the particular article in which they appeared have grown dim. The staying power of such images says much about the continuing validity of still photography in a world saturated by television, movies, and video. Joel Sartore, one of the young masters of modern photography, maintains that "still photography will never go out of style because it has the unique ability to literally stop time forever. A child is forever young in a photo; a bird is perpetually in flight."

And what makes a particular photograph memorable?

"To me a great picture has three components," Sartore says. "It has to have nice light. It must have good composition, with a background that doesn't fight with the main subject. And it must capture a moment, which could be an emotion or something that jumps out of the scene." Timing is critical. "In fact," says Sartore, "the best shots are the ones that seem impossible, that simply can't be done. A classic example is Jim Brandenburg's shot of a white wolf jumping from one iceberg to another. The photo has a wonderful, soft backlight and good composition, and it captures a perfect moment, with the wolf hanging in midair."

Some pictures can alter a person's life. Sartore will never forget seeing a 1913 image of Martha, the last passenger pigeon: "I remember staring at that photo and wondering, 'How could that be the last one? There were once millions of passenger pigeons.' I still think about that image today. In fact, it set me on my path of conservation work. It made me want to use photography to try to save the Earth, to give a voice to endangered species that have no voice."

For most of us, photographs may not change our lives, but they can certainly change our minds, opening them to the wider world and helping to engender understanding. The images in this book are vivid reminders of the communicative power of great photography, which, after more than a hundred years, continues to be reconfirmed once a month in the pages of NATIONAL GEOGRAPHIC.

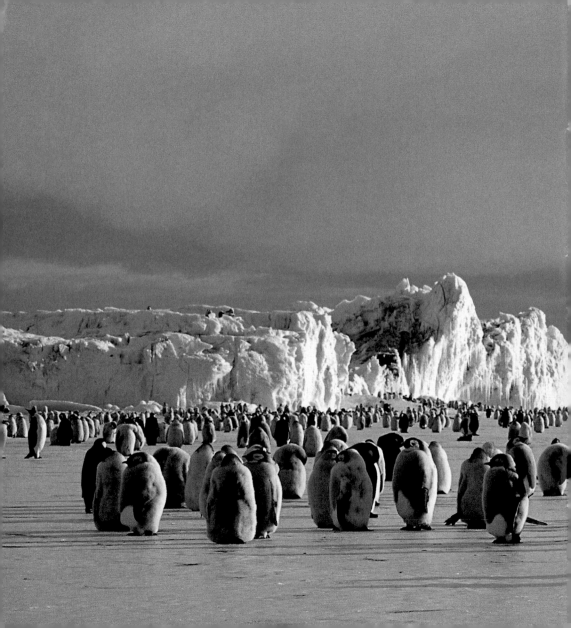

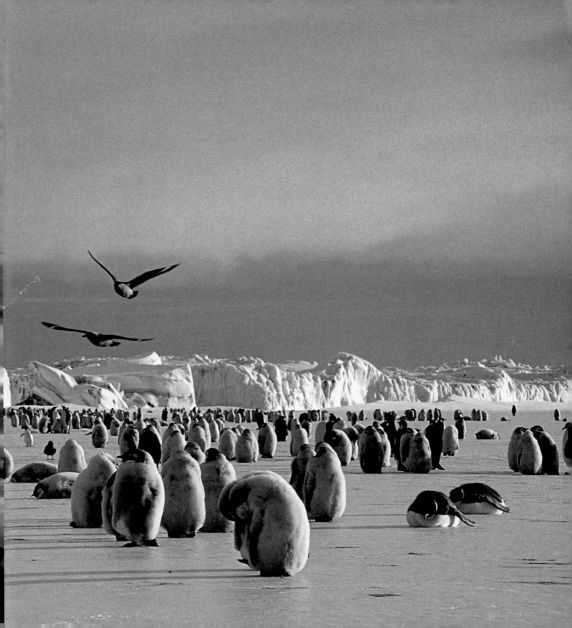

EUROPE

CROSSROADS OF CULTURE

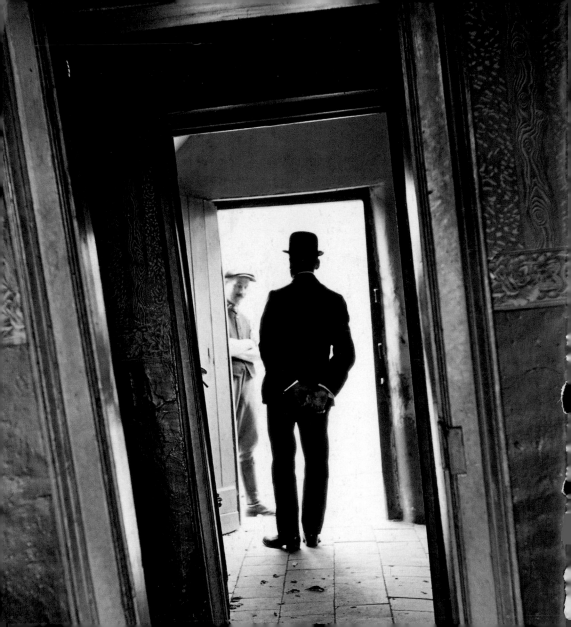

Europe
by Raphael Kadushin

We don't know the children's names, and we might have trouble finding the village of Staphorst on a map. But almost everyone, in a sentimental heartbeat, knows how to read Donald McLeish's 1929 picture of a boy and two girls, laughing with an exuberance that seems utterly guileless, in the following gallery of photographs. That's because the embroidered vests, the folkish caps, and the telltale wooden shoes — half clunky and half oddly elegant — are details that most of us associate with the Netherlands. And they set off their own daisy chain of images: Vermeer's housewives, caught in a triangle of honeyed light; gabled roofs and bowed bridges; Hans Brinker, slicing a ribbon down the ice of a frozen canal, on his silver skates; and all the windmills spinning steadily, in industrious rows.

The photograph of the children, of course, comes closer to being a cartoon of Dutch life than anything resembling contemporary reality. But it has a power of its own, partly because of its details; even if the image got cropped down to a single foot stuck in a raw wooden shoe,

PAGE 30: In Kingswinford, England, walls lean and floors tilt at the Crooked Inn, which sits atop underground colliery workings.

we would be able to guess the setting. And that's true of many of the European photographs collected in this volume. Stuart Franklin's shot of buttoned-up men in bowler hats is freeze-framed England, or at least our prim, tea-and-crumpets sense of it. The picture of men fishing on the Seine is a romance of Gallic joie de vivre, and the fashion models wearing Yves Saint Laurent evoke our other French archetype—the one rooted in haute cuisine and haute couture and pure hauteur itself. Even the photo of St. Basil's Cathedral, looking like an ice palace, is instantly recognizable: This is Dr. Zhivago's Russia, snowed in and dirgelike, despite the jaunty onion towers.

Part of the reason we can place these photographs so quickly, identifying the countries and sometimes the cities in the blink of an eye, is because Europe's patchwork of cultures is still our own, at least for a large number of Americans. This is a continent many of us have visited on three-week grand tours, and in the fairy tales and storybooks that get passed down from one generation to the next.

The ability to recognize Europe's distinct cultures is a big part of what we love about the continent, along with its capacity to spawn those cultures. Travelers riding the night train from Italy to Switzerland know when they have crossed the border, because these countries are more than just neighboring states. They are really parallel universes, each distinguished by its own sensibility and traditions: stolid fondues versus

a plate of spaghetti, squat chalets versus airy palazzos, a surfeit of cuckoo clocks versus a blithe Latin indifference to time. But we also know these countries well enough to understand that our dreamlike clichés don't tell the whole truth, especially today. The Europe we grew up on was a shared confection, a romance. And the contemporary European fairy tale is a much more complex, and grown-up, story.

In fact, the chances of finding three children wearing wooden shoes in a shadowy corner of Staphorst are slim now, and bowler hats are as rare as snuffboxes and fishwives on the streets of Oxford. In the age of the euro all our old fantasies are under siege. The new European image, or at least the one taking over, is something much less fixed, because all of the cultural boundaries are gradually blurring.

Blame it on the European Union (EU), Europe's united coalition of countries. Its symbol, appropriately, is the euro, which 16 of the 27 current EU member nations have now adopted and which can look like an emblem of the blended Europe to come. Forget the quirky, flamboyant designs that used to decorate each country's homegrown money—the portraits of Dutch poets, German statesmen, and Italian painters that qualified as miniature works of art. (Anyone who didn't save an Italian 100,000 lire note, depicting an impish Caravaggio posing in front of one of his own paintings, is probably regretting it.) Now just functionless collectibles, the old notes have given way to a faceless

currency that seems indifferent to individual cultural whimsies and heroes.

As the euro gets increasingly invoked as the symbol of where Europe itself is headed, what remains for photographers? If our common dream of the continent is based on its endless smorgasbord of singular cultures, there doesn't seem much left for the camera to capture when everything blends into one corporate "eurostate."

The choices look bleak. There is the modernist photographic approach, which tries to evoke millennial Europe. That means shots of the new everyman and woman; images of generic urban crowds; and aerial views of the autobahns shooting through the continent, connecting all those countries a little too easily and letting drivers race from Germany to Austria to Italy without ever noticing a change in the scenery. The other photographic options—quaint, dated attempts to capture a vision of Europe that has evaporated—seem even worse. Images of the last baguette baker, the Belgian lacemaker, whose handiwork really comes from Hong Kong, and Old World Christmas markets, stocked with Third World goods, all ring hollow. And false.

That is the cynical outlook, though, and while it suggests a more complicated landscape for photographers to negotiate in the future, the terrain has always been complex. In fact, the Europe we once thought we knew so well is a relatively recent invention; for centuries, most of its countries have been changing shape. The population displacements, ethnic overlapping, shifting borders, and

state of flux that have defined Europe in the last century have always defined it. The Celts of Great Britain were pushed to the edges of the island by successive waves of Romans, Angles, Saxons, and Normans. The Romans colonized a broad swath of Europe, the Slavs settled in the Balkans, and England and France kept swapping territory into the 15th century.

If we zero in on any European corner, we see that nothing has ever held steady. Alsace got tossed between Germany and France so many times that it became a little of both, a place that now dines out on both foie gras and sauerkraut. The Lot *département* of France may seem classically Gallic, but it lies in a region that dreams of the days when it was part of Occitan, a nation composed of pieces of Spain and France. The Ticino canton of Switzerland still considers itself more Italian than Swiss. While the new Europe looks like a confusing jumble on a political map, the old Europe was just as slippery. And photographers have always faced the same challenge: How do you find something solid in an always shifting scene?

But it isn't just the European Union and its constantly melting borders that will continue to challenge photographers trying to seize some sense of Europe in the coming decades. The real shift will be the growing influx of immigrants who may become the defining European story in the 21st century.

As the citizens of Europe's old colonies have moved to their respective motherlands—and

been followed by guest workers and refugees pouring in from Africa, the Middle East, Asia, and Eastern Europe—each country has become even less homogeneous than it used to be. The current reality is the mosque beside the windmill, the fish-and-chips served with curry sauce; it is the incense blending with the smell of fresh-baked madeleines, the sari blowing on the moors, and the Caribbean parades marching through Notting Hill. The ethnic mix adds a whole new layer of cultures for photographers to capture, along with another kind of blurring. In 20 years Amsterdam may have as many accents and cultural inflections as Brooklyn, New York, or South Beach, Florida.

To pretend that diversity is something new, though, means forgetting Europe's past again. The continent has always been a study in ethnic variety, and many of Europe's newest, 21st-century citizens are really just returning home. Spain, which has seen a recent influx of African refugees, is a case in point. When North African Muslims took over the country in the eighth century, the nation's urban centers quickly became multicultural models, shaped as much by Moors and Jews as by Christian Spaniards. And when Germany recently watched a tide of Russian Jews cross its border to find a fresh start in Berlin and Frankfurt, it was really welcoming back a big part of its own history; the Jews Nazi Germany almost wiped out in the 1940s were among the leading architects of Germany's modern culture. For the best photographers, shooting Europe has always meant seeing the way different things intersect.

But while the new Europe is a lot more like the old one than we may think, that's not just because it has always been a mutable place. The other reason the continent hasn't changed as much as pundits suggest is that many traditional cultures—the ones we continually cling to, like pretty dreams—have endured despite all the ongoing flux. In the end, it's easy to overstate Europe's blended face.

So far, the European Union has been more of an economic confederation than a cultural swap meet, and ironically the EU has, if anything, sharpened its member nations' sense of their own unique characters. Certainly Europeans had to consider their heritage—what did it mean to be Danish or French or Italian?—before they voted to join the EU or resist it, and the result has been a surge of regional patriotism.

From Majorca to Cornwall, more and more natives are revisiting and restoring local customs, and the payoff has been immediate. Cultures that seemed eager to bulldoze the past and think modern in the 1960s and '70s are suddenly rediscovering ancient recipes, half-extinct languages, and nearly forgotten festivals and crafts. As a result, even the oldest and most seemingly quaint photographs in this book still say something about today's Europe, a continent that is not only open to the new but also increasingly protective of its most historic and singular traditions.

Another quality that makes these images unique, and still valid, is their range of backdrops, the landscapes that frame the subjects. While

Europe has a gift for inventing distinct societies, it has also inherited a geographic variety that is among the world's richest—the organic echo of its cultural diversity. This variety will always offer a wealth of photo opportunities. England alone is a buffet of different terrains: The rocky Cornish coast, the harsh sweep of the Yorkshire moors, the softly rounded hedges of Kent, and the hills of the Lake District can keep anyone's camera clicking. Maybe Dutch children in wooden shoes are harder to find now. But the green lowlands that surround Staphorst still pose for the photographer, and so do the Russian snowbanks and the dappled Seine River and the cloud-wreathed Alpine slopes that turn so many of the following images into scenic pinups.

And ultimately even those Dutch children from 1929 reveal something that continues to be true. While wooden shoes certainly aren't as common as they used to be, clogmakers are still carving the real things and Frisian farmers continue to walk through muddy fields, leaving rounded shoe prints behind. These aren't tourist props; they are artifacts with histories of their own, each trailing a complicated legacy.

Consider the Dutch hat. While the Staphorst girls were decked out in simplified, embroidered bonnets, traditional Dutch women more commonly wore corkscrew hairpins, which took different shapes so that anyone looking at the golden horns could tell much about the wearers—such as where they came from and what their husbands did for a living. Round disks indicated

women were Catholic; squares were the marks of Protestants. The direction of the hairpins' slant across the forehead revealed the marital status of the wearers.

Of course, those hairpins won't continue to send so many concrete messages today, outside of a few small, time-warped pockets of the Netherlands. But it doesn't really matter to a photographer. In a century when Paris is starting to look a lot more like Manhattan, and parts of Brussels have begun to resemble a dozen other European cities, any heirloom grounded in such a firm sense of place looks more striking than ever. And that, finally, is what makes the following photographs so powerful.

While the continent itself is edging toward a united future, the folk hats and hairpins and wooden shoes evoke the fragile beauty of a time when every passed-on object and every square mile of Europe told their own stories. The fact that these particular items have become part of our own romance of Europe, unique to one place but familiar to a global village, is part of their power. The real challenge for today's photographers lies in finding images that resonate as deeply and speak so immediately to the viewer.

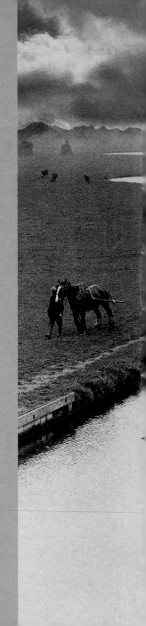

EUROPE | SCAPES

A patchwork of more than 40 independent nations, Europe ranks as Earth's second smallest continent, after Australia, and it trails only Asia in density of population. Most Europeans dwell on the broad plains that lie between the rugged highlands of the north and the Alpine mountain system that stretches through the south. Well drained by rivers, this fertile expanse of land has given rise to and supported many of the world's great cities, from Moscow in the east to Paris and Barcelona in the west.

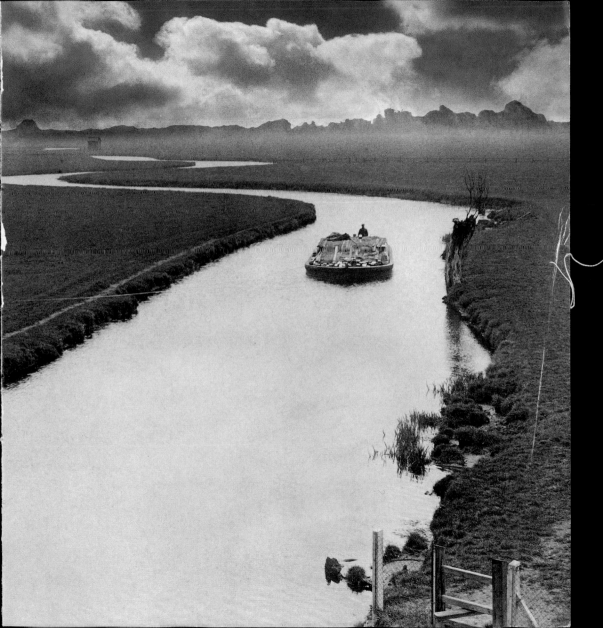

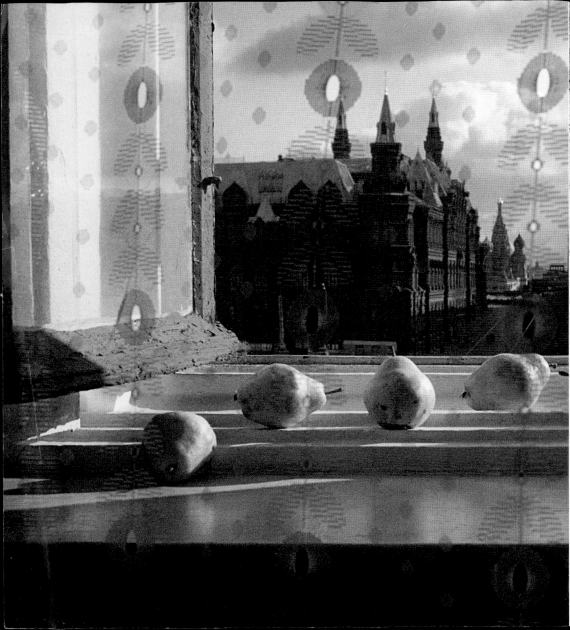

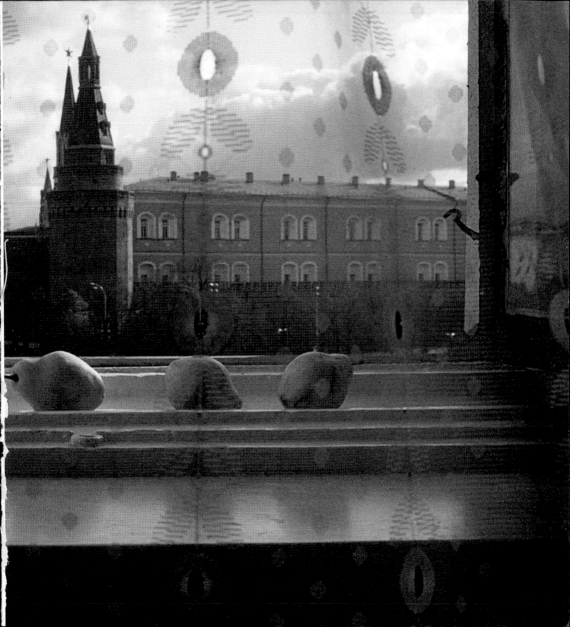

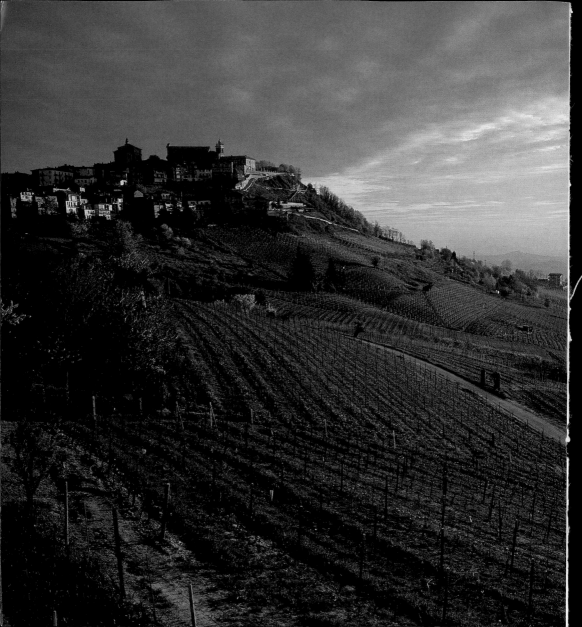

TOPICAL PRESS | 1940
PAGES 36-7: A horse tows a grain-and-timber barge along the River Chelmer in England.

SAM ABELL | 1986
PRECEDING PAGES: Pears ripen on a windowsill near the Kremlin in Moscow.

WILLIAM ALBERT ALLARD | 2002
LEFT: Vineyards near the hilltop town of La Morra, Italy, produce some of the world's finest red wines.

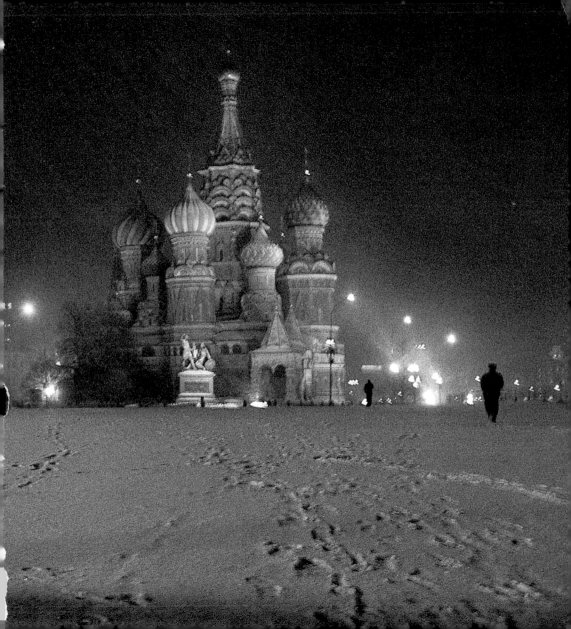

SISSE BRIMBERG | 1998

PRECEDING PAGES: St. Basil's Cathedral, in Moscow's Red Square, houses nine distinct chapels, each with its own unique dome.

LIDA AND MISO SUCHY | 1997

RIGHT: The village of Kryvorivnya, Ukraine, and its surrounding hills are the ancestral homelands of Lida Suchy's father's family.

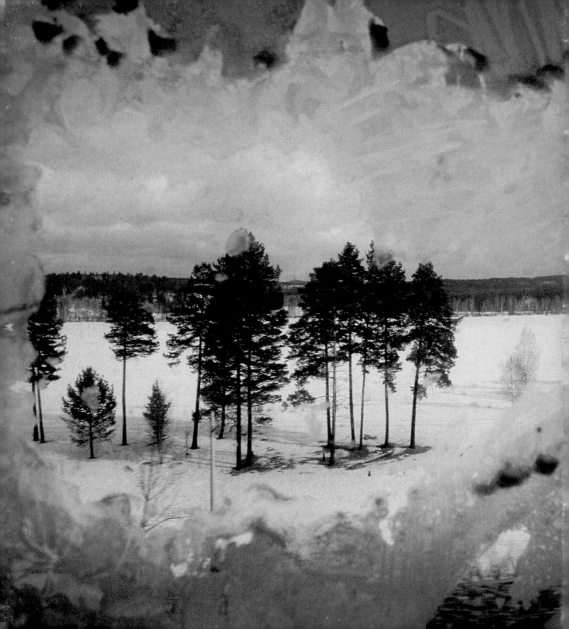

SISSE BRIMBERG | 1994
PRECEDING PAGES: The 13th-century town hall in Lüneburg, Germany, is a testament to commercialism over feudalism.

GERD LUDWIG | 1998
LEFT: In this pastoral scene, the camera captures familiar features of Russia — snow and ice and a stand of conifers.

LYNN JOHNSON | 1997
Swans prepare for flight near banks
of daffodils south of Amsterdam.

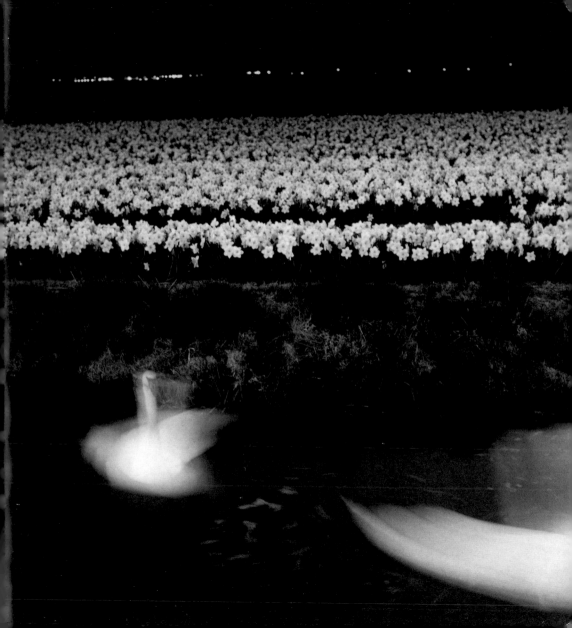

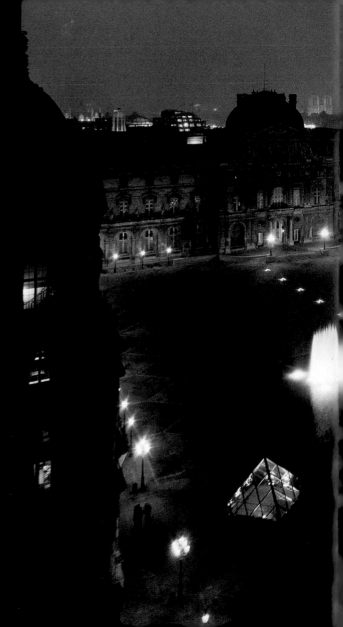

JAMES L. STANFIELD | 1989

In Paris, I.M. Peï's stark triangular anomaly marks the entrance to the Louvre Museum; once a royal palace, the Louvre has been a national museum since 1793.

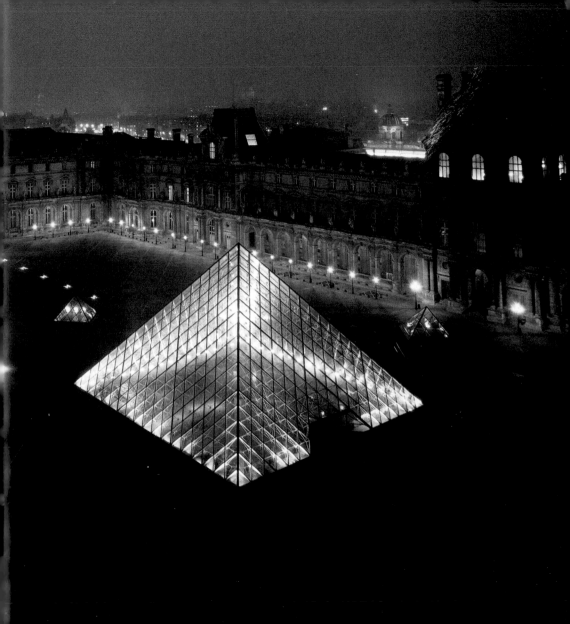

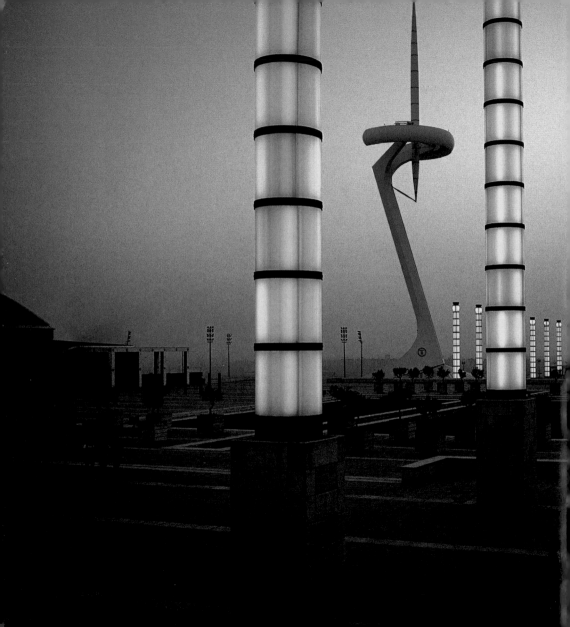

DAVID ALAN HARVEY | 1998
Glowing pillars and a telephone tower
mark the Olympic Esplanade in Barcelona,
Spain, host of the 1992 Olympic Games.

WILLIAM ALBERT ALLARD | 1995
FOLLOWING PAGES: In Provence, France,
poppies are like dashes of red paint in
an idyllic landscape.

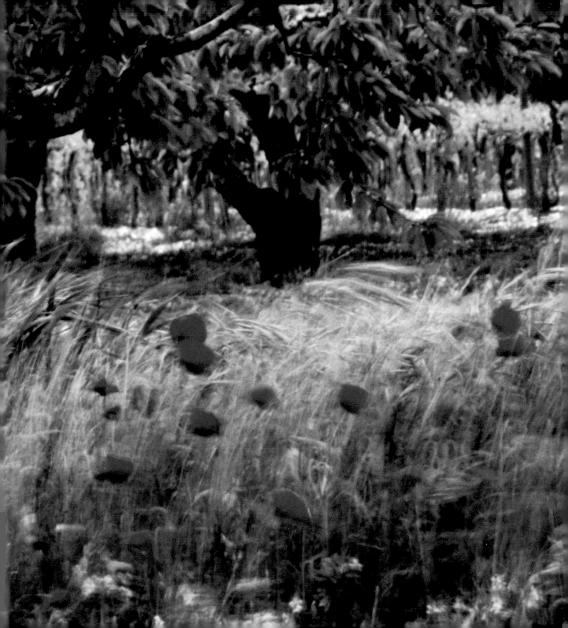

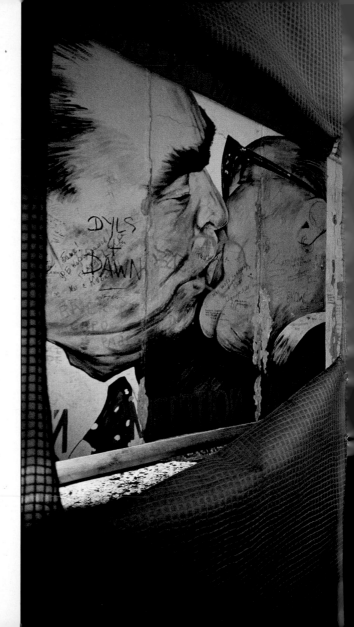

GERD LUDWIG | 1996

Taking liberties—a political painting
on the Berlin Wall shows former Soviet
Premier Leonid Brezhnev and East
German leader Erich Honeker locked
in a mock embrace.

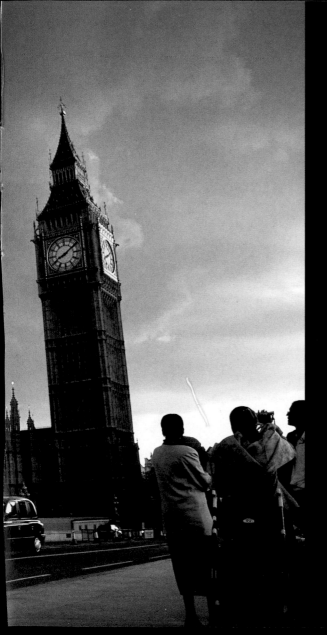

EUROPE | WORK

With ready access to the sea, a temperate climate, and bountiful natural resources, Europe has long been a world leader in agriculture and industry—though not without human costs. In the October 1924 NATIONAL GEOGRAPHIC magazine, Maynard Owen Williams wrote that "Latvia owes a heavy debt to its women, who drive the wagons, harvest the flax...run the hotels, tend the street markets, keep the stores, shovel the sawdust, and juggle the lumber." Today, workers in the 12 nations of the "eurozone" enjoy some of the world's highest levels of prosperity.

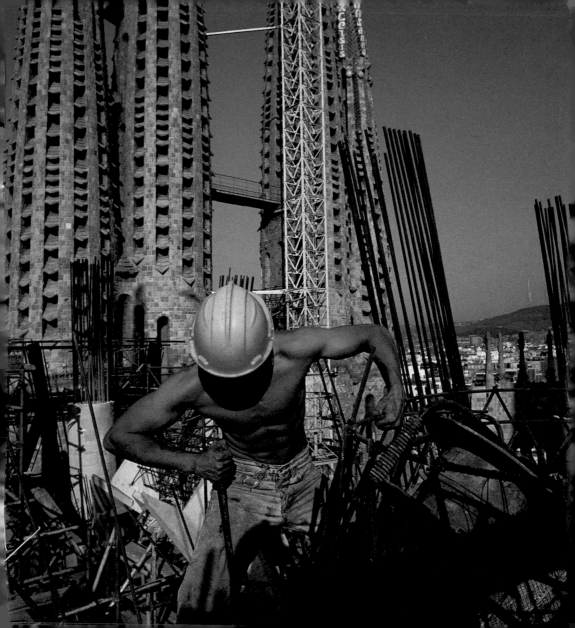

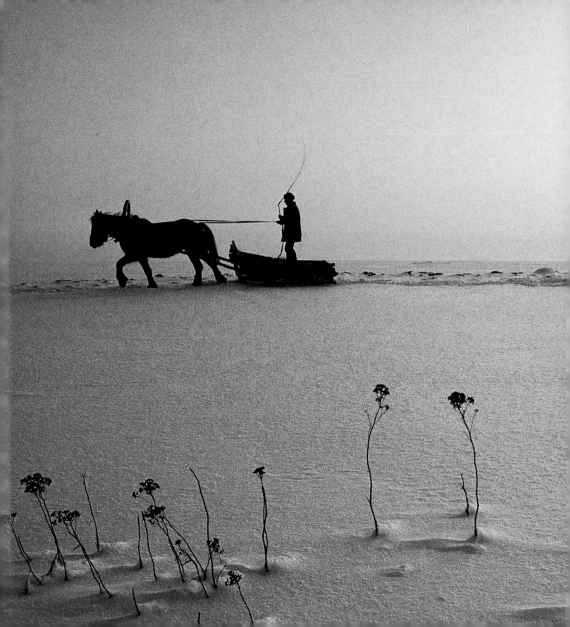

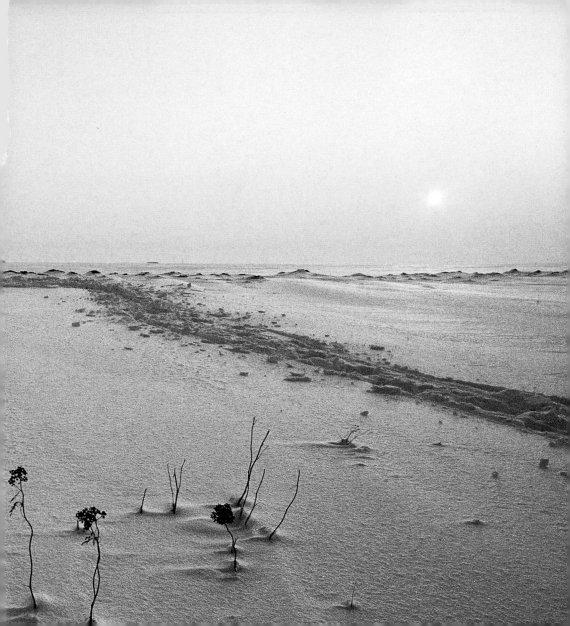

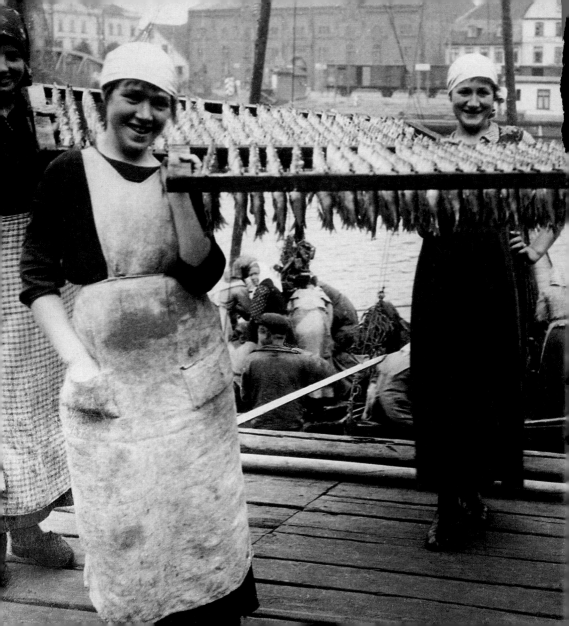

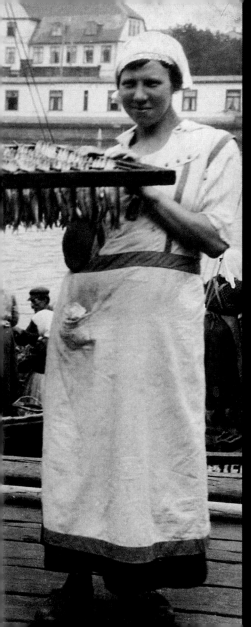

DAVID ALAN HARVEY | 1998
PAGES 62-3: Vision and strength are evident in the construction of the Sagrada Familia Church in Barcelona, Spain.

LYNN JOHNSON | 1992
PRECEDING PAGES: A workman makes his way across the former estate of Alexander Pushkin, a 19th-century Russian poet.

ERNEST PETERFFY | 1924
LEFT: At dockside, Latvian women proudly display salmonlike sea trout.

REZA | 1994

Empowered as guardians of the republic, military men in Ankara, Turkey, attend the funeral of President Turgut Ozal in 1993.

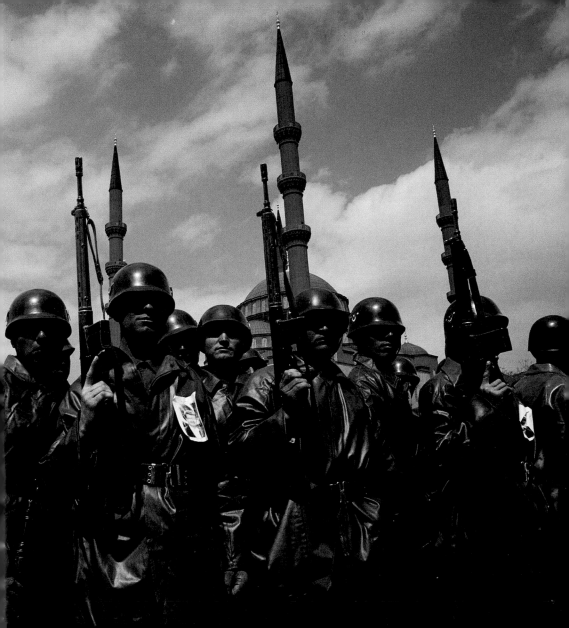

IRA BLOCK | 1999

Ceramic urns hold the "liquid gold" known as Italian olive oil, produced at this Tuscan estate for more than a thousand years.

EUROPE | CHILDREN

The children of Europe offer an intimate portrait of their disparate cultures. For youngsters enjoying a seaside holiday in England, life presents a timeless moment of dalliance. In France, young Gypsies still find time for the pleasures of childhood despite the nomadic ways of their families. Writing about the closeness of Sicilian families in the August 1995 NATIONAL GEOGRAPHIC, Jane Vessels told of a mother and father who call their 27-year-old son in far-off Milan every morning to wake him up.

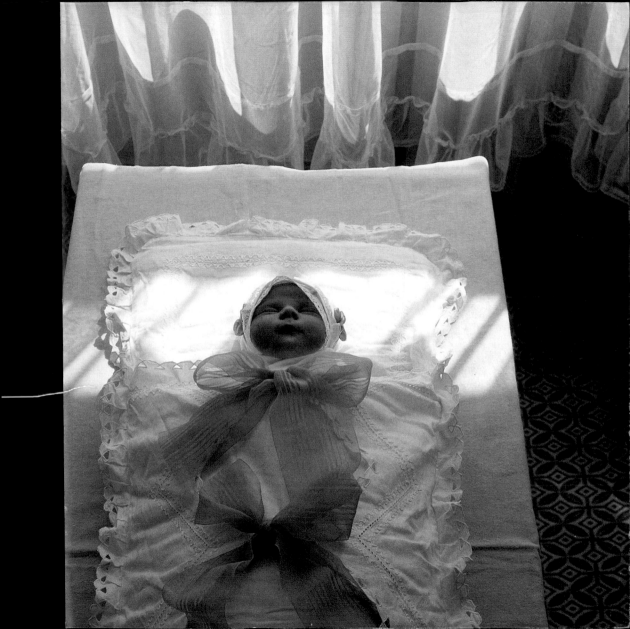

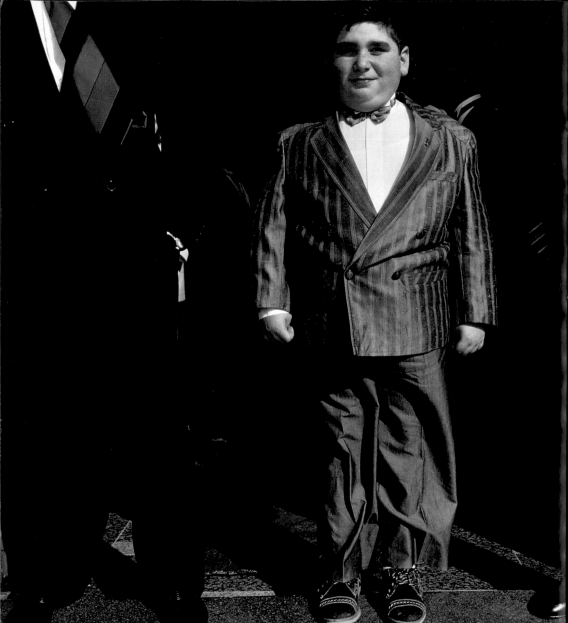

LARRY C. PRICE | 1990
PAGES 72-3: Wrapped like a gift,
a newborn awaits her parents at
a maternity hospital in Vilnius, Lithuania.

TOMASZ TOMASZEWSKI | 2001
PRECEDING PAGES: Gypsy children in
Lourdes, France, play on the grass
after riding with their families in a
caravan of cars.

WILLIAM ALBERT ALLARD | 1995
LEFT: An eight-year-old boy proudly
sports his best suit for a wedding
in Sciacca, Sicily.

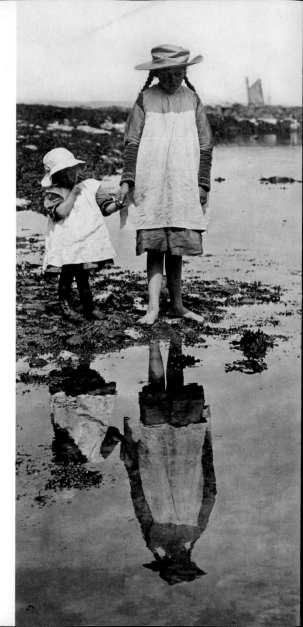

A.W. CUTLER | 1929
Tide pools in Lynmouth, England,
delight a budding yachtsman and
his young friends.

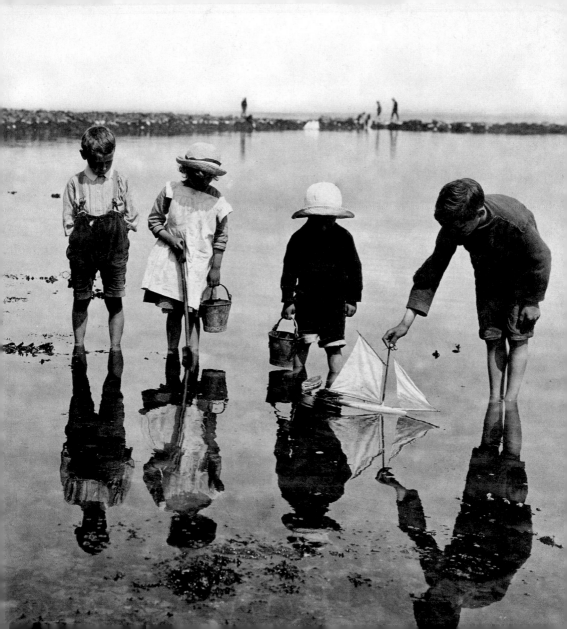

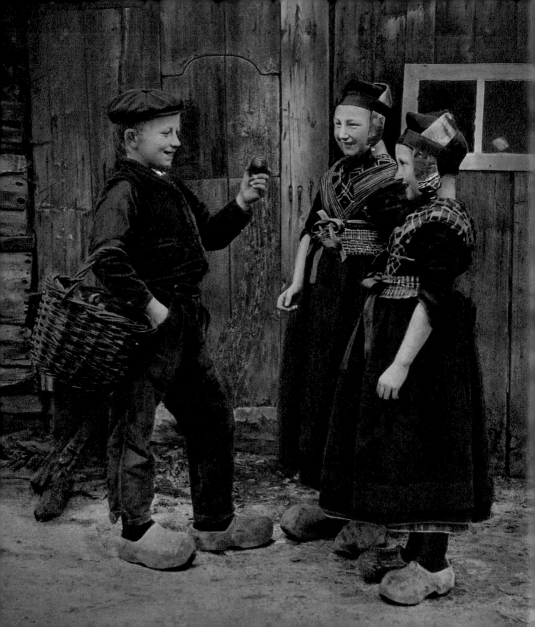

DONALD MCLEISH | 1929

Wearing wooden shoes and other
traditional garb, three children greet
each other with smiles in the village
of Staphorst, Holland.

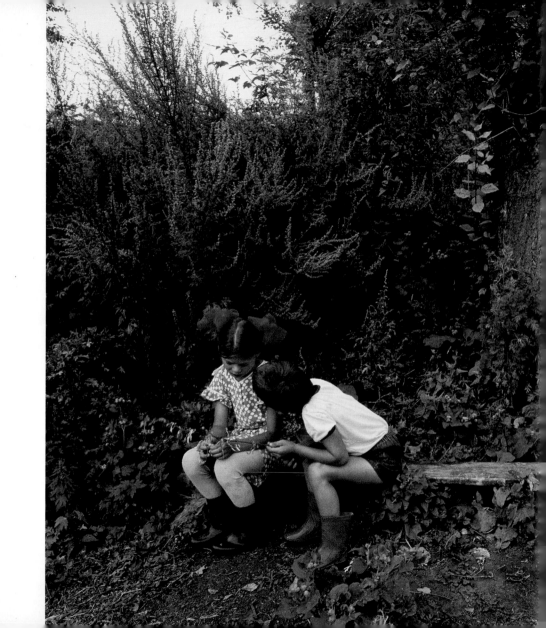

JAMES P. BLAIR | 1994

Children share secrets in an overgrown garden in Grebeni, one of many villages on the banks of Russia's Volga Matushka.

EUROPE | WOMEN

Mirrors of society, the lives of women reflect prevailing attitudes of time and place. Modern-day Istanbul offers a study in contrasting lifestyles. In the October 2002 NATIONAL GEOGRAPHIC, Rick Gore described a city where women with "hemlines hovering at mid-thigh share the sidewalks…with women hidden head to toe under…black chadors." Economics plays a major role in shaping lives: While working-class Italian women may share crowded living quarters with their families, more fortunate females shop for the latest Parisian fashions.

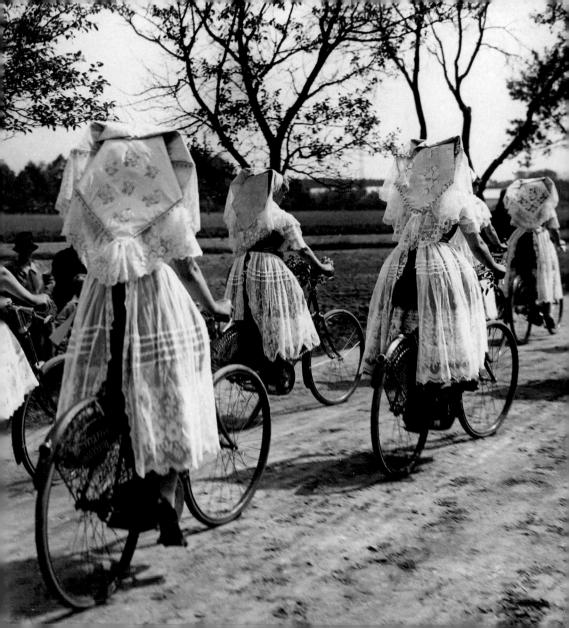

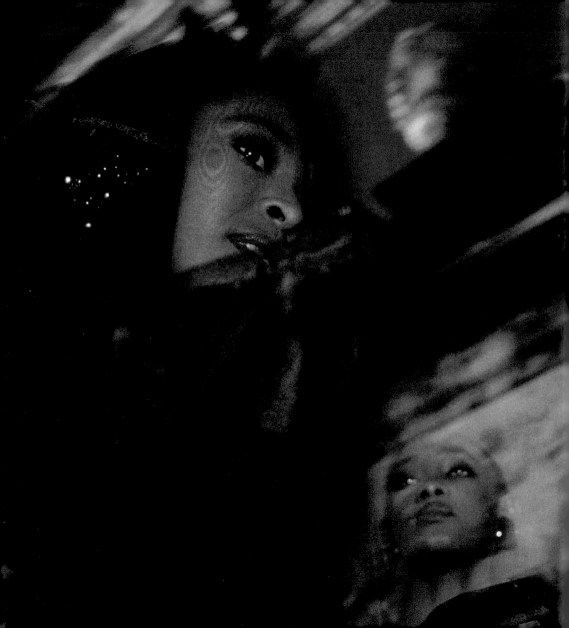

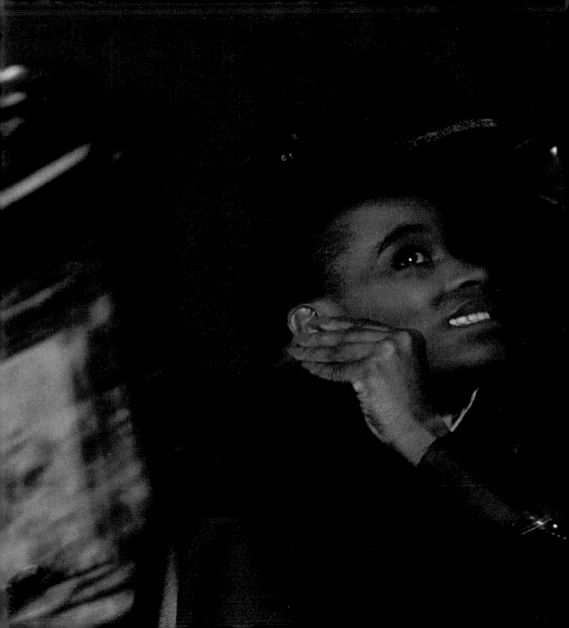

ACME | 1937
PAGES 84-5: Large fancy hats adorn ladies
from the Spreewald swamps near Berlin.

WILLIAM ALBERT ALLARD | 1989
PRECEDING PAGES: Models wearing Yves
Saint Laurent designer gowns prepare
to parade down a runway in France.

WILLIAM ALBERT ALLARD | 1995
OPPOSITE: Gazing through a black veil,
a Sicilian actress strikes a dramatic pose.

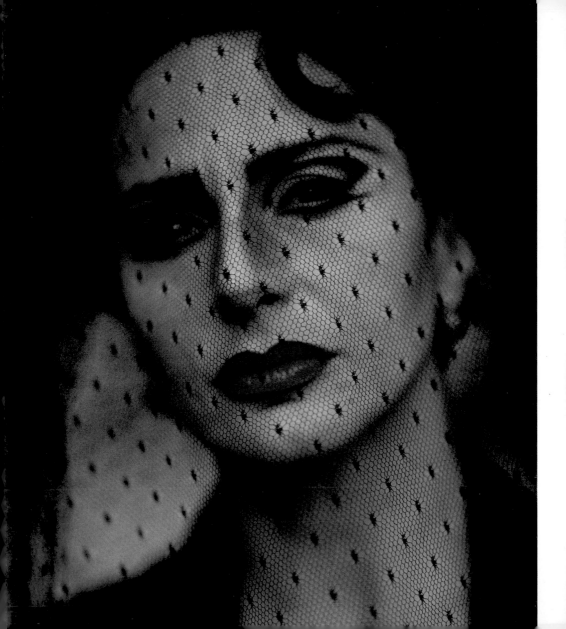

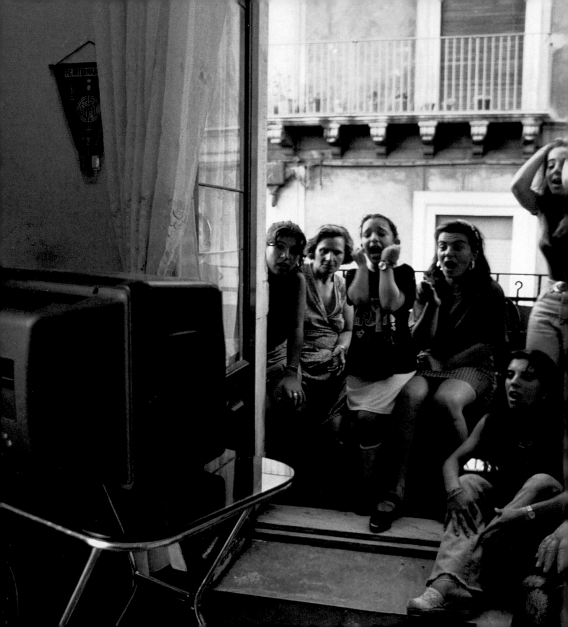

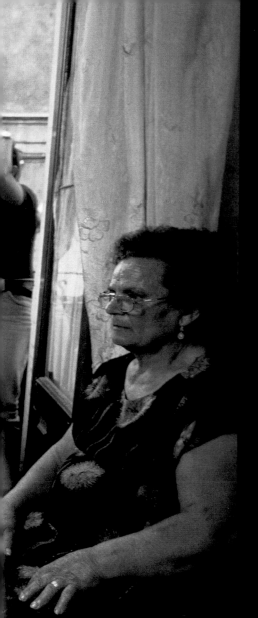

WILLIAM ALBERT ALLARD | 1995
In Catania, Sicily, soccer fans react
as World Cup action unfolds on their
TV screen.

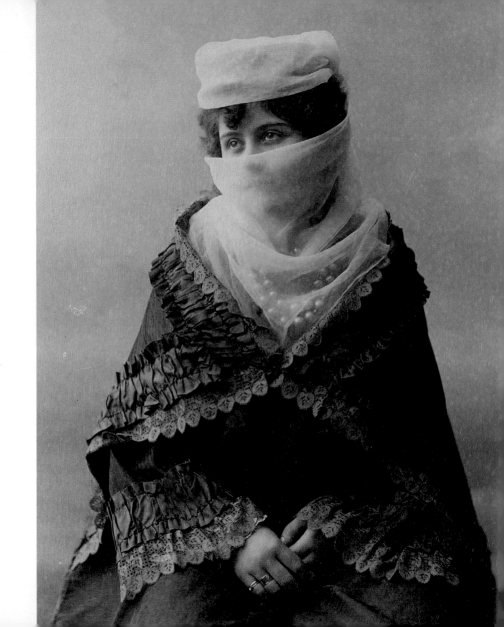

SEBAH & JOAILLIER | 1929

Maynard Owen Williams, once a frequent NATIONAL GEOGRAPHIC contributor, purchased this portrait of a lady in Turkey and brought it back to the United States in 1929.

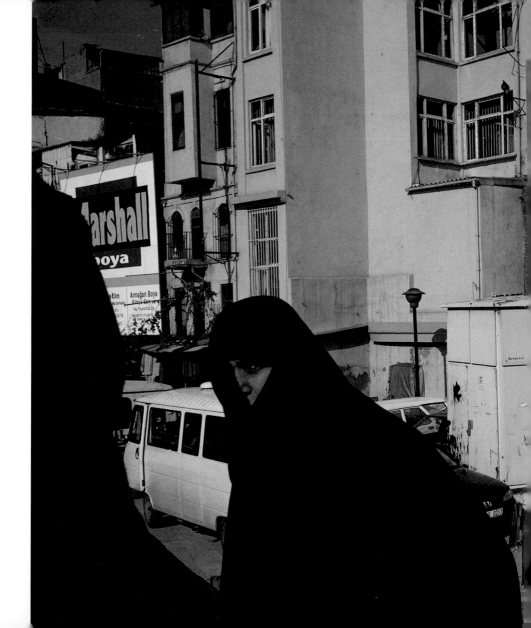

ALEX WEBB | 2002
East meets West in Istanbul, Turkey, where women in black chadors might encounter females in more revealing attire.

Perfecting la dolce vita, the people of Europe are renowned for their wholehearted embrace of life's rewards, from festivals to fine dining to stolen moments with friends or loved ones. A night of revelry at a pub in Prague might bring out a serenading duo dressed as characters in a favorite Czech novel, while compatriots in Paris may share a quiet afternoon of fishing on the Seine. For a father and his son and dog in Wales, nothing could be finer than a drive through the countryside in a vintage roadster.

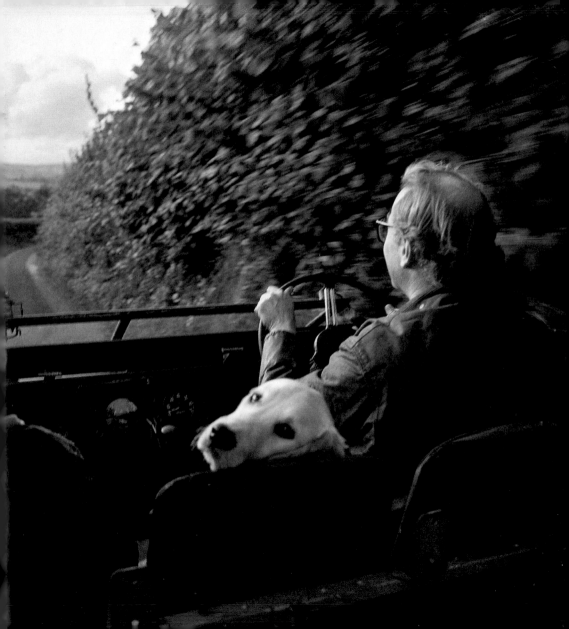

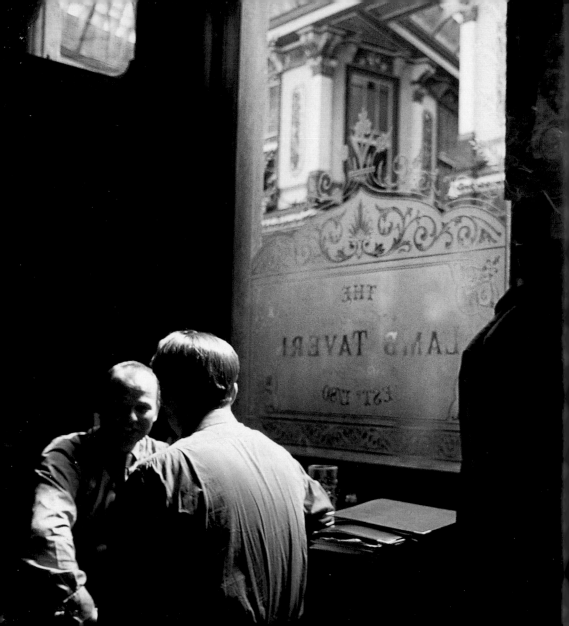

SAM ABELL | 1993
PAGES 96-7: A father, son, and dog roll past miles of hedgerows in Wales.

JODI COBB | 2000
PRECEDING PAGES: A pubgoer downs a pint at London's Lamb Tavern, founded in 1780 and frequented by city workers ever since.

ACME | 1933
RIGHT: Passengers on a German Junkers trimotor enjoy first-class service on a flight between Berlin and Amsterdam.

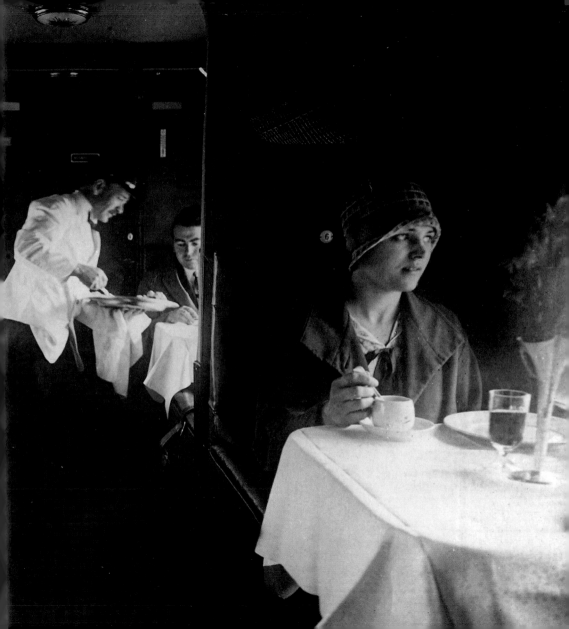

GERD LUDWIG | 2001
On a shopping expedition, a couple in Moscow seem oblivious to the eye-catching ad behind them.

W. ROBERT MOORE | 1936

Fishing on the banks of the Seine is a favorite pastime for Parisians and a popular subject for scores of French artists.

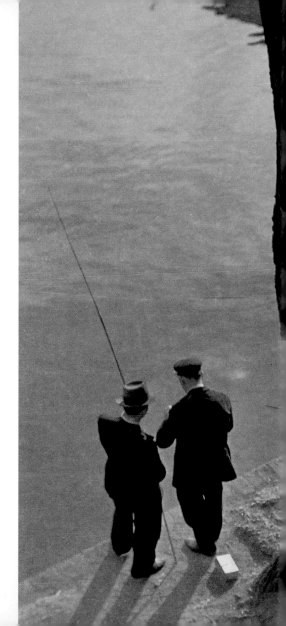

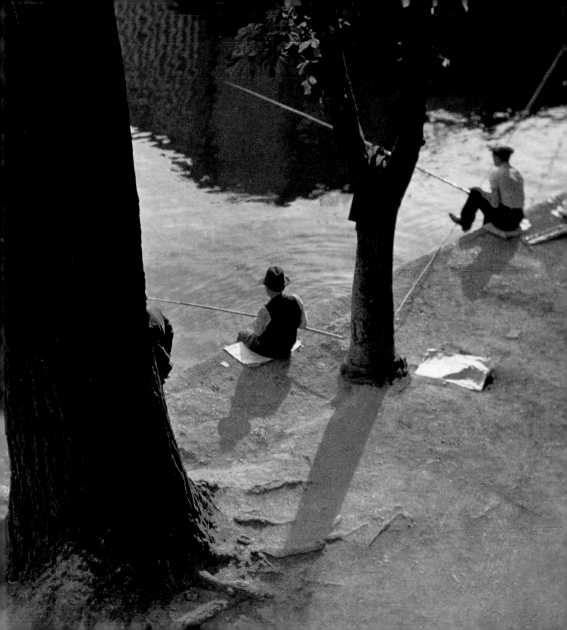

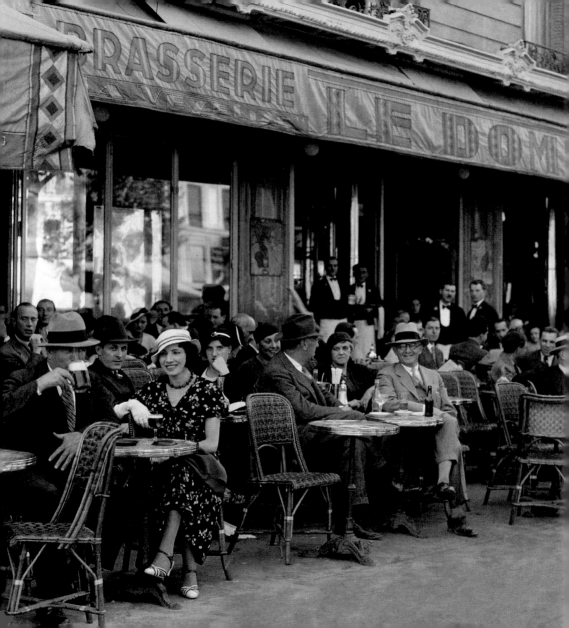

W. ROBERT MOORE | 1936

Café-goers enjoy a pleasant afternoon
in Montparnasse—Left Bank center
of bohemian life in Paris.

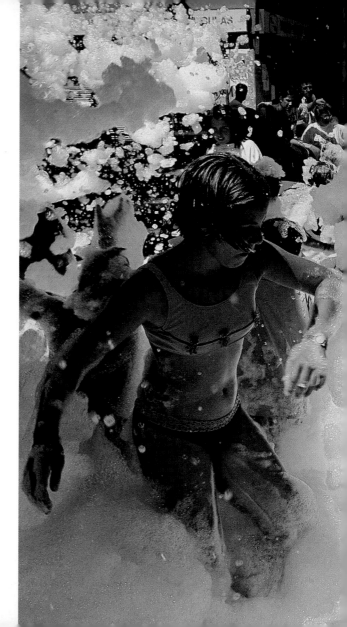

DAVID ALAN HARVEY | 1998
Children play in bubbles in Barcelona,
Spain, which celebrates some 140
festivals a year.

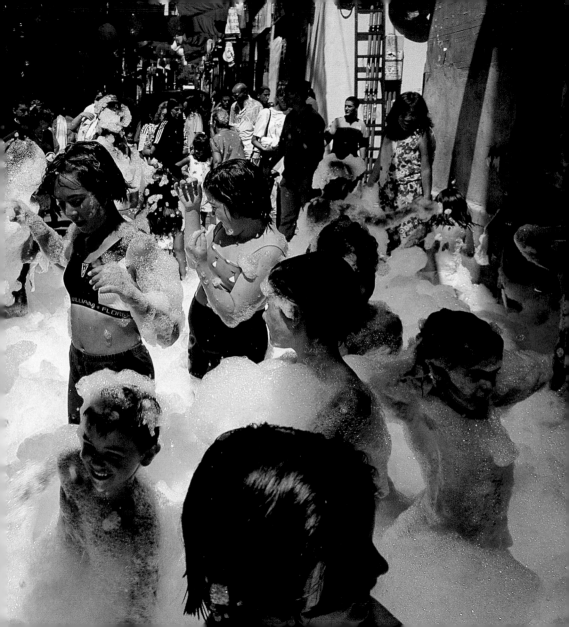

Grotesque masks bob along in a burst
of pre-Lenten revelry in Nice, France.

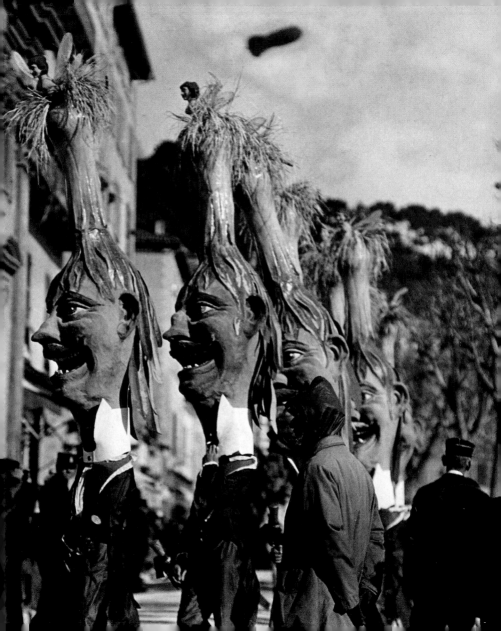

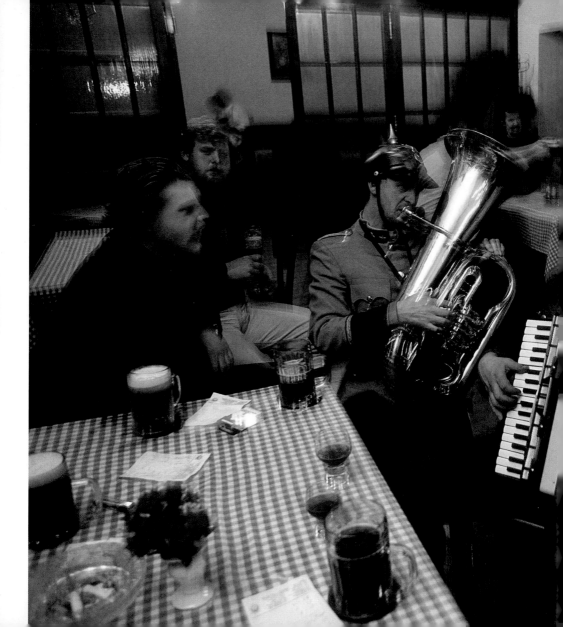

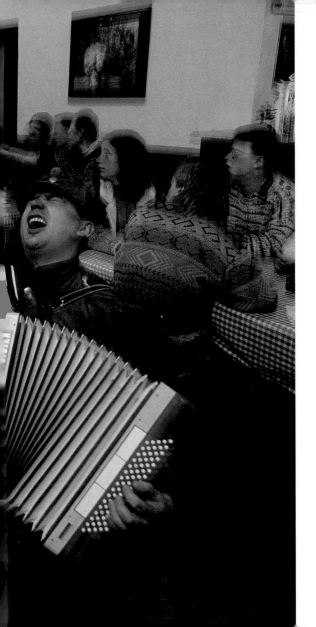

JAMES L. STANFIELD | 1993
Musicians in a Prague pub pay tribute
to a revered Czech antihero.

113

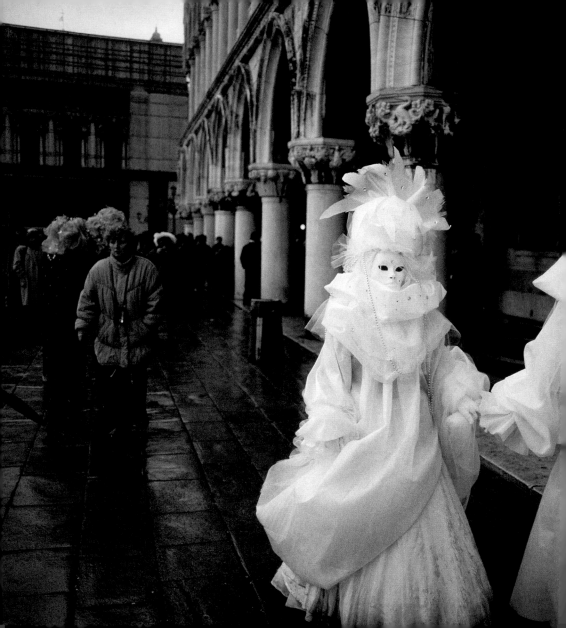

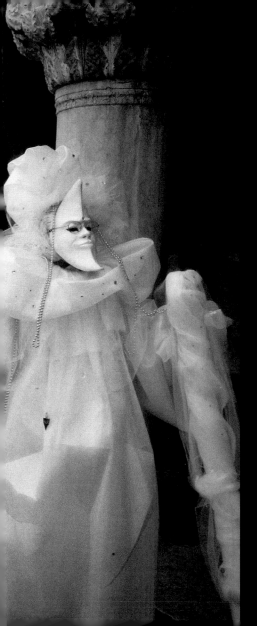

Carnival participants in whimsical
costumes stroll along a street in Venice.

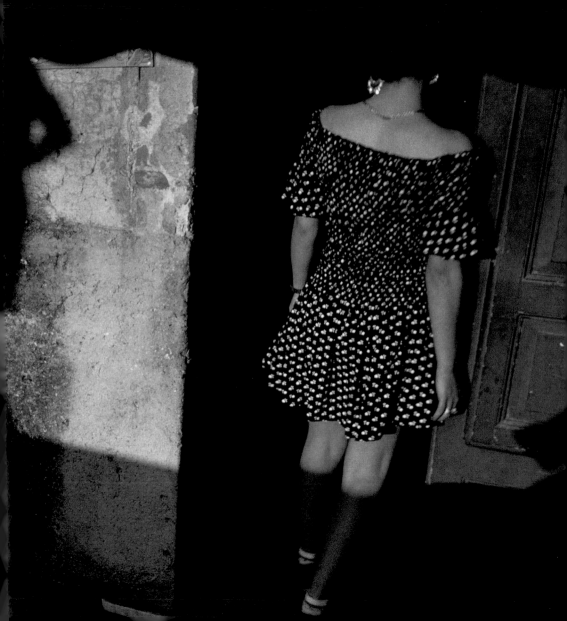

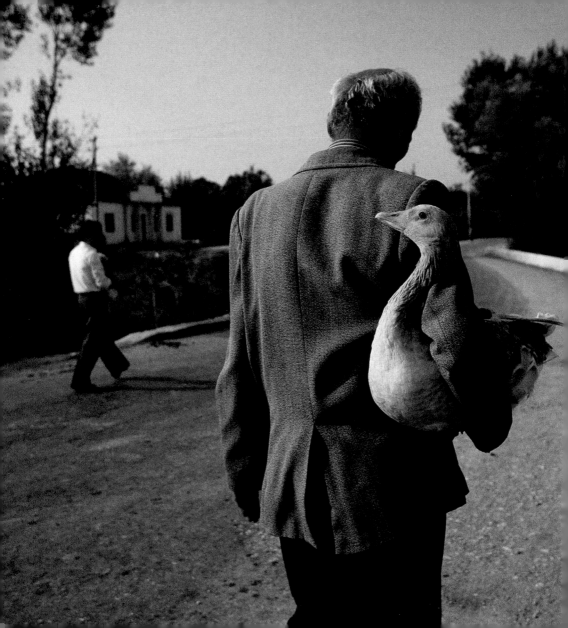

WILLIAM ALBERT ALLARD | 1995
PRECEDING PAGES: A villager spends the afternoon at a café in Alcara li Fusi, Sicily, talking politics and soccer with friends.

NICOLE BENGIVENO | 1992
LEFT: In Albania, a fat goose holds the promise of simple pleasures—a good meal for a man and his family.

STUART FRANKLIN | 1995

With a kiss and a yellow balloon,
a couple lightens the mood at Oxford,
where bowler-topped "bulldogs" monitor
security during final exams at Britain's
oldest university.

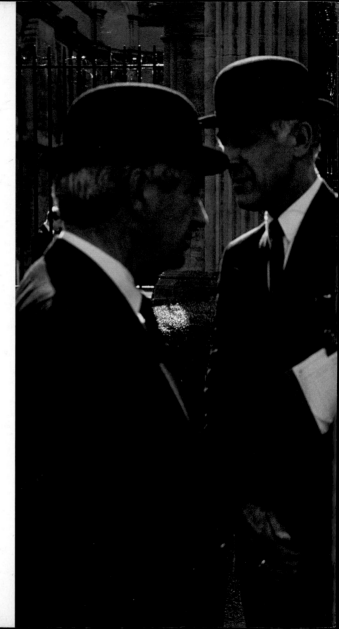

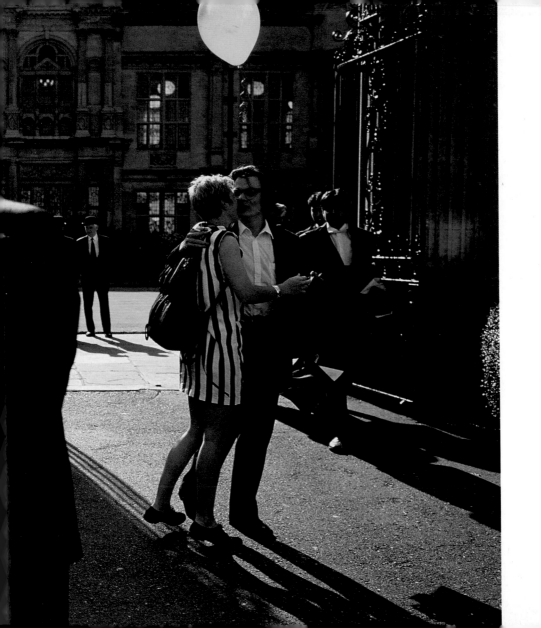

ASIA

ETERNAL LANDS OF THE EAST

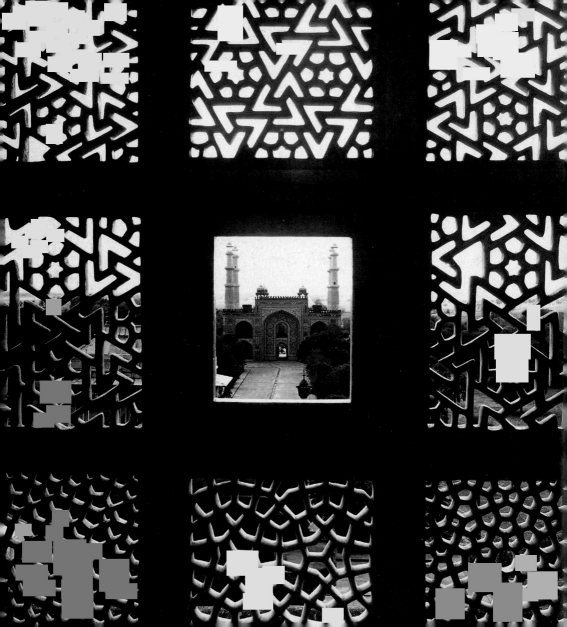

Asia

by Daisann McLane

"A land so oriental, full of unusual scenes, and customs so strange…," wrote photographer William W. Chapin in the November 1910 issue of NATIONAL GEOGRAPHIC. Although he was describing Korea, he was also conveying to his readers a vision of Asia that has long resonated in the imagination of Westerners and inspired countless attempts by photographers to capture it on film.

In the early 20th century, Americans found few places as fascinating as the Orient. They pored over Chapin's words and studied his photographs of Korea and Japan, which were hand-tinted by a Japanese artist. Today the old images of everyday life in Seoul, of peasants and street-sellers, seem quaint and almost ordinary, their faded sepia and rose tones evoking a sense of nostalgia. But in 1910 they provided a marvelous peek into countries that had only recently extended a welcome to outsiders. Korea was said "to have been death not alone to the foreigner who landed on her shore," Chapin wrote, "but to the native who gave him shelter."

HERBERT G. PONTING | 1924

PAGE 124: Stone filigree screens near Agra, India, frame the garden and tomb of Emperor Akbar, who died in 1605.

The public's delight in Chapin's glimpses of a "land so oriental" proved critical to the early success, and even the future, of the National Geographic Society. In fact, the November 1910 issue was so well received that Gilbert H. Grosvenor, then President of the Society, decided to make color photographs a regular feature in the magazine. Thus, in a very real way publication of the Asia pictures was a significant step in the Society's fledgling magazine venture. In the decades since, images of the continent have continued to enthrall, entertain, and educate NATIONAL GEOGRAPHIC readers around the world.

The Asia photographs featured in this book range from posed shots of Nepalese ladies and Taiwanese girls, made in 1920, to a recent picture of an Afghan woman who, as a refugee 17 years earlier, had graced the cover of the June 1985 GEOGRAPHIC. Some images are breathtakingly beautiful; others may be thought-provoking or even upsetting. Taken as a body, the photos first impress you with their diversity. The generic, pastoral land of oriental curiosities captured by William Chapin and other early 20th-century photographers has made way for a vision that more accurately reflects the largest and most populous continent. In this collection we see Asia as the setting for great civilizations and for a host of cultures and callings, from the ancient and vanished Khmer of Angkor, in Cambodia, to modern-day Sumo wrestlers in Japan.

Although time and familiarity have worn down the old visual trope of exotic Asia, they have yet to bring about its complete demise. In all likelihood, the same people who marveled at pictures of Korean peasants in the 1910 National Geographic would be just as fascinated by the post-World War II photo of hundreds of nearly naked Japanese pilgrims celebrating New Year's (published in the September 1988 and 2000 issues) and by the 1996 picture of a circumcision ceremony in China. The photographs, old and new, are certainly striking; modern eyes appreciate them as well. But the old way of looking at Asia—focusing on the "unusual scenes" or "customs so strange"—has become increasingly less common, and our view of Asia has expanded to include an interesting mix of past and present.

For at least 75 years, NATIONAL GEOGRAPHIC writers and photographers covering the continent have been exploring the theme of traditional Asia versus modern Asia. One can't help but chuckle when reading Paul Hutchinson's observations and speculations on "Old China" and "New China" in the June 1927 issue of the magazine; his prediction that "there are bound to be changes, subtle differences in spirit, between the China of Confucius and the China of the future" could easily have been lifted from an essay by any number of China "hands" in 2002.

Depicting Asia as a place where centuries overlap and coexist is an endeavor tailor-made for the art of photography, which can capture the contrasts and contradictions in a way that writers cannot. A writer might need hundreds of words to describe how a certain society balances moder-

nity with continued adherence to ancient customs, but a photographer can instantly show that aspect of the culture with just the right image.

Consider John Launois's "Farewell to Guests." This 1960 photograph shows a group of Japanese women standing outside their *ryokan*, or inn, in Matsuyama, a famous hot springs resort. Dressed in bright kimonos, the women bow in unison to say good-bye to a gentleman in the backseat of a fabulously finned 1950s American automobile. Although NATIONAL GEOGRAPHIC readers in the 1960s might have reasonably presumed that modern ways, represented by the car, would emerge the victor in this particular tug of war between past and present, time has proved the reverse to be true. More than 40 years have passed since that photo was first published, and yet visitors leaving Matsuyama hotels still receive somewhat similar farewells.

Tradition versus modernity is also a subtext in Mattias Klum's "King Cobra." Previously published in the November 2001 GEOGRAPHIC, this riveting photograph features a sneaker-clad snake handler sitting within striking distance of a swaying serpent in Thailand.

There is another aspect to this group of remarkable images: In a very direct way, and without irony or photographic pyrotechnics, many of the contemporary pictures present an Asia that just simply is. These images represent no particular theme or perhaps convey several of them, and we can take each photo at face value or read what we will into it. If, for instance, you contemplate Steve McCurry's photograph of crumbling stones in the Preah Khan temple at Angkor, you might perceive Shelley-like intimations on the impermanence of great civilizations. You might also be reminded, sadly, of Cambodia's anguish during the 1970s, when radical communism was enforced by the Khmer Rouge; starvation, disease, and mass executions killed some two million people.

Among the book's most striking pictures are those of cities such as Kowloon, in Hong Kong, and Shanghai, China—modern metropolises filled with neon signs and soaring skyscrapers. Certainly, photographs of Asia's densely populated urban districts and bizarrely modern cityscapes are reflections that have much to say about the continent and need no interpretation.

While trying to capture the peoples and places of Asia on film, photographers sometimes overlook the continent's great natural beauty and stunning wildlife. But when they do focus on Asia's wild side, they can have spectacular results there, too. Just look at the iridescent greens and reds of Tim Laman's amazingly close-up portrait of a hornbill in the Indonesian rain forest, or study Laman's in-the-air shot of a leaping proboscis monkey, her baby clinging tightly to her chest.

The photographs in this book—direct, unvarnished, and filled with the beauty of Asia's many faces—present a vision of the continent that this traveler recognizes and holds close to her heart. Perhaps if William Chapin and his contemporaries could peer through these "windows" at today's Asia, they would like what they see, too.

ASIA | SCAPES

Cities pulsing with diverse humanity…archaeological treasures of ancient civilizations… landscapes of staggering scale—these are among the many intriguing faces of Asia, home to three-fifths of the world's population. Vastly different in their social, religious, and economic profiles, the complex cultures of Asia weave a tapestry of endless fascination. Says NATIONAL GEOGRAPHIC contributor Steve McCurry of his favorite photographic subject, "Wherever you go in that part of the world, there is the riot of life carried out in the streets and bazaars."

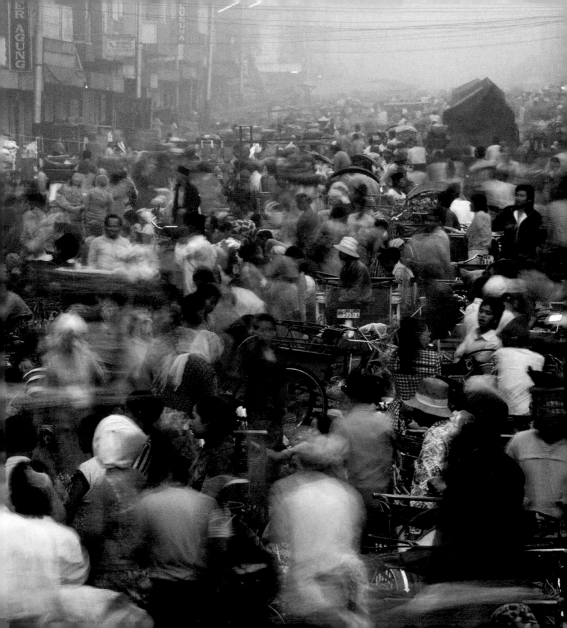

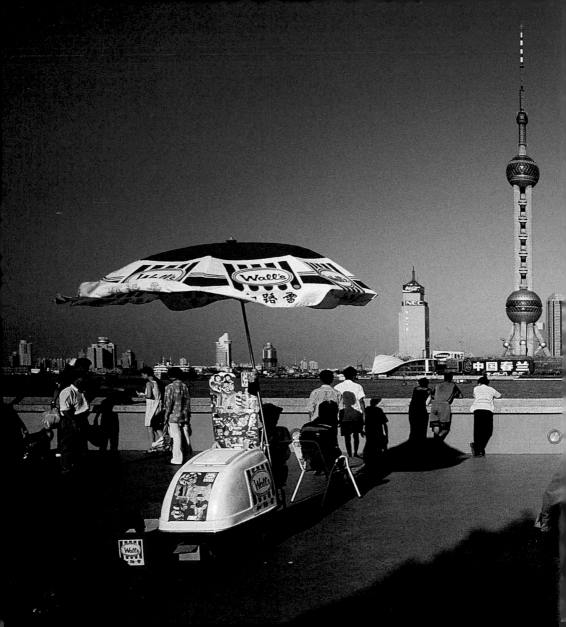

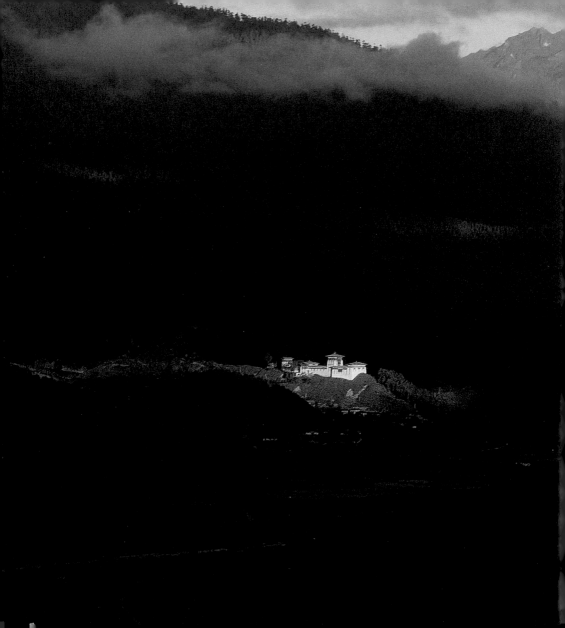

CHARLES O'REAR | 1989
PAGES 128-9: Morning shoppers jam the market at Malang, one of Java's finest and most neatly planned hill towns.

JOE MCNALLY | 1999
PRECEDING PAGES: The Oriental Pearl TV Tower, 1,500 feet tall, soars over the modern Pudong New Area in Shanghai, China.

JAMES L. STANFIELD | 1991
LEFT: Shadows and light surround a monastic fortress in Bhutan. In legend, Guru Rimpoche rode a flying tiger into the Himalaya and dispelled evil spirits from Bhutan.

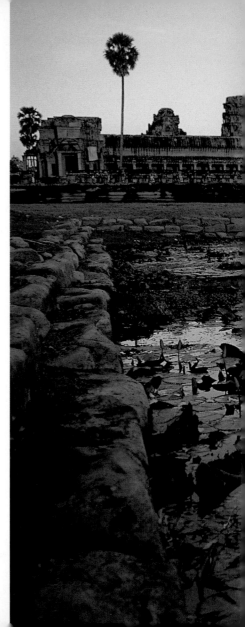

STEVE MCCURRY | 2000

Pilgrims who travel to the temple of Angkor Wat, in Cambodia, offer locally grown lotus flowers to Buddhas at the site.

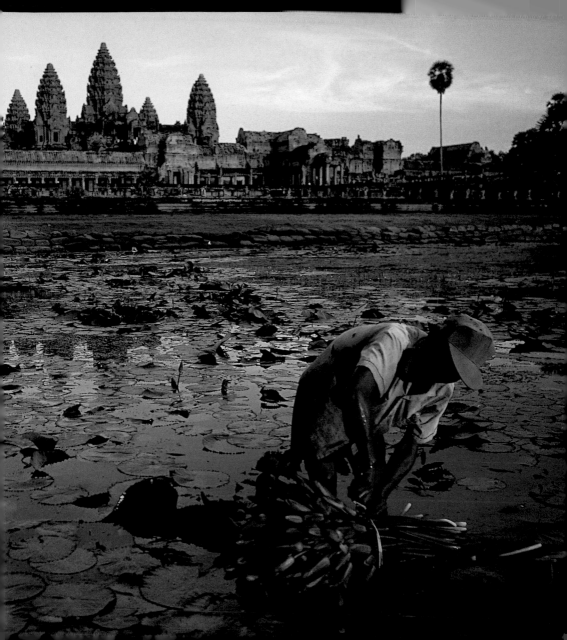

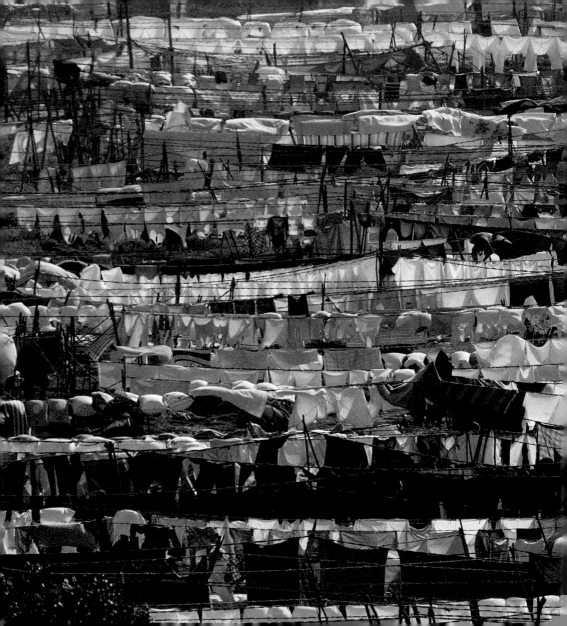

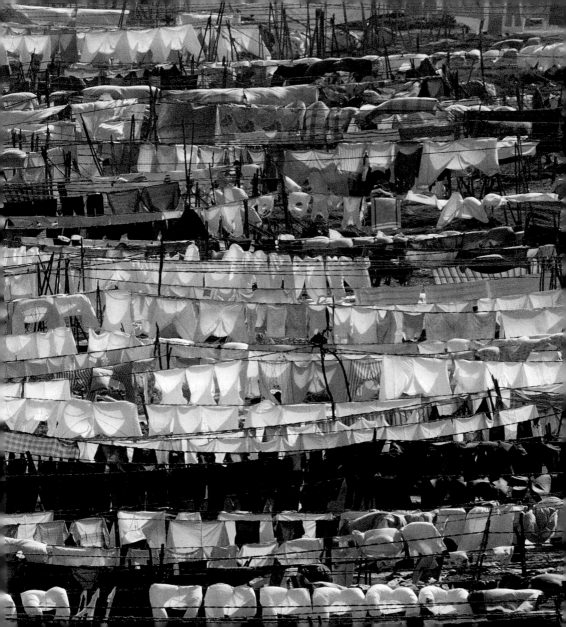

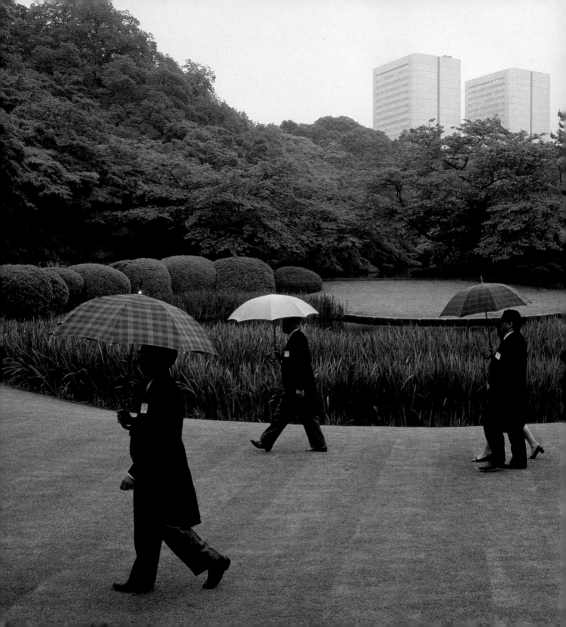

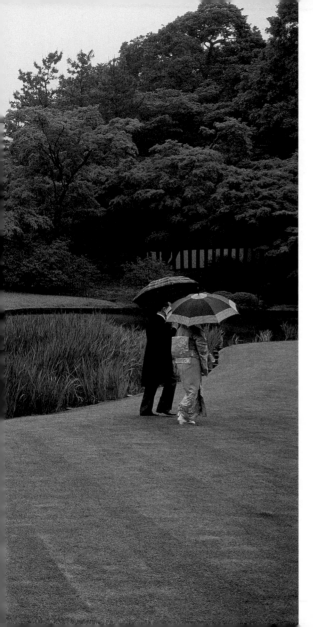

JAMES L. STANFIELD | 1981
PRECEDING PAGES: Boiled, beaten, and hung out to dry, laundry fills lines at Dhobi Ghat (washermen's place) in Karachi, Pakistan.

SAM ABELL | 2001
LEFT: In Tokyo, Japan, guests of the emperor attend a garden party honoring statesmen, scientists, and other exceptional citizens.

JOHN SCOFIELD | 1962
FOLLOWING PAGES: Along Nathan Road in Kowloon, a policeman directs traffic in Hong Kong's busiest shopping area.

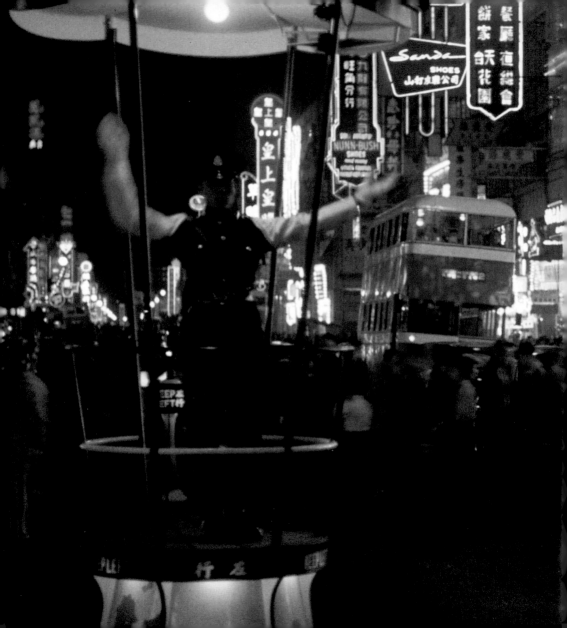

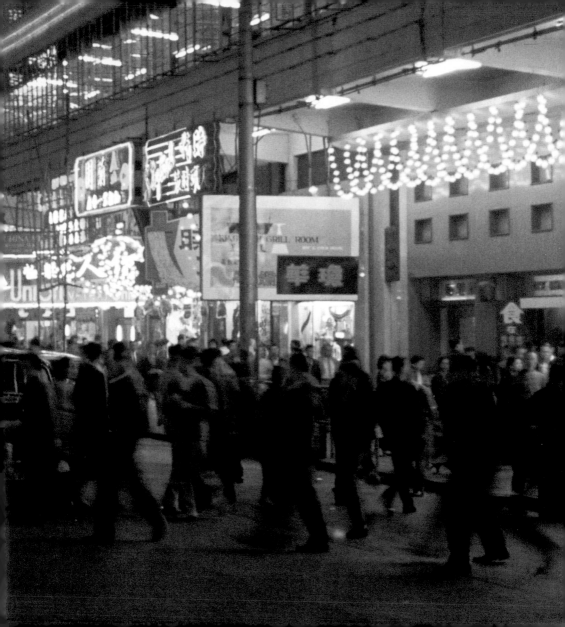

ASIA | ARCHAEOLOGY

Silent stones whisper of an Asia of long ago. The archaeological record here encompasses the crowning achievement of Cambodia's Khmer civilization—the sprawling, thousand-year-old complex of Angkor—as well as historical milestones in China such as the centuries-old Great Wall, one of humanity's largest construction projects ever. "Despite its decay," wrote Adam Warwick in the February 1923 NATIONAL GEOGRAPHIC, "the Great Wall remains a magnificent monument. Once seen, it can never be forgotten."

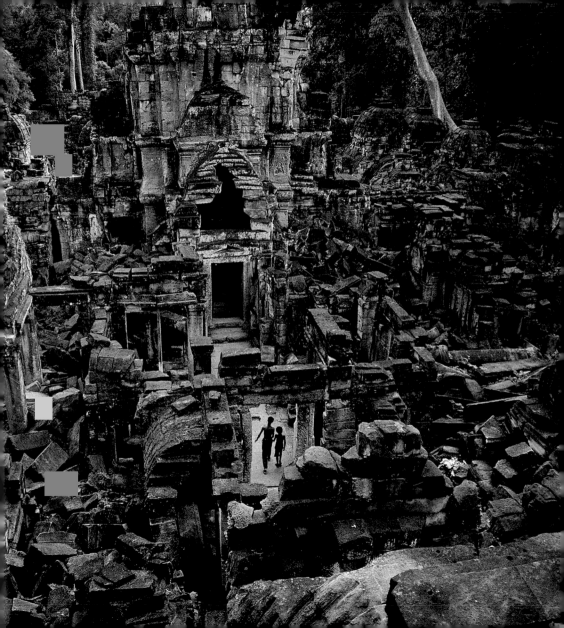

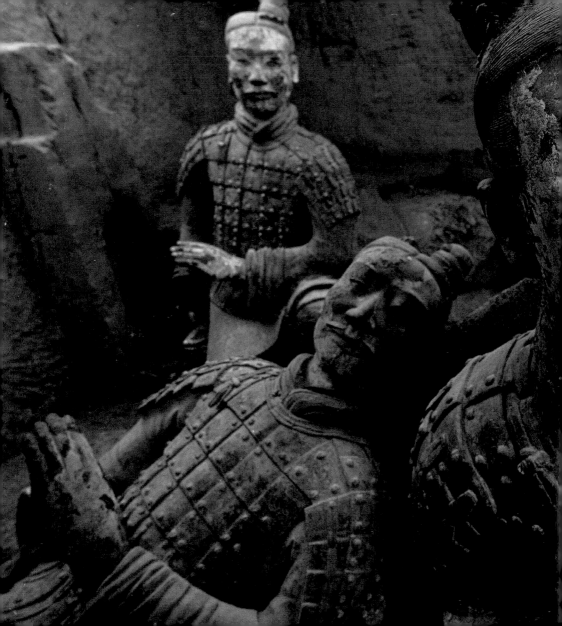

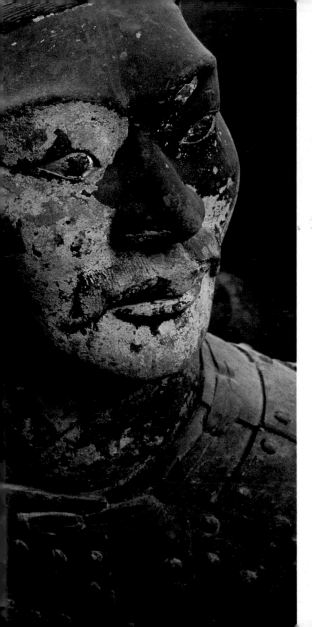

STEVE MCCURRY | 2000
PRECEDING PAGES: Visitors walk among the ruins of 12th-century Khmer temples at Angkor's Preah Khan, in Cambodia.

O. LOUIS MAZZATENTA | 2001
LEFT: Paint still clings to 2,200-year-old terracotta soldiers found in the tomb of Qin Shi Huang Di, the first emperor of China.

MICHAEL S. YAMASHITA | 2003
FOLLOWING PAGES: Catching the light and the imagination, the Great Wall snakes along the crests of mountains in China.

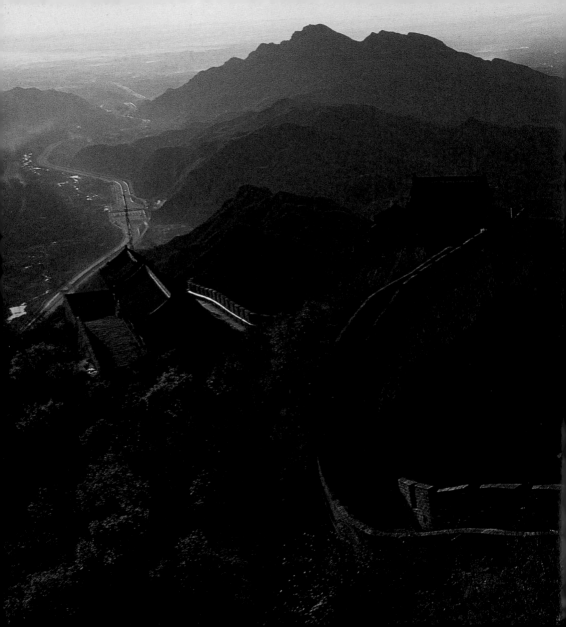

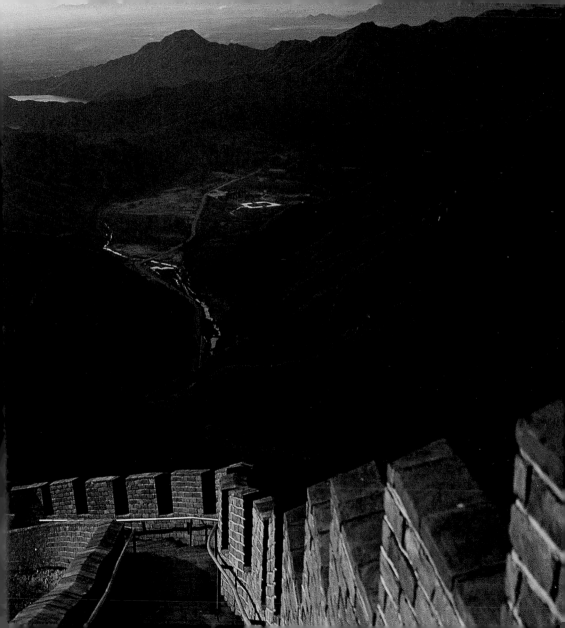

ASIA | WOMEN

In their male-dominated cultures, Asian women often face lives restricted to home-making and child-rearing, but they may exercise significant power within their families. Japanese housewives told writer Deborah Fallows, in the April 1990 NATIONAL GEOGRAPHIC, that they doled out allowances to their husbands for "walking around money." Fallows says that while Japanese women have begun to assert themselves in business and politics, "those few women who have 'made it' tend to be feminine— that is, humble about their success."

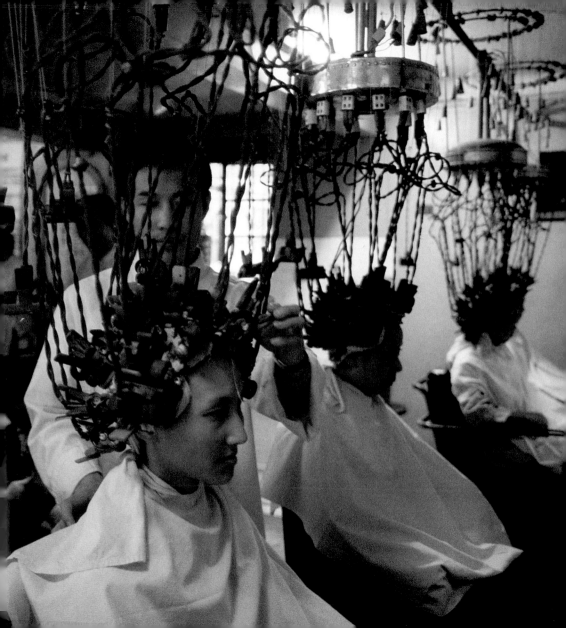

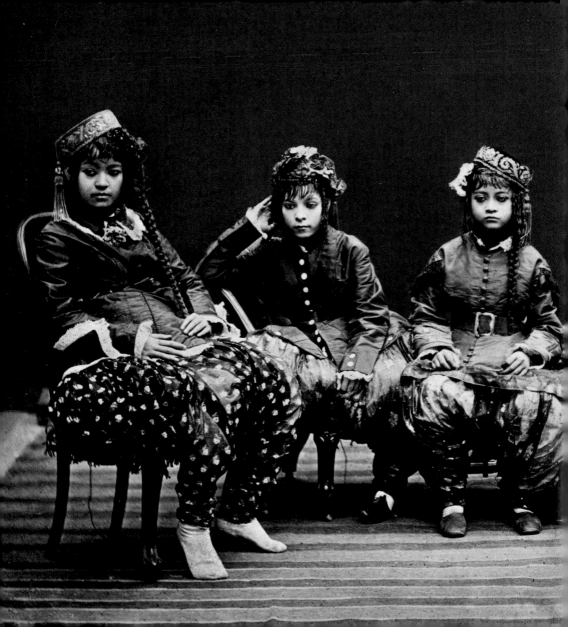

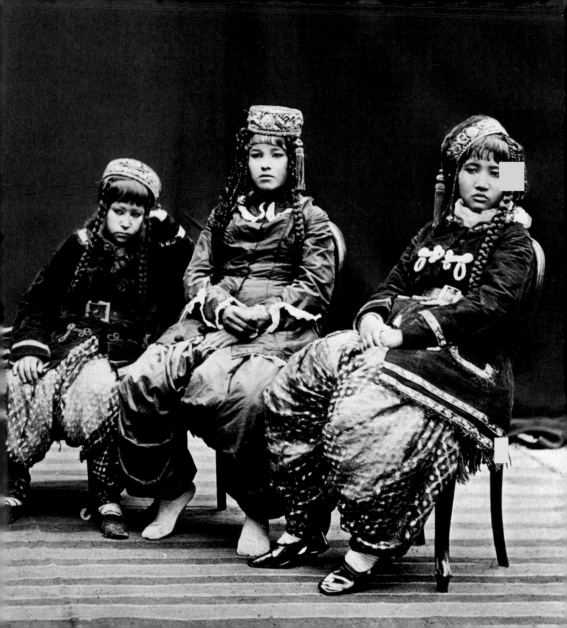

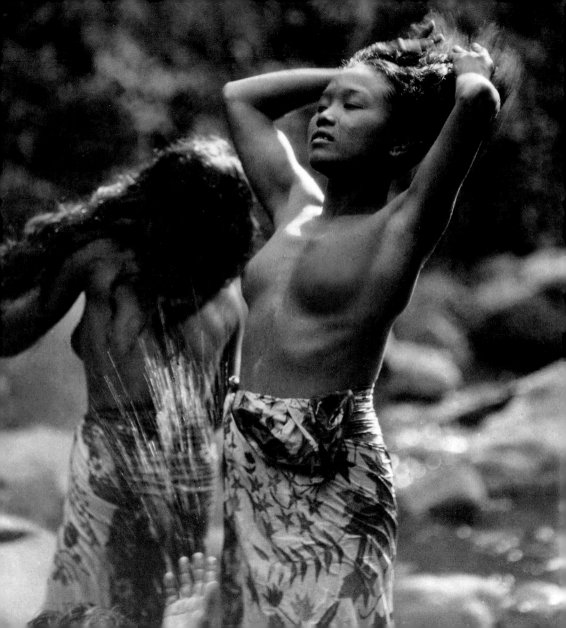

BRUCE DALE | 1980

PAGES 148-9: Women in Shanghai, China, trust their tresses to a hairdresser—and perm machines more than 50 years old.

JOHN CLAUDE WHITE | 1920

PRECEDING PAGES: Young Nepalese ladies wear elaborate costumes reminiscent of their Mongolian heritage.

W. DOUGLAS BURDEN | 1927

OPPOSITE: Beauty is abundant in Bali, an Indonesian paradise where villagers enjoy a refreshing open-air bath.

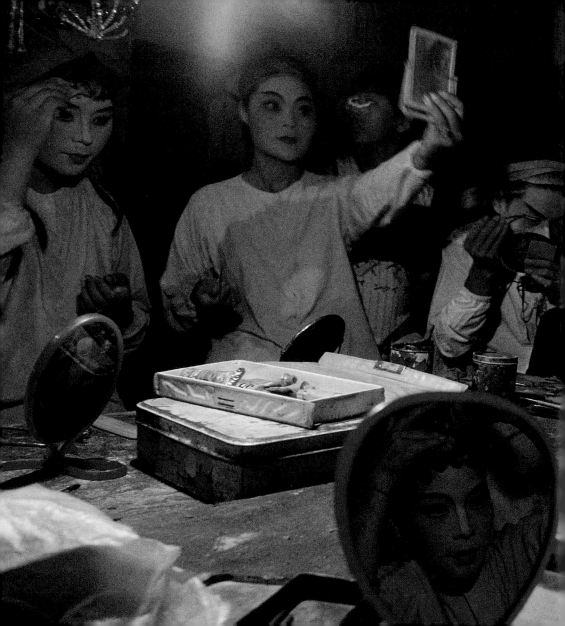

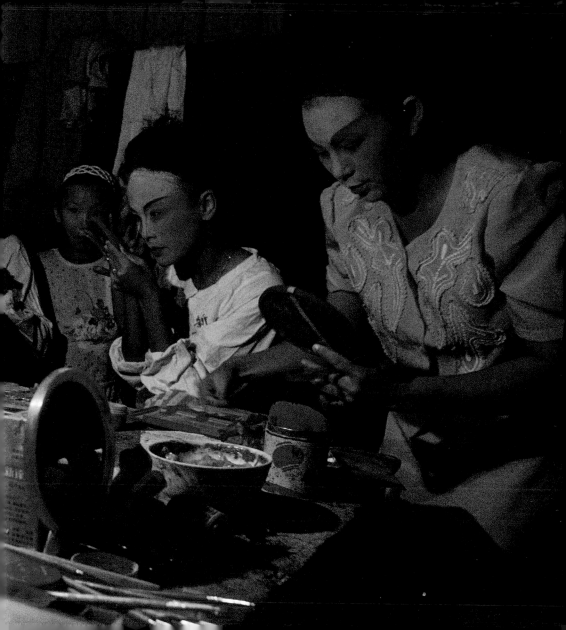

JAMES L. STANFIELD | 1991

PRECEDING PAGES: Actors make final
touches to their makeup before performing
an opera near Quanzhou, China.

STEVE MCCURRY | 2002

OPPOSITE: An Afghan woman poses with
a picture of herself, taken 17 years earlier
and published on the cover of the June
1985 NATIONAL GEOGRAPHIC.

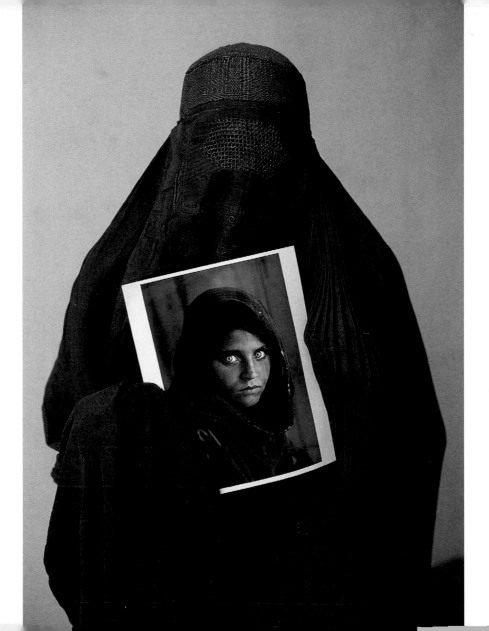

JAPANESE GOVERNMENT RAILWAYS | 1942
A housewife in Beppu, Japan, boils eggs over bubbling hot springs, which also heat stoves around the town.

ASIA | CHILDREN

A holy presence embodied in a child attests to the power of religion in Asia. Like the young Buddha of Guya, a "boy god" encountered in Tibet in the 1920s, children must often assume meaningful roles, whether it be to watch over water buffalo or entertain at a teahouse. NATIONAL GEOGRAPHIC's June 1993 article on Bangladesh reported that most children "start working before age ten." But even when children are forced to grow up fast, rituals of childhood remain, such as the universal experience of cramming before the school day begins.

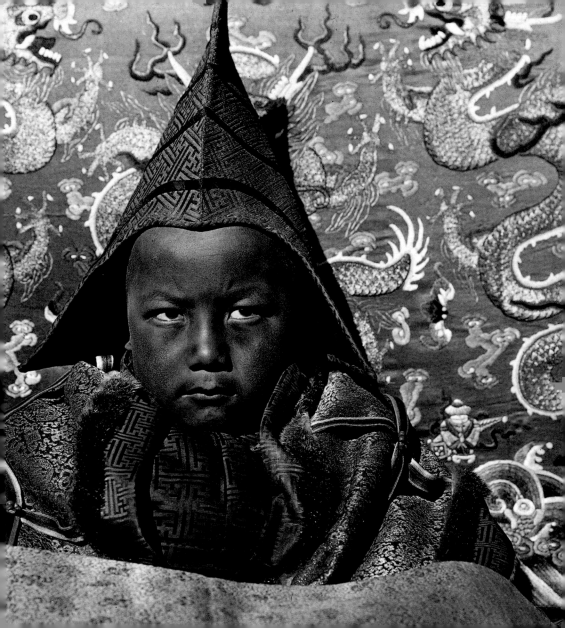

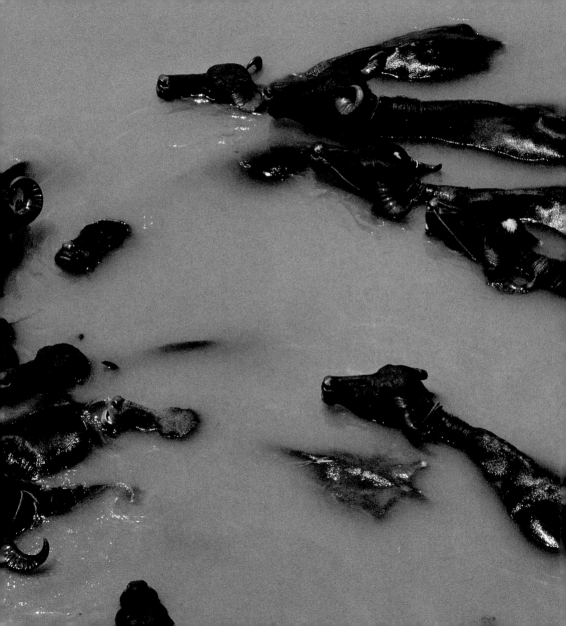

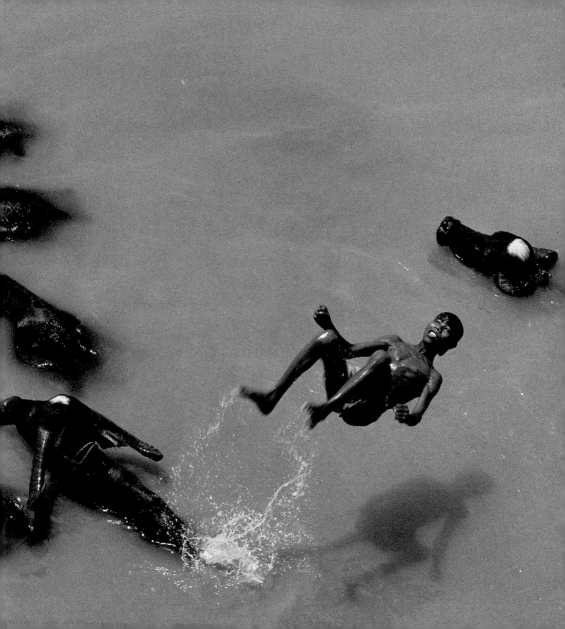

JOSEPH ROCK | 1928
PAGES 160-61: In the 1920s, Tibetans recognized a six-year-old boy as the living Buddha of Guya.

JAMES P. BLAIR | 1993
PRECEDING PAGES: A young herder performs a back flip off a water buffalo in the Turag River west of Dhaka, Bangladesh.

TAIWAN GOVERNMENT | 1920
RIGHT: "Sing-song" girls in Taiwan play traditional Chinese instruments for guests at a teahouse.

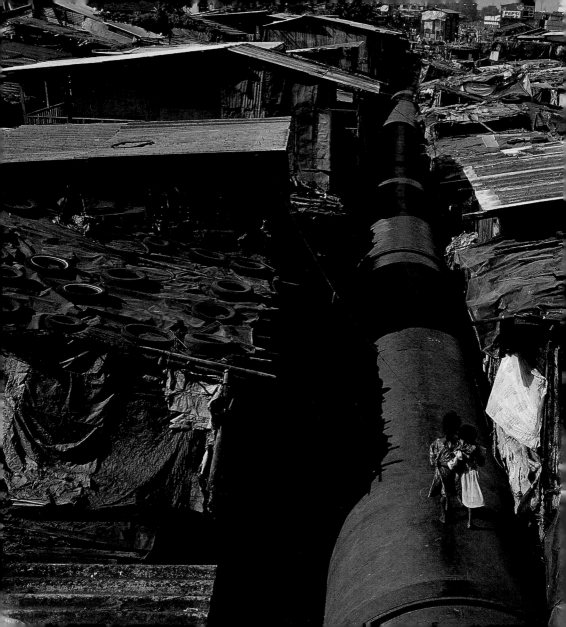

A pipeline carrying water to a wealthier suburb of Bombay stretches through a part of town where poor residents must share public spigots.

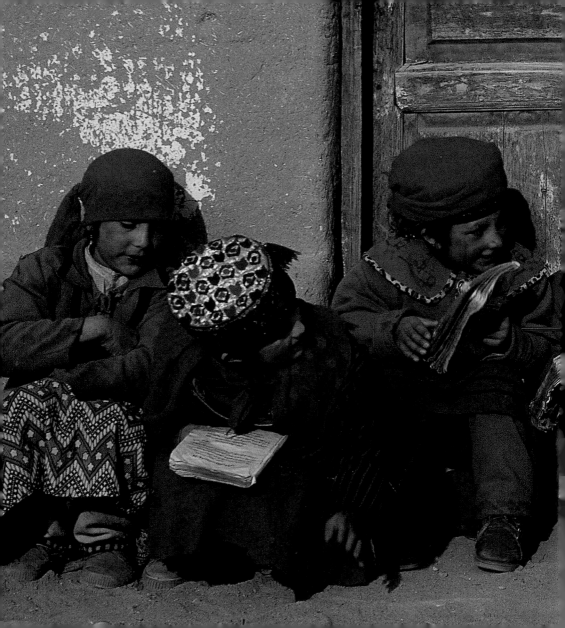

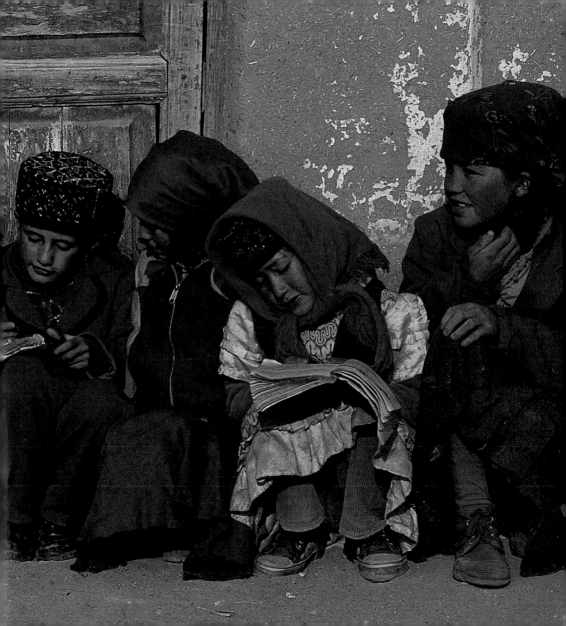

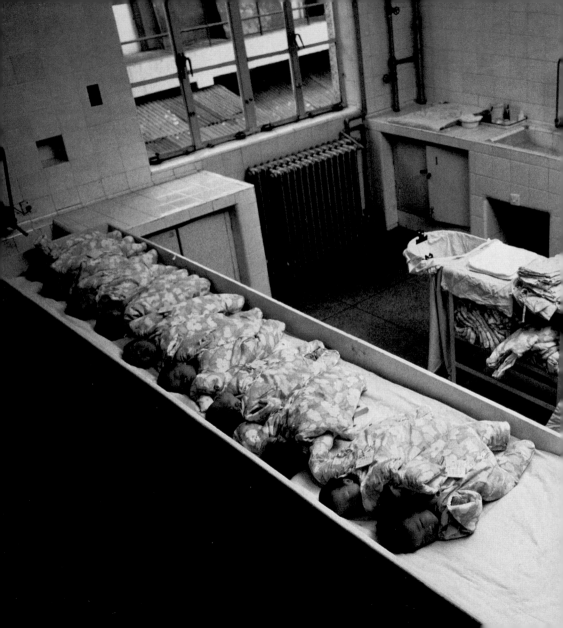

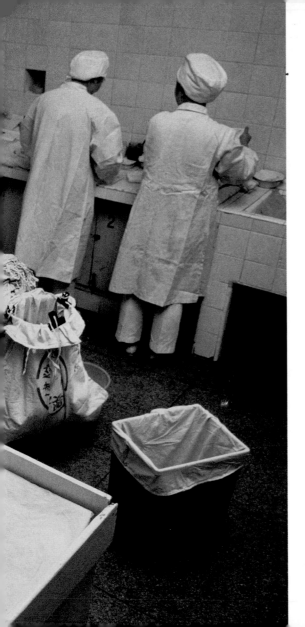

MICHAEL S. YAMASHITA | 2001
PRECEDING PAGES: Tajik children go over class notes before school in a mountain village of China's Xinjiang Province.

STUART FRANKLIN | 1994
LEFT: Lined up like loaves at a market, infants nearly fill a countertop at a hospital washing station in Shanghai, China.

Life can be arduous for Asian workers, most of whom earn their living as farmers, fishermen, or tradesmen. Agriculture predominates, despite the fact that less than 10 percent of the land is under cultivation due to the large areas of inhospitable desert, mountains, and jungle. Traditionally, much of Asia's population has clustered near the sea or rivers. In Vietnam, cargo-laden sampans crowd the waterways around Ho Chi Minh City, while in Japan, some fishermen harvest their catches using trained cormorants.

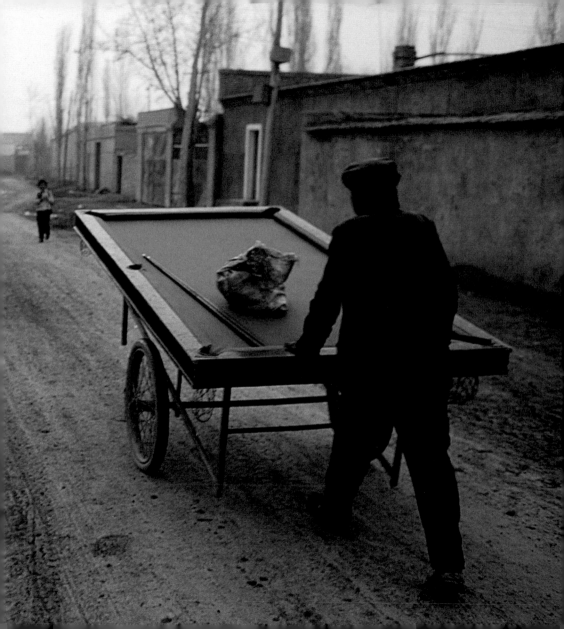

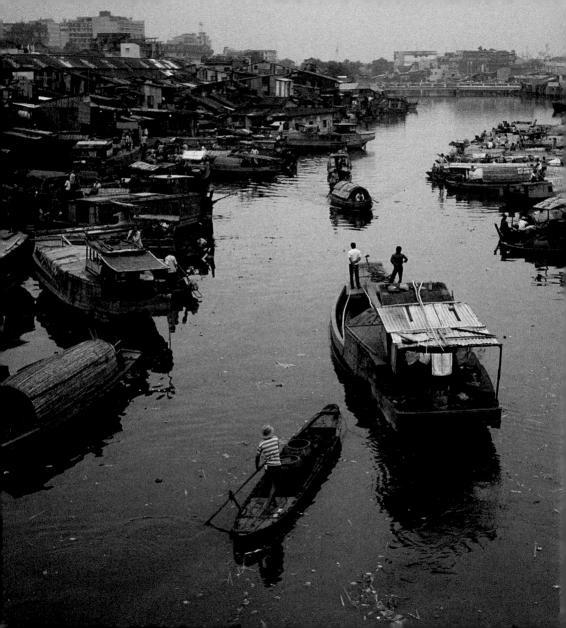

REZA | 1996
PAGES 172-3: Asking 20 cents a game, a Uygur entrepreneur pushes his portable pool table in Xinjiang Province, China.

DILIP MEHTA | 1993
PRECEDING PAGES: A tailor in northwest India sews clothes for a Rabari wedding that will take place during the summer monsoon—when the seminomadic Rabari stay in one place for a while.

DAVID ALAN HARVEY | 1989
LEFT: On a branch of the Saigon River, traders sell rice from the Mekong Delta, reaping a profit that can far exceed the salary of a civil servant.

W. ROBERT MOORE | 1936

Tethered and collared, cormorants
catch and disgorge fish into a boat
in Japan. The fisherman tightens the
birds' collars to keep them from
swallowing their catches.

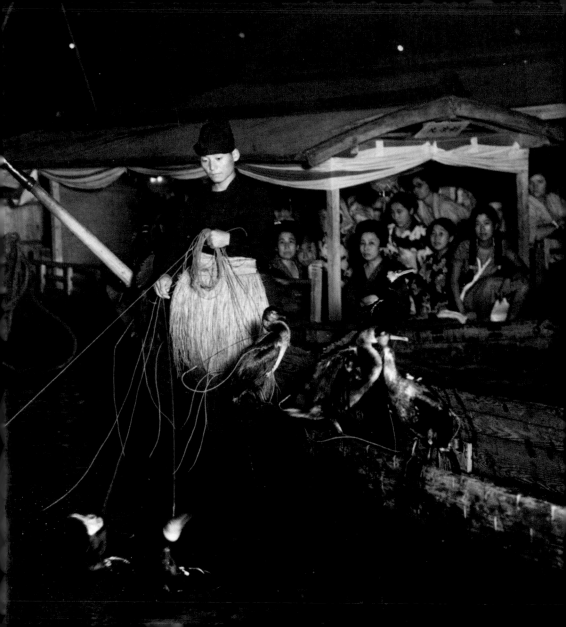

Changing yet change-
less, Asian society greets the modern world with a respectful
bow, while still maintaining time-honored ways—perhaps
more graphically than any other part of the world. "It is this
unbroken continuity with the past and ancient beliefs that still
takes me back to Asia," says photographer Steve McCurry.
Ritual guides many aspects of Asian life, such as the sym-
bolic practices of Japanese sumo. Begun many centuries
ago as a ceremony to ensure a good harvest, sumo retains
elements of its religious origin.

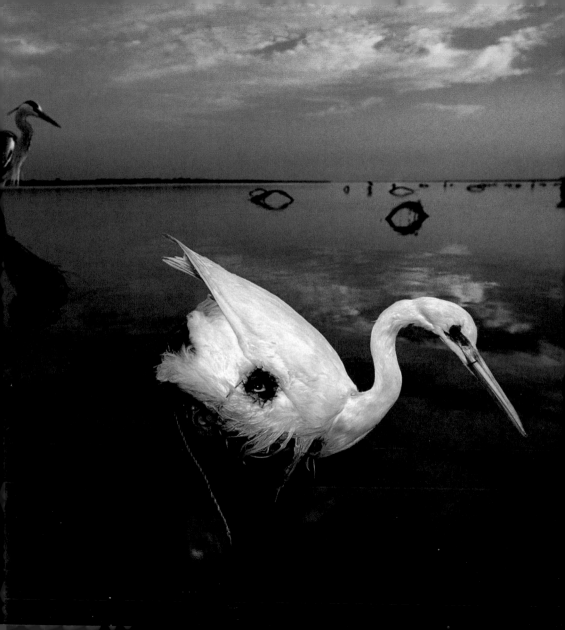

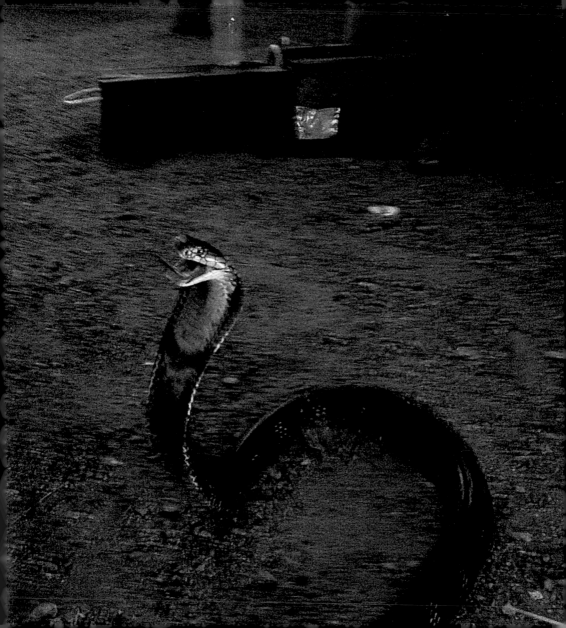

RANDY OLSON | 2000
PAGES 180-81: A hunter peeks from inside
a decoy on the Indus River in Pakistan.

MATTIAS KLUM | 2001
PRECEDING PAGES: In northeastern Thailand,
a man-snake encounter amuses villagers
and tempts them to buy snakebite remedies.

ROBB KENDRICK | 1997
RIGHT: Sumo wrestlers in Niigata, Japan,
parade in a pre-tournament ceremony.
Their ancient sport originated 1,500 years ago.

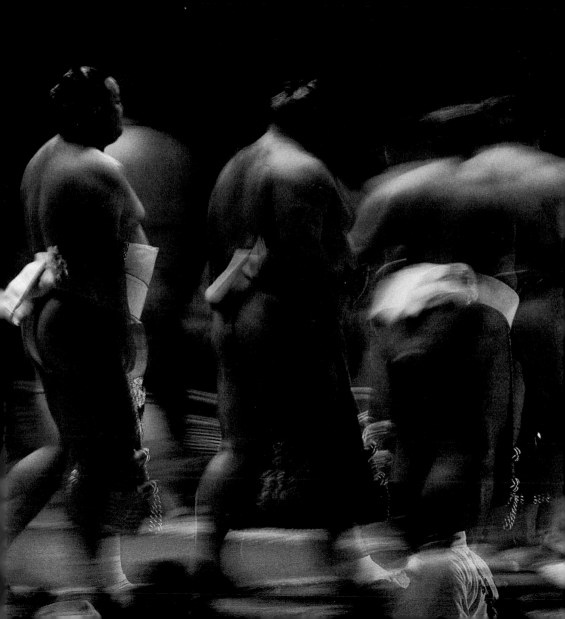

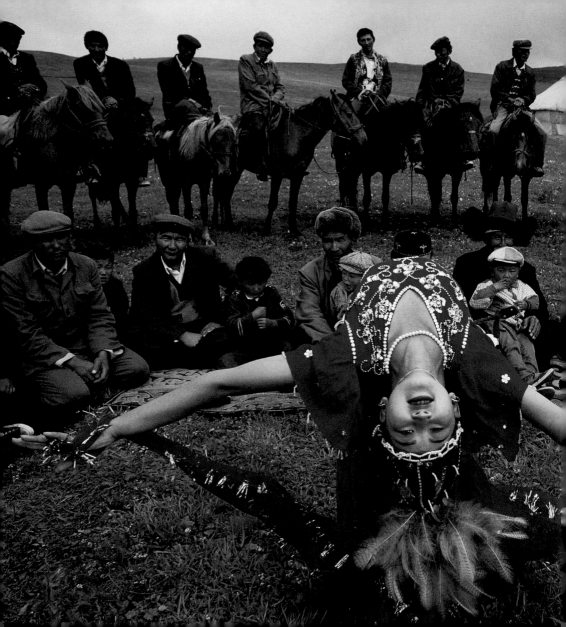

REZA | 1996
A dancer entertains at a circumcision ceremony in the Altay mountains of Xinjiang, China, where Kazakh herders gather each summer.

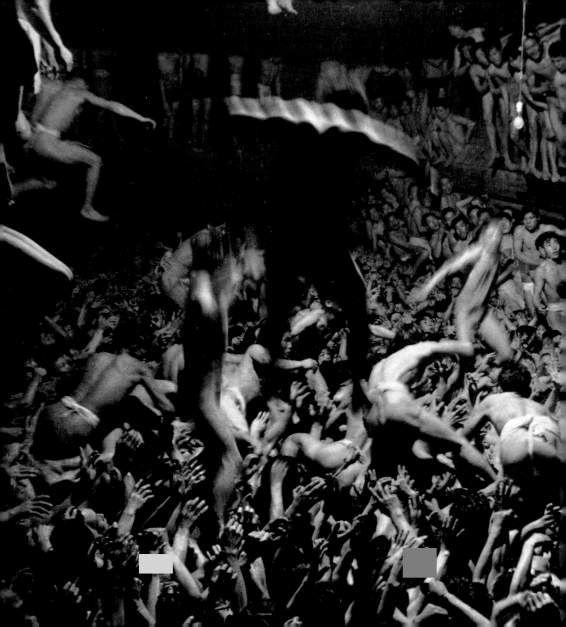

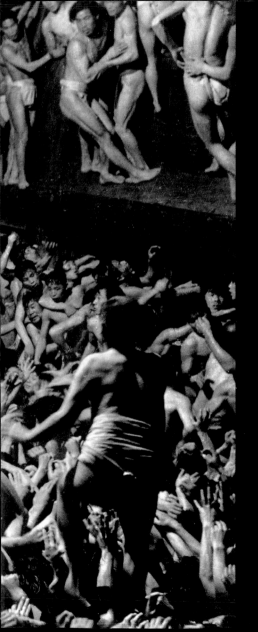

HORACE BRISTOL | POST-WWII
Men scramble to find camphor-scented batons tossed to them by a priest at a New Year's celebration in Okayama, Japan. This photograph was taken shortly after World War II and published in the September 1988 and 2000 issues of NATIONAL GEOGRAPHIC.

JOHN LAUNOIS | 1960
FOLLOWING PAGES: With elaborate good manners, hotel maids in Matsuyama, Japan, bow in farewell to a departing guest

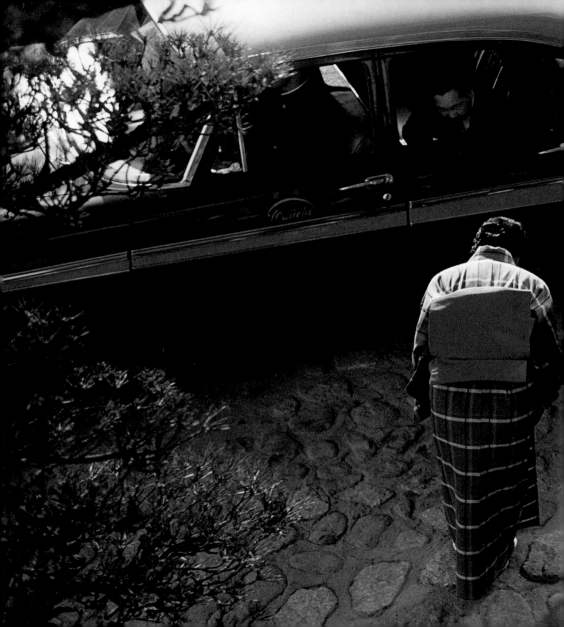

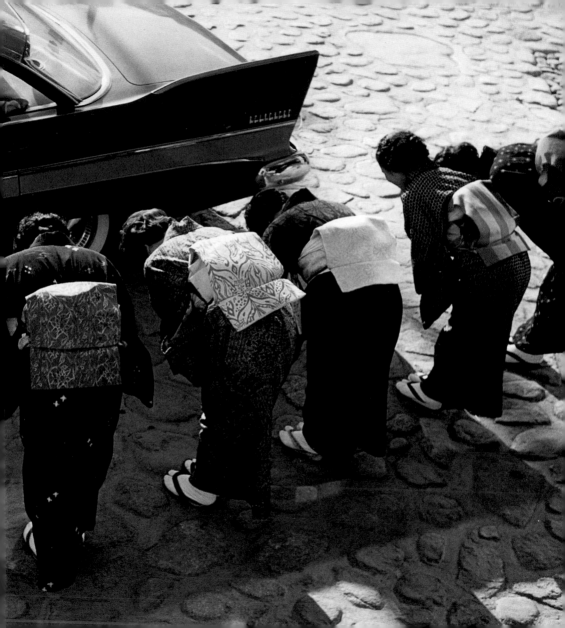

Caught between a burgeoning human population and dwindling natural habitat, many of Asia's wild species are at risk. Illegal trade in animal parts used in folk remedies or eaten as delicacies severely impacts tigers and other animals. Describing a trip to India in the November 1924 NATIONAL GEOGRAPHIC, Brig. Gen. William Mitchell reported that his host, the Maharaja of Surguja, had "personally killed more than 250 tigers." In 1973, India began Project Tiger to protect the big cats, which were being killed in record numbers by trophy hunters.

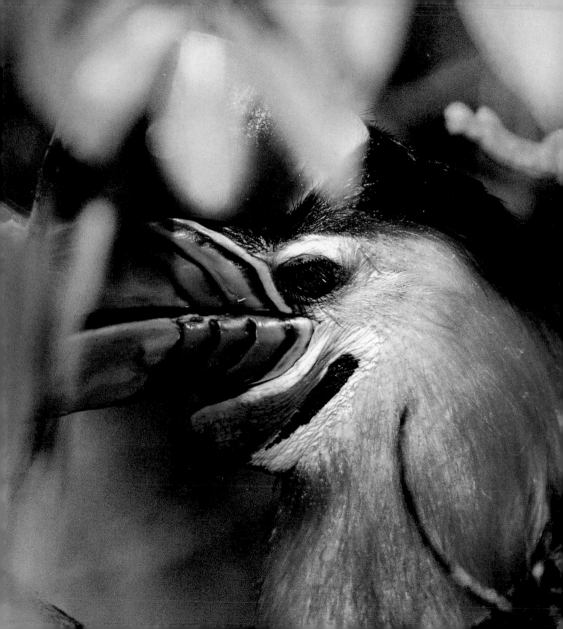

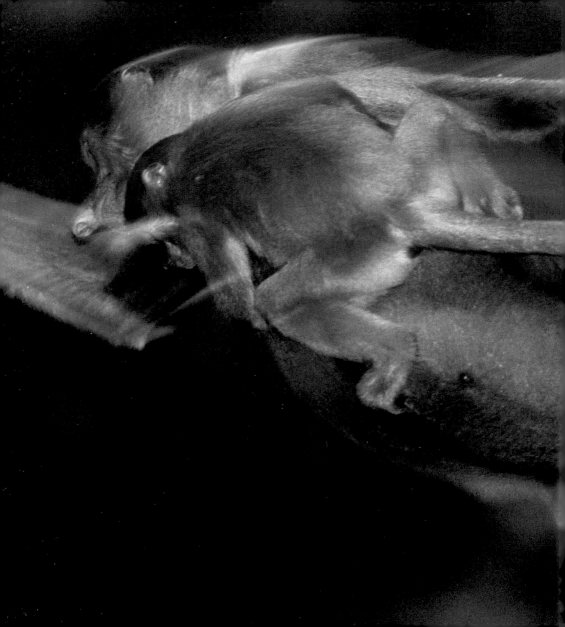

TIM LAMAN | 1999
PAGES 192-3: Distinctive markings identify this denizen of the rain forest: a red-knobbed hornbill on the Indonesian island of Sulawesi.

TIM LAMAN | 2002
PRECEDING PAGES: A young proboscis monkey clings to its mother in Borneo, where they live among the trees and swim in nearby rivers.

ERNEST B. SCHOEDSACK | 1928
RIGHT: Perched atop a domesticated Asian buffalo, a farmer's child rides through fields in Thailand. The image first appeared in a NATIONAL GEOGRAPHIC story on "jungle folk" and "wild animals in northern Siam."

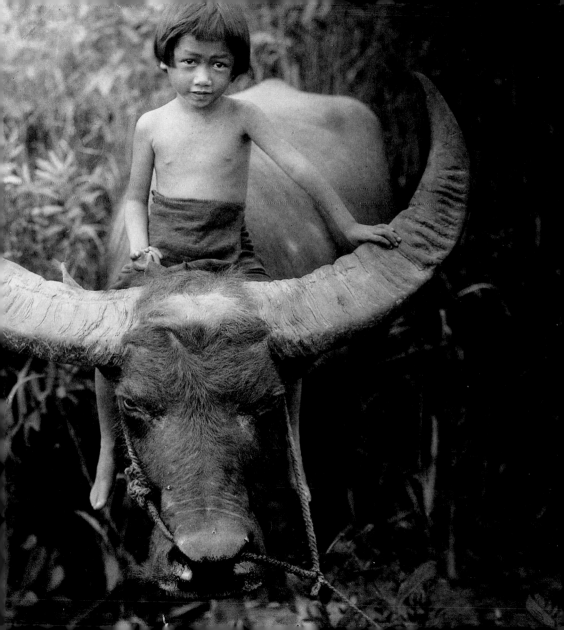

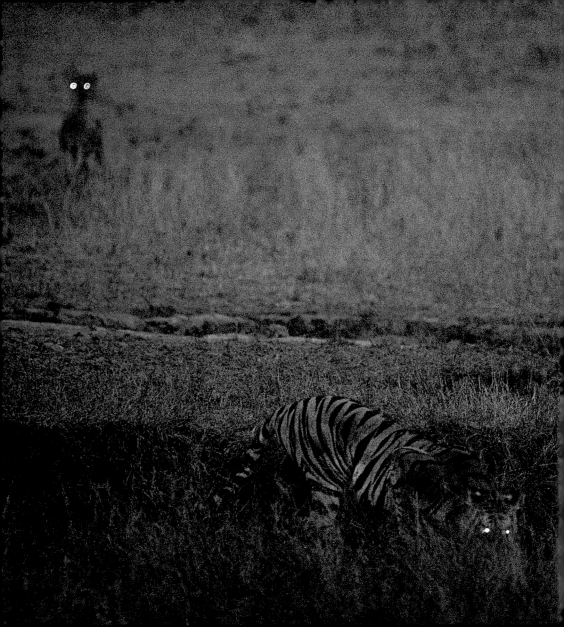

MICHAEL NICHOLS | 1997

More thirsty than hungry, a tiger laps
up water as potential prey watches warily
in Bandhangarh, India.

MATTIAS KLUM | 1997

From toenails to tail, the Asiatic elephant is a
massive creature that feeds 18 hours a day.

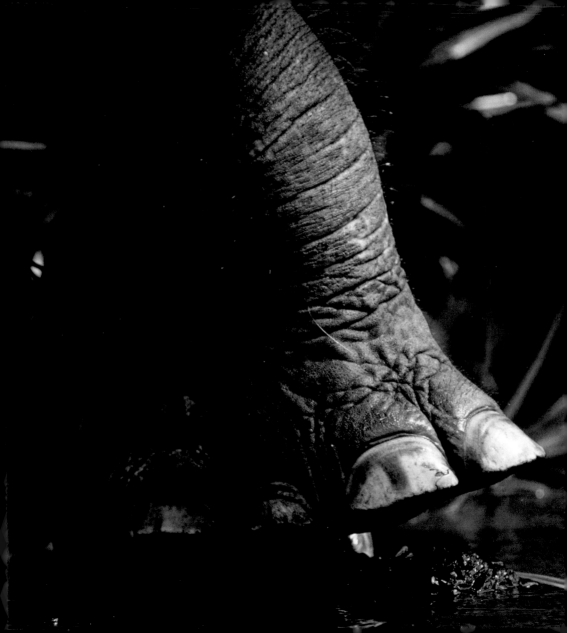

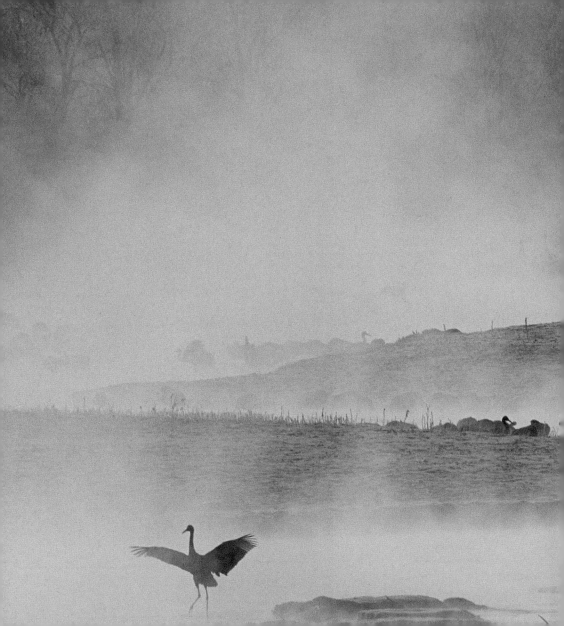

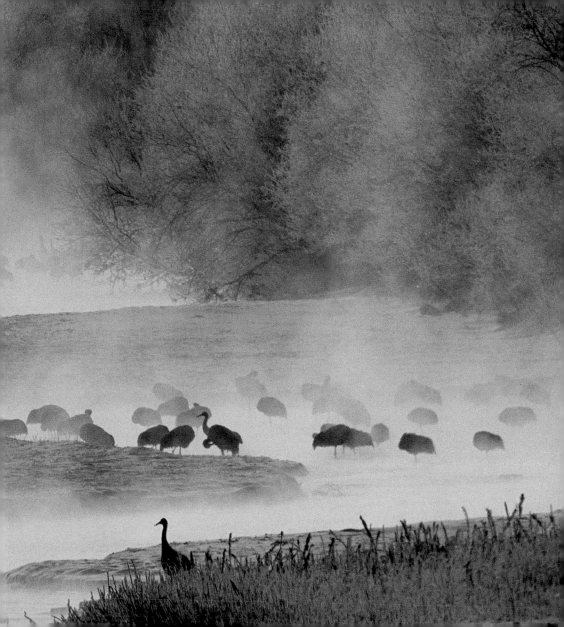

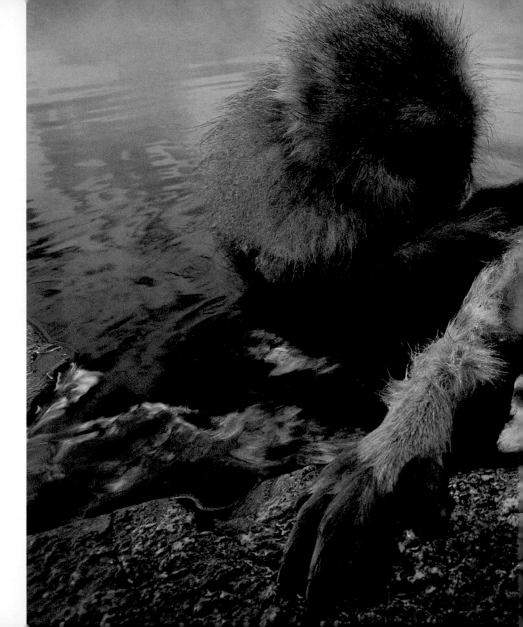

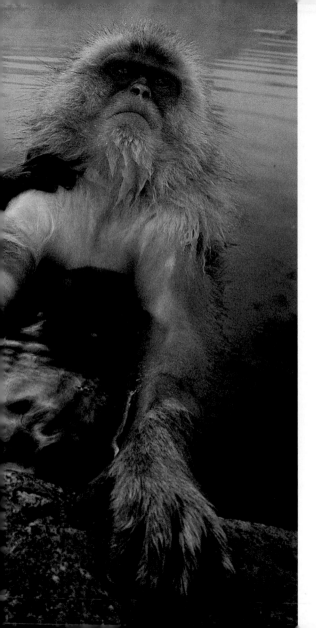

TIM LAMAN | 2003

PRECEDING PAGES: In the heart of winter, rare red-crowned cranes scoop up feed laid out by farmers on Japan's Hokkaido Island.

TIM LAMAN | 2003

LEFT: Two Japanese macaques, or snow monkeys, while away a cold winter's day in the waters of a hot spring.

AFRICA
& MIDDLE
EAST

CRADLE OF LIFE AND FAITH

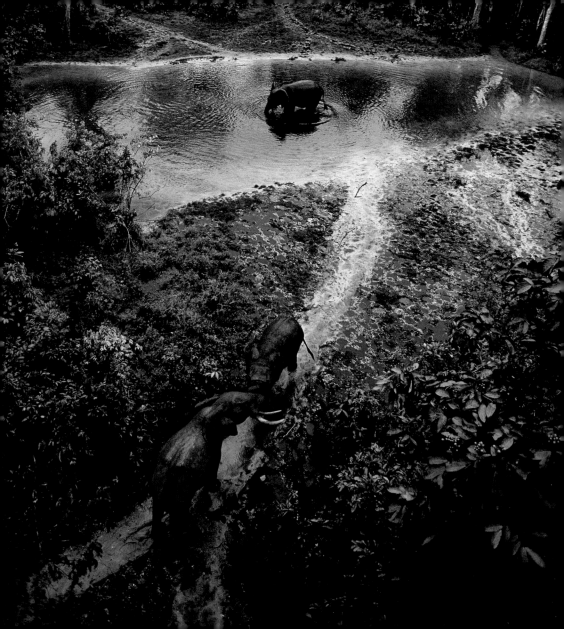

Africa

by Douglas Bennett Lee

Africa can be called the oldest continent, a landmass that kept its position while others broke off from the primeval supercontinent of Pangaea and sailed away on tides of tectonic plate movements. It is also our species' natal home, where the earliest humanoid fossils have been found.

Today, first-time visitors to the continent may experience a strange sense of recognition, a curious and compelling familiarity, a feeling of coming home to a place where they've never been. Some of us might say that's because we grew up with images of Africa in books and magazines, notably the NATIONAL GEOGRAPHIC, which published its first photographs of Africa in the 1890s and has since published thousands more. We have also come to know the continent through motion pictures, television, and even "critter cams" that bring us live action on our computer screens. But possibly the reason lies much deeper: Our ancestors became human here, and memories from that time may be imprinted indelibly in our genes.

MICHAEL NICHOLS | 1995

PAGE 208: In their travels through a forest, elephants create trails such as these in the Republic of the Congo's Nouabalé-Ndoki National Park.

A first-time encounter with a lion in the wild can stir up some of those early memories. The sight of a full-grown male, sleeping quietly in the midst of a great open plain or roaring in anger as his enormous yellow eyes glare in defiance, evokes an instinctive respect—even from the vantage point of a safe, comfortable safari vehicle. We look on in awe, experiencing a heady draught of opposing emotions, of mingled alarm and admiration, inspired by one of the most ancient perils for humankind: the large, dangerous animals of Africa.

Images of nature red in tooth and claw are probably the most recognized representations of Africa to GEOGRAPHIC readers over the past century. But the people who call this continent home have also been splendidly realized in the magazine's pages. Africa is populated by hundreds of ethnic groups organized all too arbitrarily into 51 nations, many of which became scenes of misrule, violence, and even genocide when European colonial domination ended its checkered, half-millennium reign in the latter decades of the 20th century. Yet beneath the scars of history, powerful beliefs and customs that defined precolonial Africa still hold sway behind a deceptive screen of modernity.

If Africa is mankind's cradle, then the Middle East must be counted among its temples. Here the three great monotheistic religions—Judaism, Christianity, and Islam—were founded, and the sites where they began continue to be revered by much of the world's population. Cities began here,

too, along the Fertile Crescent of Mesopotamia's Tigris and Euphrates Rivers. With the advent of urban populations came organized warfare, and to this day war has seldom been a stranger to the Middle East.

One of the most strife-torn parts of the region is the West Bank of the Jordan River. Here Jerusalem—revered by Jews, Christians, and Muslims alike—was established more than 3,000 years ago. About 15 miles to the northeast is the even older town of Jericho, one of the oldest communities in the world, built beside a perennial spring on an arid plain north of the Dead Sea. About 10,000 years ago, soon after nearby parts of Southwest Asia first mastered animal husbandry and domesticated crops, a stone wall was raised around Jericho. The excavated remnants of this wall and a 30-foot-tall stump of a stone tower evidence a society that was constructing impressive public works some five millennia before Egypt started building pyramids and Mesopotamia began erecting ziggurats.

What was the purpose of Jericho's wall? Self-defense, in all probability. The town's inhabitants wanted to protect their persons and their polity against the predatory ways of nomads and, if subsequent history is any indicator, various neighbors as well. Submerged many times by successive waves of aggressive humanity, sacked and torched more than once, Jericho nonetheless rose again and again to thrive at its Jordan River Valley oasis, nurtured by artesian water and ancient trade routes.

Commerce in copper, obsidian, lapis lazuli, and seashells was carried out along prehistoric trade routes thousands of years before a wall surrounded Jericho. Many millennia later, the Middle East would become an important crossroads through which East and West communicated and exchanged goods and ideas: The Silk Road that linked Europe with China ran through the region, as did the Spice Route to India and Southeast Asia. For a time, early in the second millennium, Islamic societies in the Middle East and North Africa flourished at the apogee of enlightened and tolerant civilizations.

The two most holy cities in Islam—Mecca, the birthplace of the Prophet Muhammad, and Medina, site of the Prophet's tomb—are in western Saudi Arabia. With Jerusalem, they anchor the heartlands of three great faiths, which have spread far beyond their Middle Eastern origins. NATIONAL GEOGRAPHIC's coverage of world religions has led readers into the innermost sanctums of Mecca and the shrines of Jerusalem.

Judaism, the oldest monotheistic religion, is represented by Jews and Jewish culture in many parts of the world, with the largest numbers of adherents in the United States and Israel. Since 1948, the struggle between Israel and parts of the Arab world has dominated interactions among followers of the three faiths and has been exacerbated and maintained by politically and ideologically motivated interpreters and nihilistic opportunists.

Christianity, which arose among Jewish adherents in first-century Palestine, spread through the Roman Empire to become the universal religion of western, southern, and Slavic Europe; later it was exported to North and South America, Australia, Oceania, and parts of Africa and Asia.

Islam is based on the teachings of Muhammad, born around A.D. 570. This faith was carried from the deserts of Arabia to Egypt, the Mediterranean coast of Africa, the southern edges of the Sahara, and the East African littoral, and it reached even farther, into Spain, eastern Europe, and southern and southeastern Asia.

For large numbers of Islam's billion-plus faithful, discontent with stagnant autocratic governments and limited societal opportunities has combined with the rapid growth of radical elements of Islam to stoke unrest and, in too many cases, breed terrorism practiced in the name of causes that might otherwise command a better hearing.

Fanning the flames are the immense wealth of major oil-producing nations (in glaring contrast to pockets of poverty that persist alongside them); the abundance of foreign goods bought with these riches; and Western notions of entertainment, recreation, mass media, women's rights, and democratization. Such things threaten many traditionalists and disaffected members of an underemployed and stymied younger generation, whose fundamentalist schooling has led them to believe that a lost golden age of Islam can be reborn by purging the Muslim world— violently, if necessary—of everything "infected" by Western influence. Still, free elections in Bahrain and Qatar have put the lie to claims that Arabic

Islam and Western-style democracy must be mutually exclusive.

While the Middle East has been closely identified with oil since the 1900s, Africa has for centuries been of interest to the world at large for such prime products as ivory, animal skins and horns, exotic birds and beasts, and, until relatively recent times, slaves. Over hundreds of years, millions of black Africans were shipped by slave traders to the Arab and Mediterranean worlds and to North and South America, where they became one of the earliest and most significant immigrant populations. On their unhappy passage across the Atlantic Ocean, the unwilling Africans brought with them many of the traditional beliefs, recipes, songs, and stories that now make up an important part of New World cultures.

Present-day Africa, especially south of the Sahara, is more likely to be thought of for its continuing troubles: nigh-endemic warfare, obstinate and aging dictators, famine (often linked with dictators), nonstarter economies, deadly diseases such as malaria and HIV/AIDS, and the destruction of rain forests and other natural resources. Africa's most lucrative export, legal diamonds, has been tainted by the so-called "blood diamonds" smuggled out to finance conflicts, mayhem, and further looting of the continent's great natural wealth.

But Africa is a far richer, more wonderful story than headlines reveal. In the far south, Nelson Mandela led his fellow citizens through an amazingly lawful transition from apartheid rule to racial and political equality, opening the way for South Africa to take its place as the continent's premier economic and intellectual powerhouse. In the jungled mountains of the continental midriff, local and international sources have helped chimpanzees, bonobos, and gorillas hang on against the pressures of Africa's ever growing human population. Supported by the National Geographic Society and made famous in the pages of its monthly magazine, Jane Goodall uncovered the secret worlds of chimps in the wild; Dian Fossey pursued a passion for gorillas that saved many and ultimately led to her death; and Penny Patterson taught the gorilla Koko to speak through symbols and to use a camera, making Koko the only nonhuman photographer ever featured on the cover of the NATIONAL GEOGRAPHIC.

In Mozambique, members of the once reviled South African Defense Force risked their lives to save Mozambicans deluged by La Niña-driven rains in 2000. For weeks, helicopter crewmen of black African, Afrikaner, British, and Asian backgrounds were the only lifeline their flood-stricken neighbors had to grasp until the United States spearheaded wider international involvement.

Most of the major tribal groups south of the Sahara share Bantu roots traced through their languages, which were dispersed by waves of Bantu-speaking peoples who began moving south from the equatorial regions nearly 3,000 years ago. Consequently, many widely flung peoples have similar inherited customs and oral traditions.

Notable exceptions are the rain forest Pygmies, in central Africa, and the San, or Bushmen, of southern Africa's Kalahari Desert. These groups have been in place longer—in some instances, far longer—than the Bantu, who replaced them over most of their original territory. Bushmen have inhabited the sand sea of the Kalahari for at least 50,000 years, an astounding length of time when considered against the estimated 150,000 years that modern humans have walked the Earth. Equally astounding, they continued as recently as our lifetime to rely on the same hunter-gatherer skills their forebears perfected and handed down from generation to generation.

In the central Kalahari of Botswana and Namibia, Bushmen still occupy the same sites that were visited by thousands of generations of their ancestors, whose wandering existence was bounded more by seasons and rainfall and animal migrations than by geographical borders. Seamlessly integrated with their desert home, these people owe their staying power in the region to those age-old wandering ways, which have rarely overtaxed the productive capacity of the harsh but secretly generous environment.

In more than a hundred years' coverage of Africa's many cultures, NATIONAL GEOGRAPHIC has too often documented the waning days of ancient ways of life. In recent years, the governments of southern Africa have largely forced an end to the Bushmen's free roaming and hunting, citing the need to introduce all of their citizens to the charms of the 21st century, ready or not.

Tragically, enforced settlement has almost invariably resulted in spiritual and physical decline, alcoholism, and malaise.

While modernity beckons to Africa, the past seems to recede out of reach. Is it any wonder that there is deep confusion on the part of individuals and whole peoples, who question where their identities lie? Do they lean toward tribalism or nationhood? Past or future? Private venality or the common good?

The last question, at least, is easy to answer by the light of traditional African virtues. The purpose of a village is to nurture its children, support its adults, and provide a hearth for the unseen ancestors who continue to bless or bedevil daily life and intervene with higher gods on behalf of their descendants. The purpose of children is to grow into adults who will ensure the ongoing orderly functioning of the village. All are watched over by the spirits of their ancestors and instructed by customs and traditions that reach as far back as the dawn of humanity.

In these ancient ideals may yet lie the strength and salvation of modern Africa.

AFRICA | SCAPES

The continent of beginnings—where humans are thought to have evolved— Africa is divided at its center by the Equator. Rain forests spread north and south, giving way to grasslands and eventually deserts. With 20 percent of the world's land surface but only a tenth of its population, Africa is a realm of open spaces, like the arid Makgadikgadi Pans of Botswana. Most Africans live along the coast or near lakes or rivers such as the mighty Zambezi.

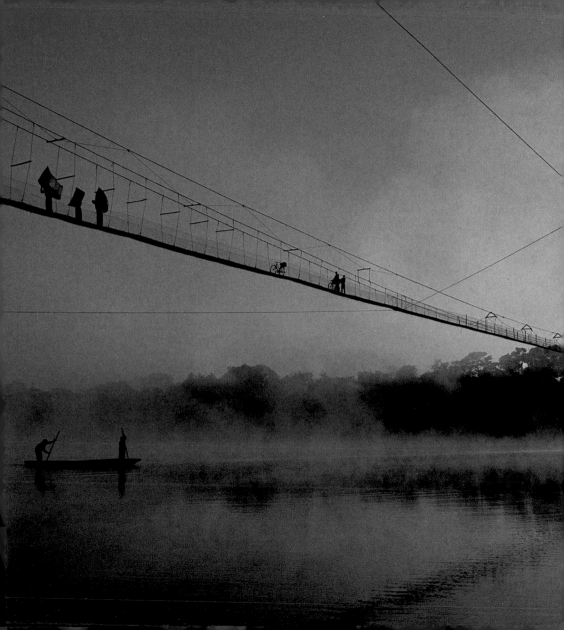

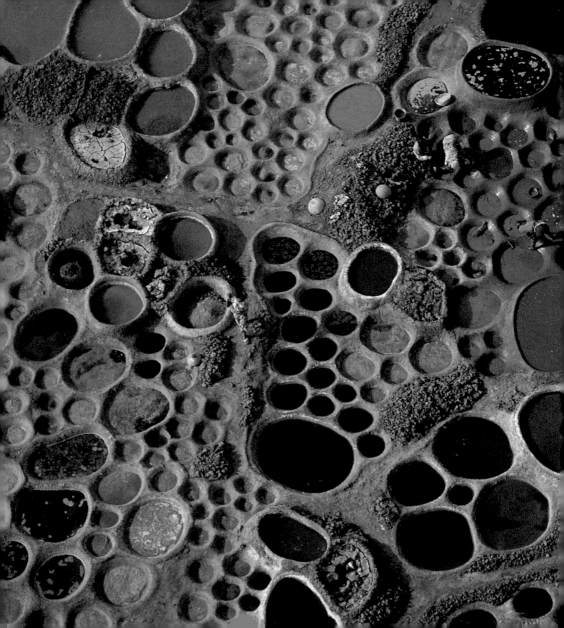

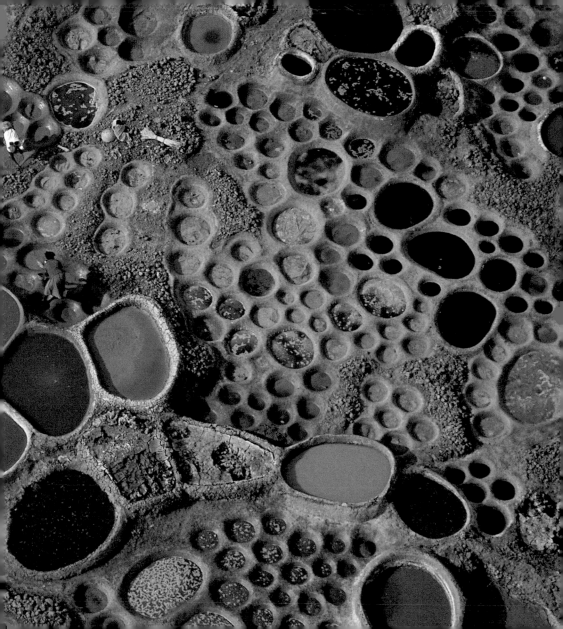

CHRIS JOHNS | 1997
PAGES 214-5: A 700-foot-long footbridge bobs and sways over the Zambezi River at Chinyingi, Zambia.

GEORGE STEINMETZ | 1999
PRECEDING PAGES: Salt producers at Teguidda-n-Tessoumt, in Niger, mix brackish well water with salty earth in large depressions; then they place the mud in smaller ponds for evaporation.

FRANS LANTING | 1990
LEFT: The ghostly fingers of a shrinking lake reach across the Makgadikgadi Pans of Botswana.

JIM BRANDENBURG | 1982

In Namibia, a protective labyrinth of stick
walls can be moved to confound foes who
try to reach the Ovambo headman's hut.

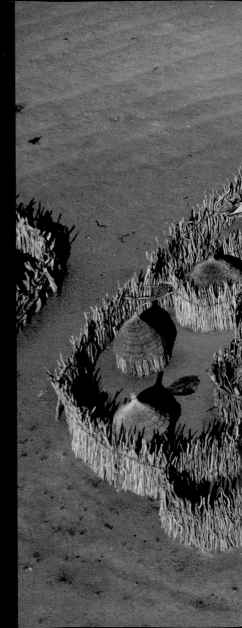

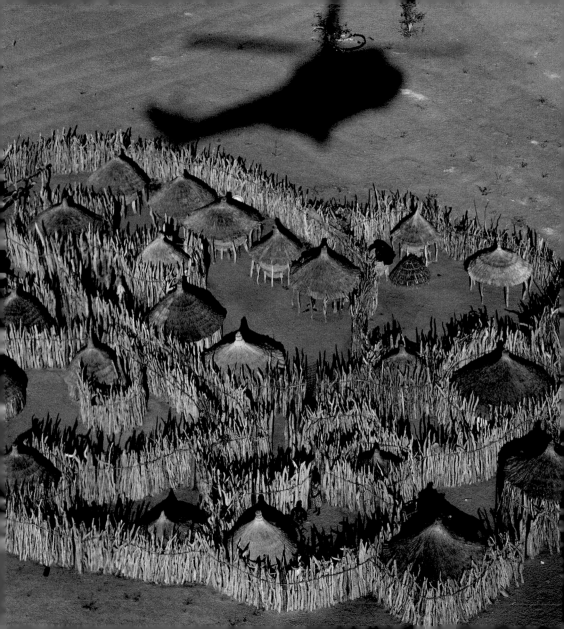

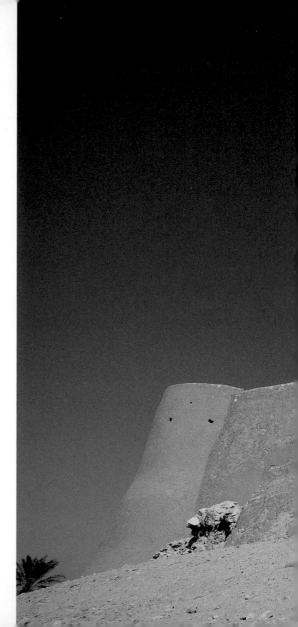

JODI COBB | 1987
Only women may enter an old fortress on
Tarut Island in Saudi Arabia; its walls enclose
a spring used for bathing and doing laundry.

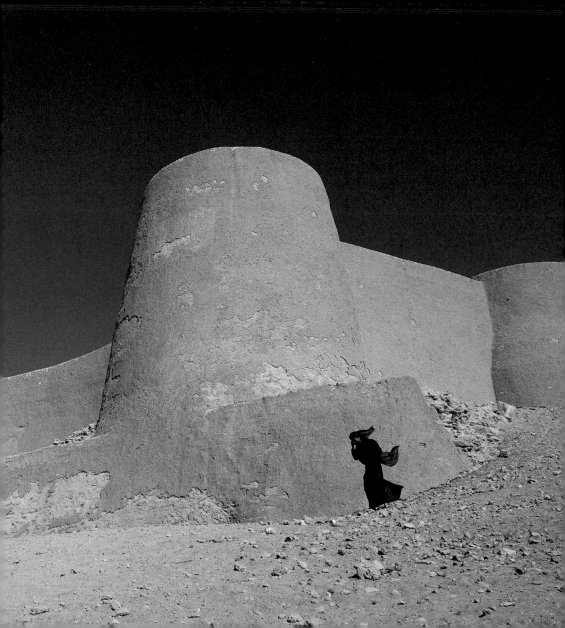

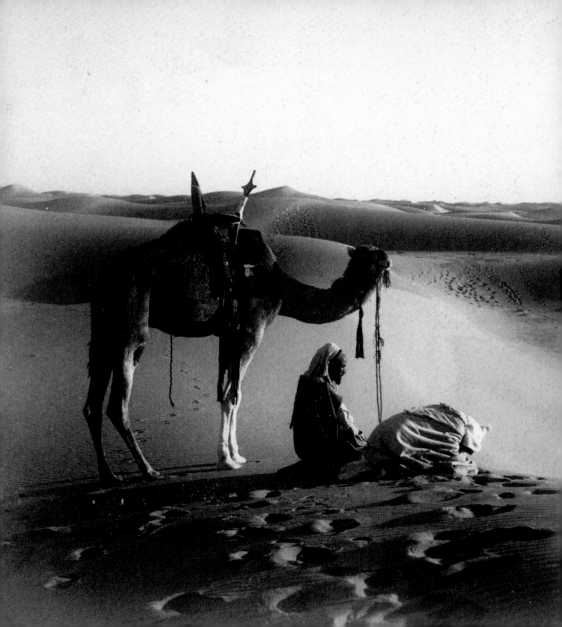

LEHNERT AND LANDROCK | 1911

Travelers in the Sahara bow in praise to Allah, giving thanks for the beauty and blessings of their desert home.

AFRICA | WORK

Life's work for most Africans means hard physical labor, such as the drudgery captured by Melville Chater in his 1931 images of black South Africans toiling in orchards and mines owned by their white countrymen. About 60 percent of the people eke out a living as small-scale farmers, while thousands more chip away at the earth in search of gold or diamonds. The poorest continent, Africa generates a meager one percent of the world's economic output. Bad land-use practices abound.

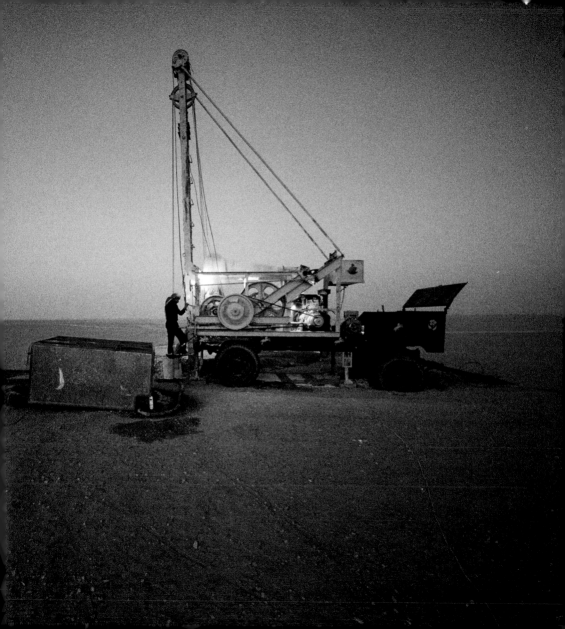

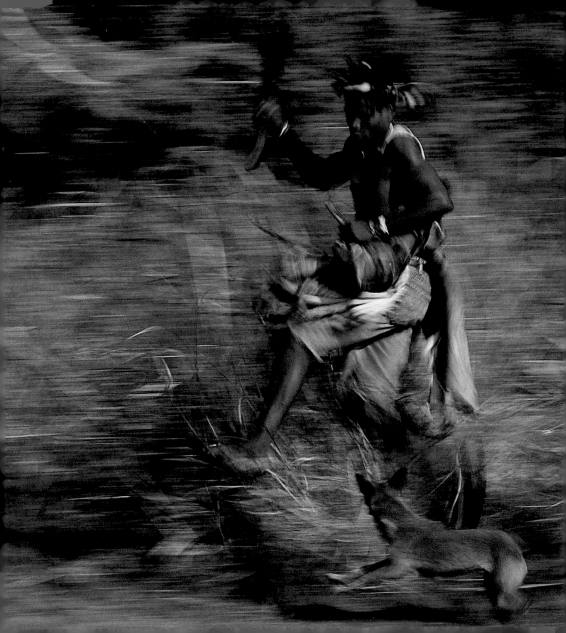

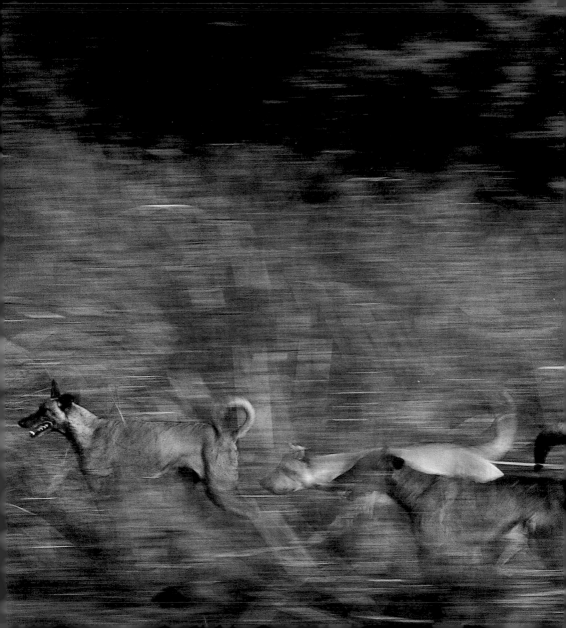

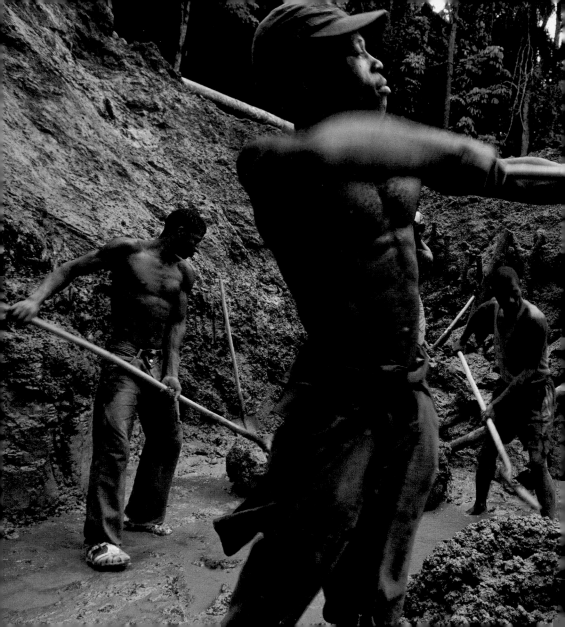

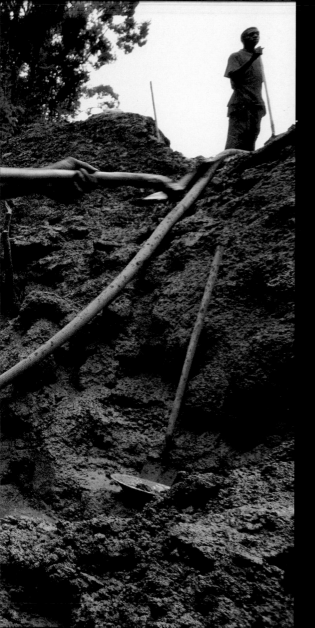

ED KASHI | 1993
PAGES 226-7: Bedouin in Syria drill for water in the northern steppe, where diminished supplies of well water are becoming too salty for agricultural use.

CHRIS JOHNS | 2001
PRECEDING PAGES: A hunter and his dogs search the brush for delectable cane rats in KwaZulu-Natal Province, South Africa.

MICHAEL NICHOLS | 2001
LEFT: Gold miners labor to remove pay dirt at the central African outpost of Minkébé.

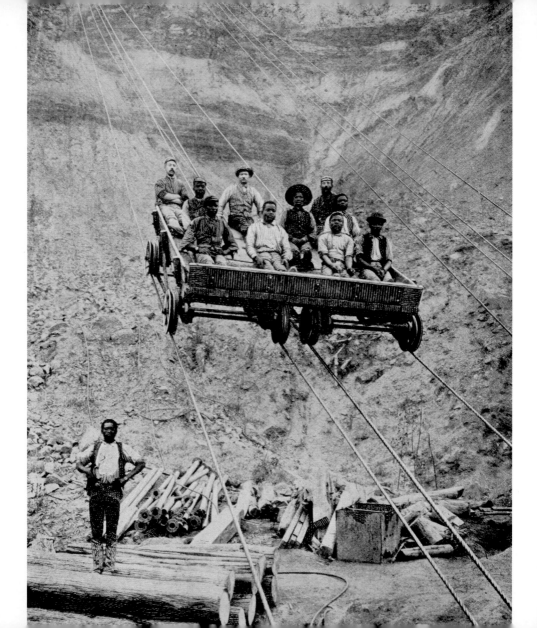

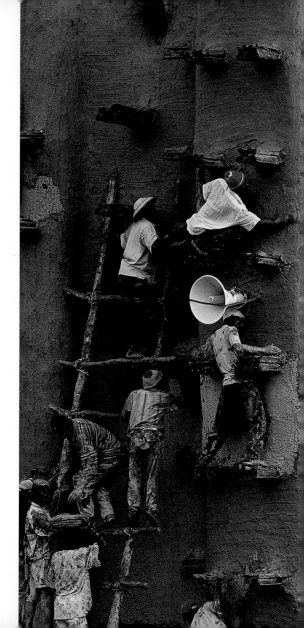

ESHA CHIOCCHIO | 2001
Workers make repairs on the walls of the
Great Mosque in Djénné, Mali.

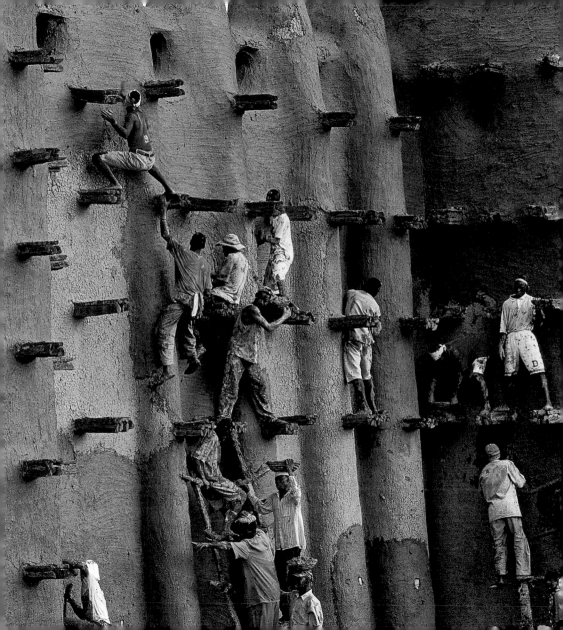

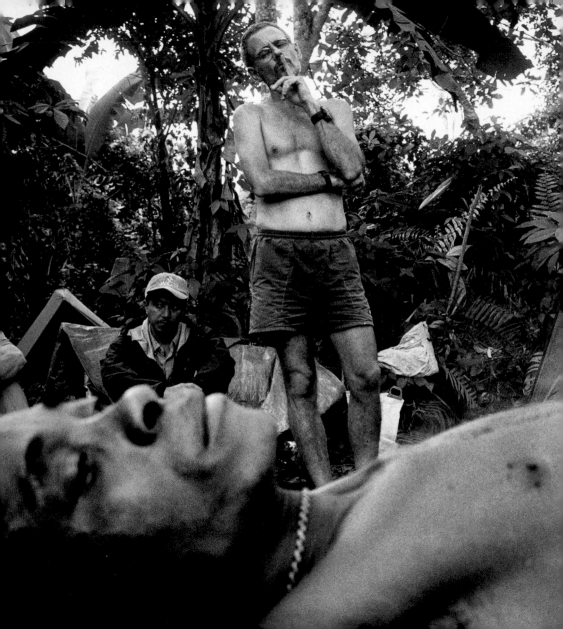

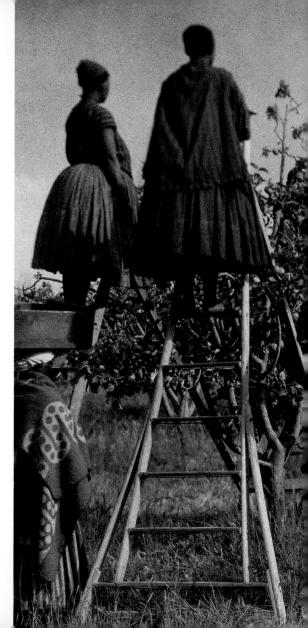

MELVILLE CHATER | 1931

Basuto women pick apples in the Prairie Province of South Africa.

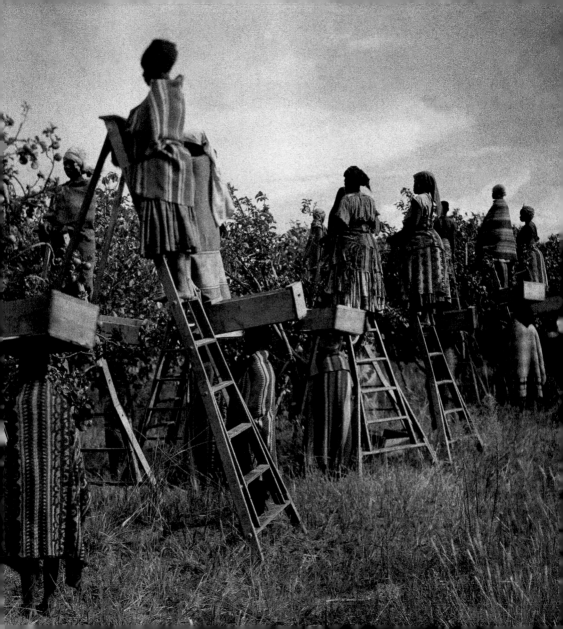

AFRICA | WOMEN

Tethered to lives of limited scope, most women of Africa and the Middle East must find their fulfillment in domestic responsibilities. Bearing and looking after children can consume countless hours of a woman's time and energy: In Africa, for example, women give birth to an average of six children each. While religious or ethnic dictates rule much of their existence, poverty is an overarching influence in their lives. Like the wives of cattle herders in Nigeria, many women own little more than the clothes on their backs.

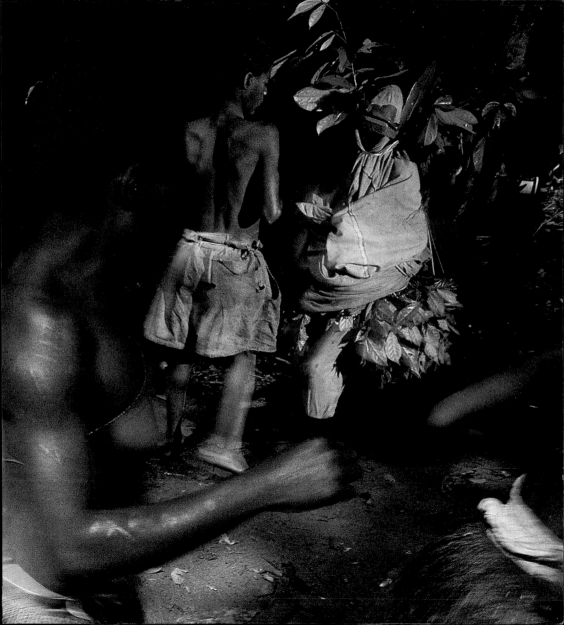

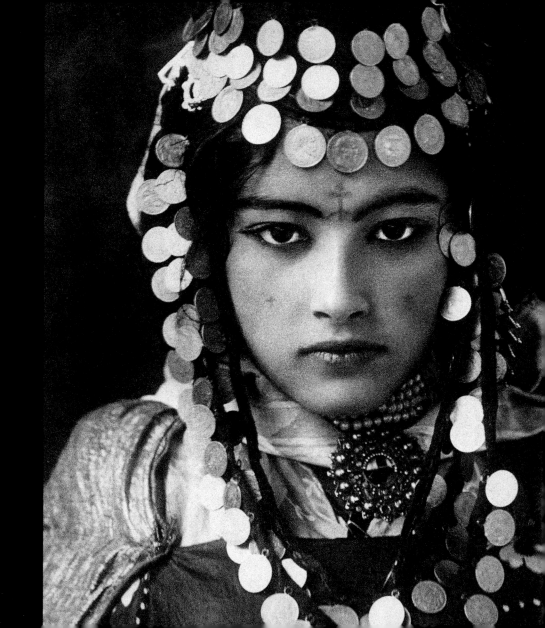

ANNIE GRIFFITHS BELT | 1996
PAGES 240-41: On Good Friday, a pilgrim worships in a Jerusalem grotto.

MICHAEL NICHOLS | 2000
PRECEDING PAGES: Bambendjelle women dance to taunt the thieving Enyomo, among dozens of spirits in central Africa's forests.

LEHNERT AND LANDROCK | 1922
OPPOSITE: Wearing her dowry, this young woman belongs to the Ouled Nails tribe of North Africa; girls from the tribe dance for gold coins in Mediterranean ports.

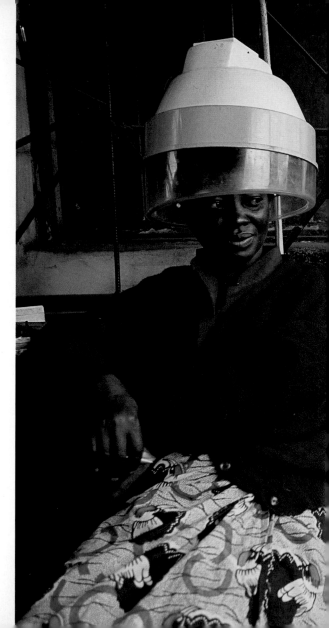

CHRIS JOHNS | 1996

Village women enjoy a bit of pampering in a beauty salon near the Zambezi River.

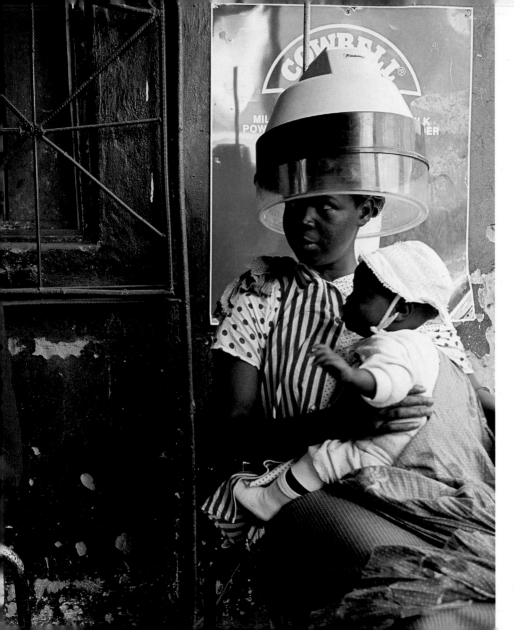

ALEXANDRA AVAKIAN | 1996

In the battle-weary Gaza Strip, a woman
holds a symbol of freedom and peace.

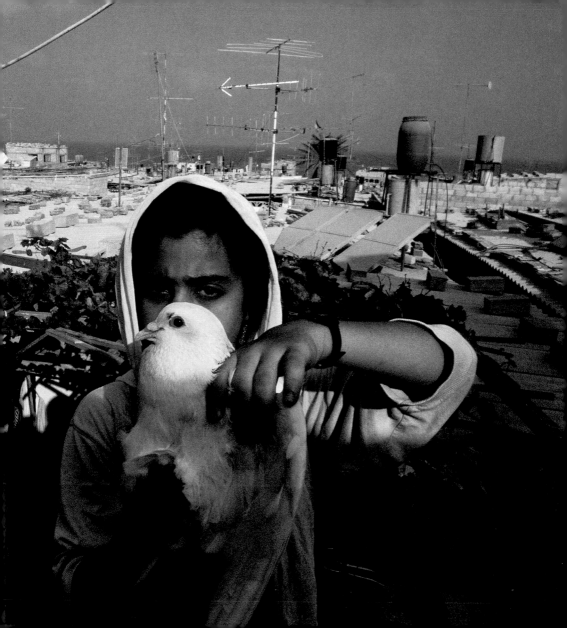

REZA | 2000
Following strict Islamic tradition, a Libyan woman in the Tripoli airport is swathed from head to toe.

KAREN KASMAUSKI | 2002

In Niger, a family of cattle herders relies on mosquito netting to protect themselves against malaria.

STEVE MCCURRY | 2000

FOLLOWING PAGES: Women in Sanaa, Yemen, line up to vote in a parliamentary election.

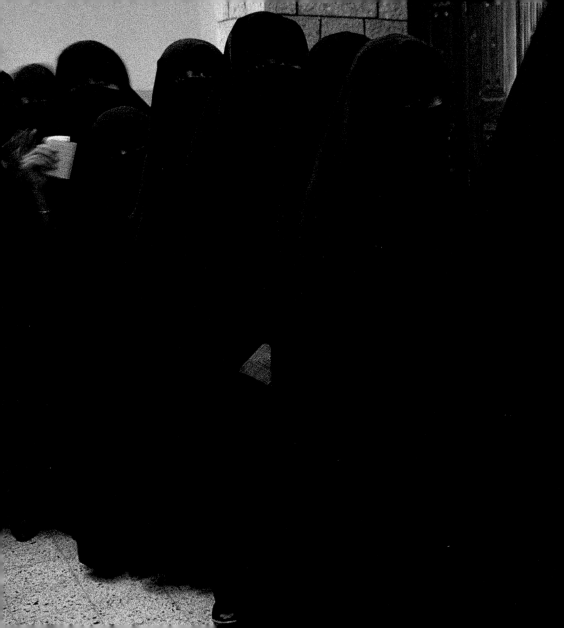

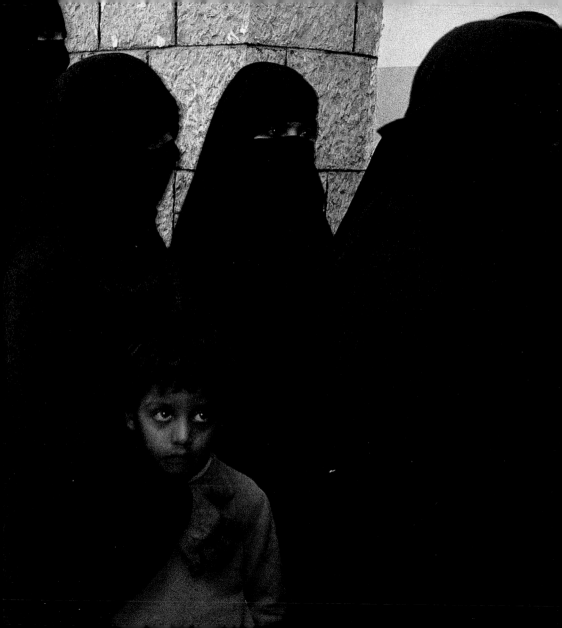

AFRICA | TRADITIONS

The ways of the past hold sway throughout Africa, where traditions provide guidance for every tribe and ethnic group. Through the centuries, oral narratives have helped preserve collective memories, and bards called griots have spun tales and performed epic songs. Rituals to ensure health and good harvests are common, along with ceremonies to mark adulthood. Most major religions are represented, with Islam and Christianity each claiming about 300 million adherents. Shamanism remains a powerful spiritual force.

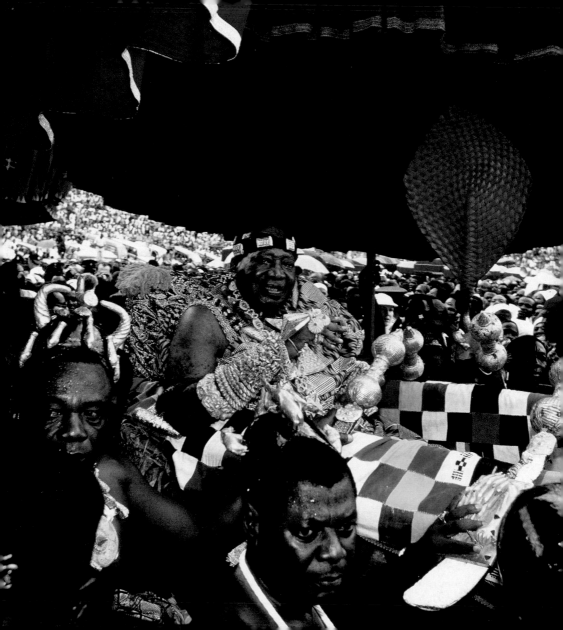

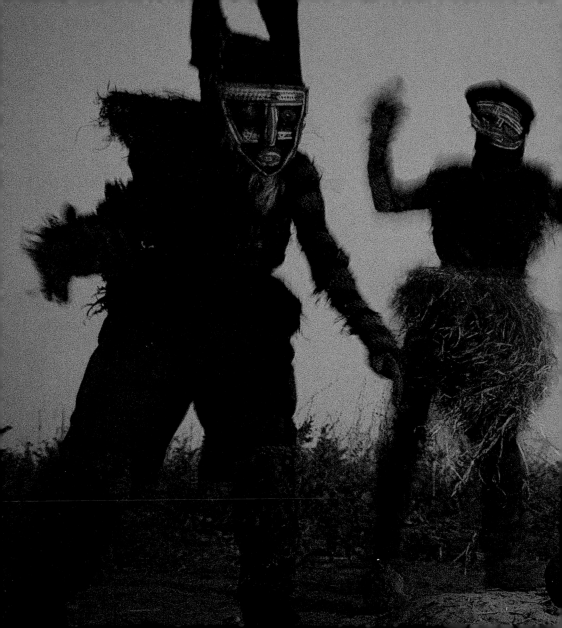

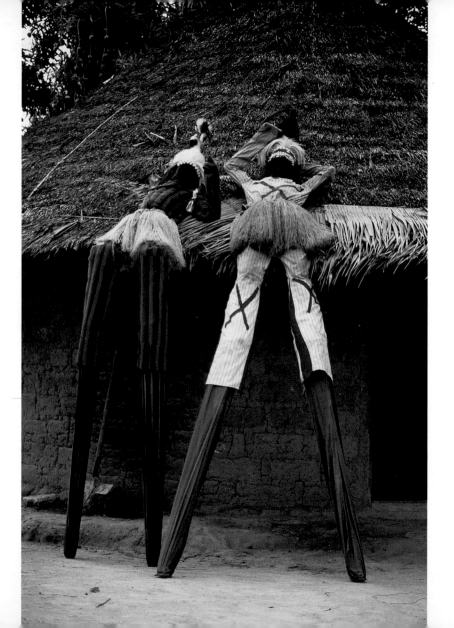

CAROL BECKWITH AND ANGELA FISHER | 1996

PAGES 256-7: In Kumasi, Ghana, Asante sword bearers escort their king on the 25th anniversary of his coronation.

CHRIS JOHNS | 1997

PRECEDING PAGES: Makishi dancers in western Zambia perform for a group of recently circumcised boys.

MICHAEL KIRTLEY AND AUBINE KIRTLEY | 1982

OPPOSITE: Dan stilt dancers rest their legs and backs after a performance in Côte d'Ivoire.

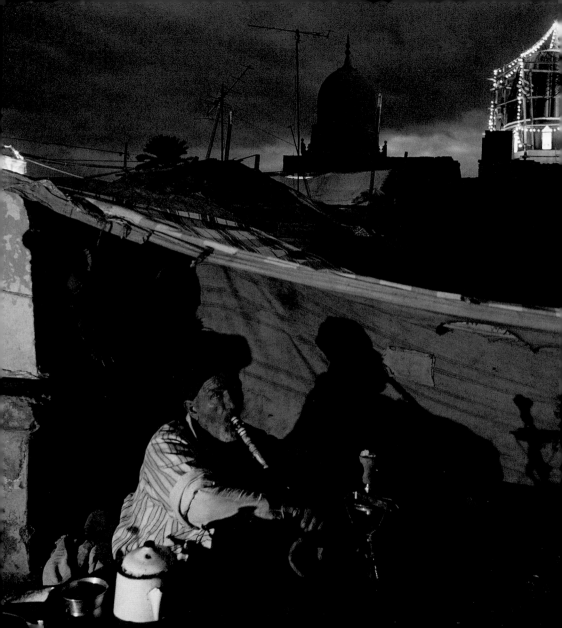

REZA | 1993

Puffing on his water pipe, a squatter finds peace in a Cairo cemetery. Peddlers often gather here when crowds come to a nearby mosque to celebrate the birthday of Zein el-Abidin, an eighth-century holy man.

CHRIS JOHNS | 2001
A Bushman of southern Africa enters a trance state and tries to rid a girl of the evil that caused her to hoard meat.

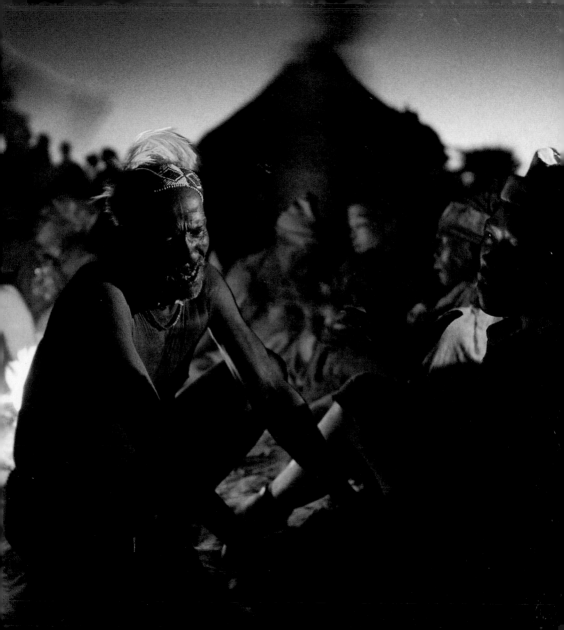

AFRICA | STRUGGLE

The denizens of Africa and the Middle East live their days amid the tumult of the world's most unstable regions. For young Israelis, the uncertainties of the future are forgotten during a kiss in Zion Square, in West Jerusalem, while Saudi visitors in Damascus, Syria, find respite in a meal with a view. What writer Paul Theroux said of the impoverished people of Malawi, Africa, in the September 1989 NATIONAL GEOGRAPHIC could well apply to much of that vast continent: "It is both a worry and a marvel…that they are still there."

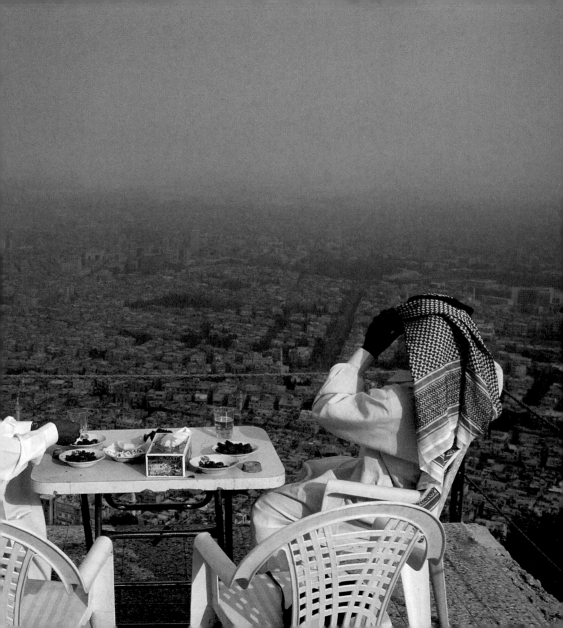

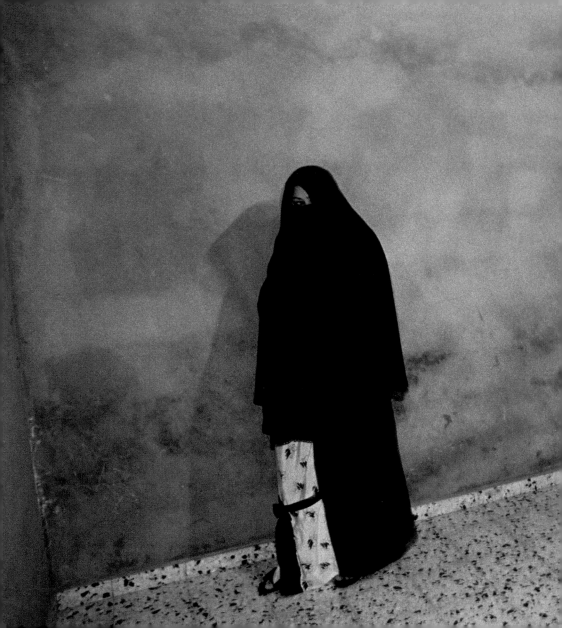

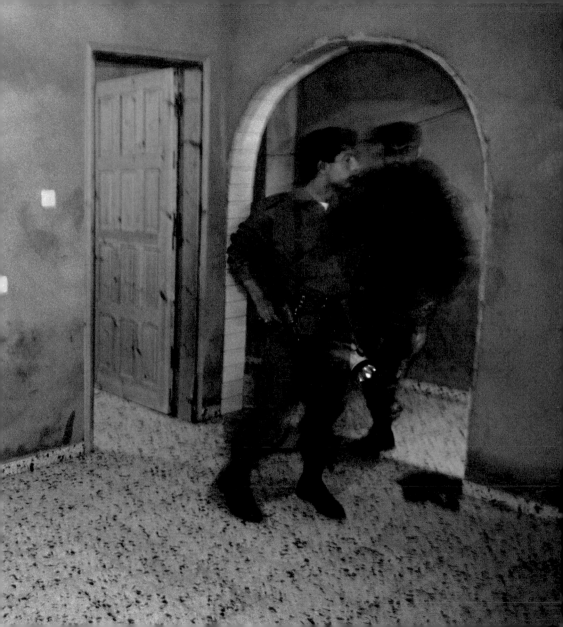

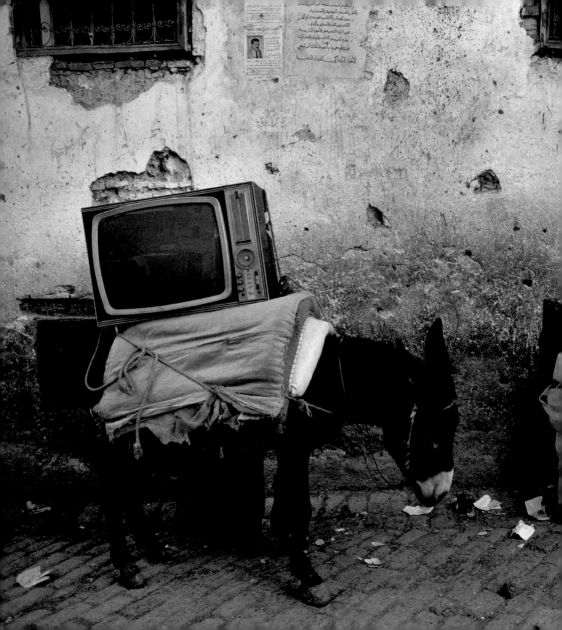

ED KASHI | 1996
PAGES 266-7: Saudi visitors view a dust storm over the suburbs of Damascus, Syria.

ALEXANDRA AVAKIAN | 1996
PRECEDING PAGES: Palestinian security forces rousted this woman when they raided the house of a suspected member of Hamas.

BRUNO BARBEY | 1986
LEFT: A donkey carries prized cargo through the narrow streets of Fez, Morocco.

CHRIS JOHNS | 2001

PRECEDING PAGES: A barbed wire clothesline delineates a Bushman settlement in the Kalahari Desert of southern Africa.

LYNN JOHNSON | 1991

RIGHT: Supported by her mother, a starving child receives soy milk at the Kersey Home for Children in Ogbomosho, Nigeria.

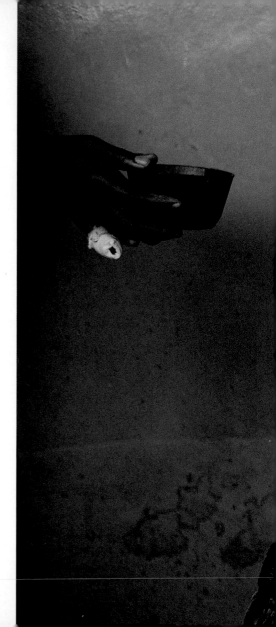

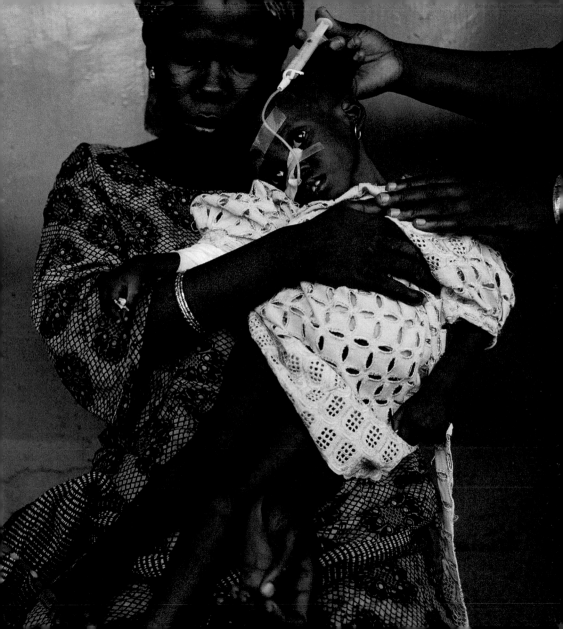

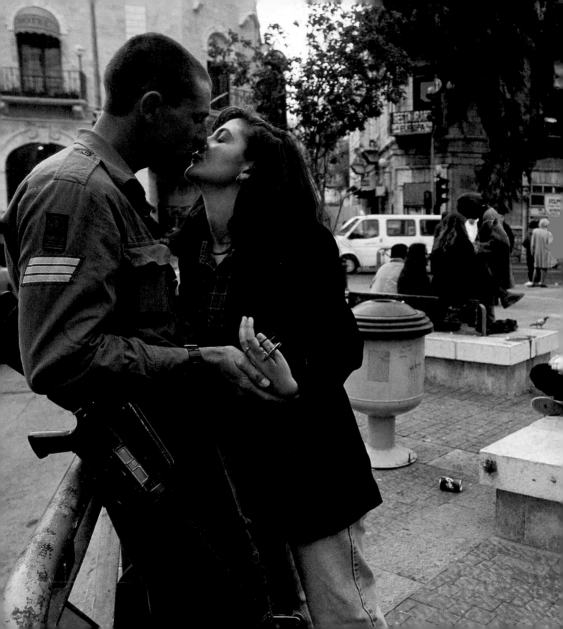

ANNIE GRIFFITHS BELT | 1996
An off-duty sergeant in the Israeli Army
lets down his guard for a kiss in West
Jerusalem's Zion Square.

AFRICA | WILDLIFE

A precarious ark of wildlife, Africa shelters a wealth of species. Tourists from around the world journey to eastern and southern Africa in hopes of seeing the Big Five—the old trophy hunters' term for lion, leopard, elephant, rhino, and Cape buffalo—as well as other wild creatures. Unfortunately, many African species face an uncertain future because of poaching, deforestation, and overgrazing. Mountain gorillas in Rwanda, Zaire, and Uganda, where civil strife has repeatedly erupted, have dwindled to a few hundred animals.

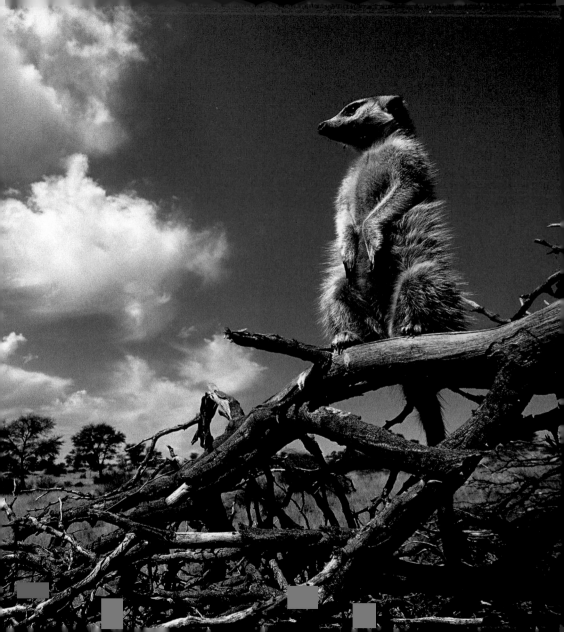

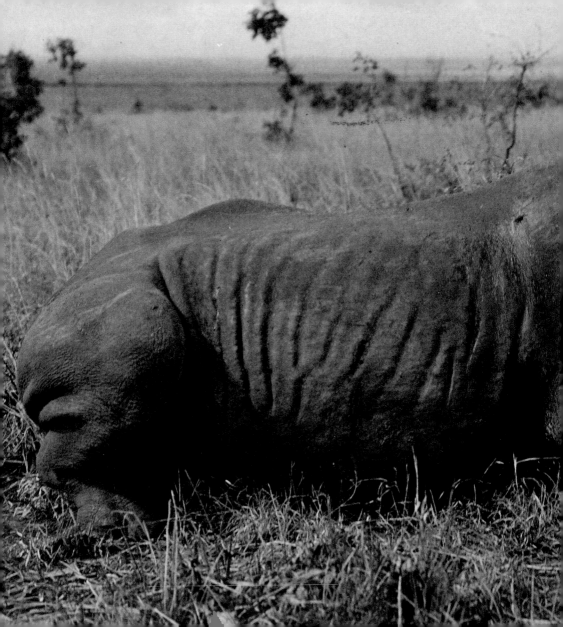

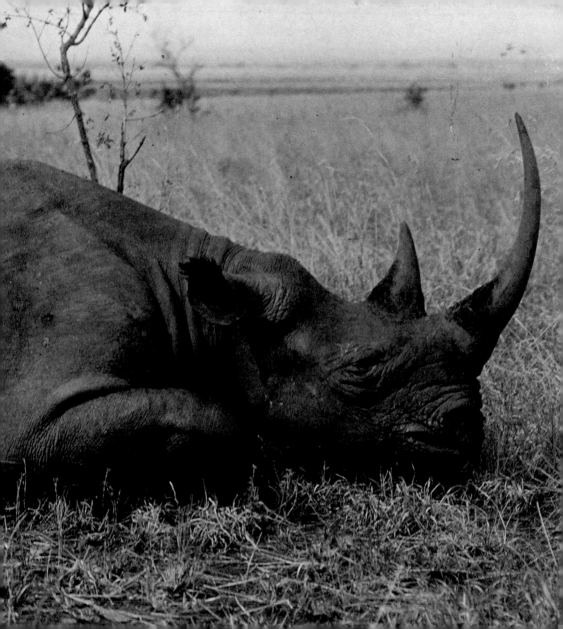

MATTIAS KLUM | 2002

PAGES 278-9: Staying alert, a meerkat keeps watch while its groupmates forage in the Kalahari Desert.

C.E. AKELEY | 1909

PRECEDING PAGES: A picture of a black rhino helped illustrate "Where Roosevelt Will Hunt," a story by Sir Harry Johnston in the March 1909 NATIONAL GEOGRAPHIC.

MICHAEL NICHOLS | 2002

RIGHT: A baby baboon clings to its mother in the highlands of Ethiopia.

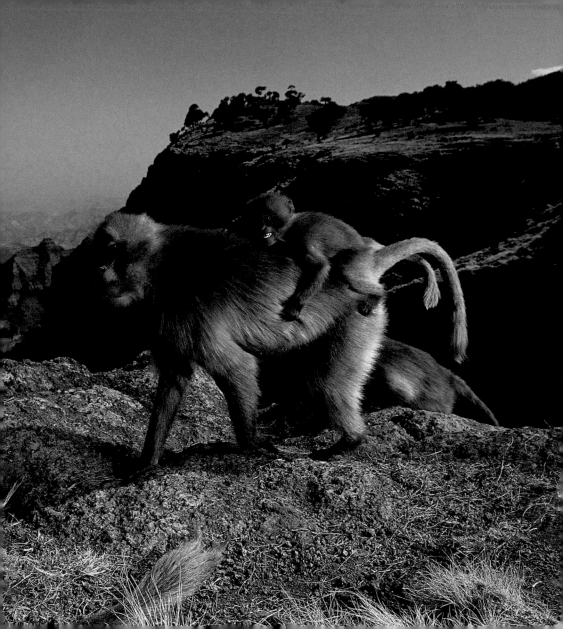

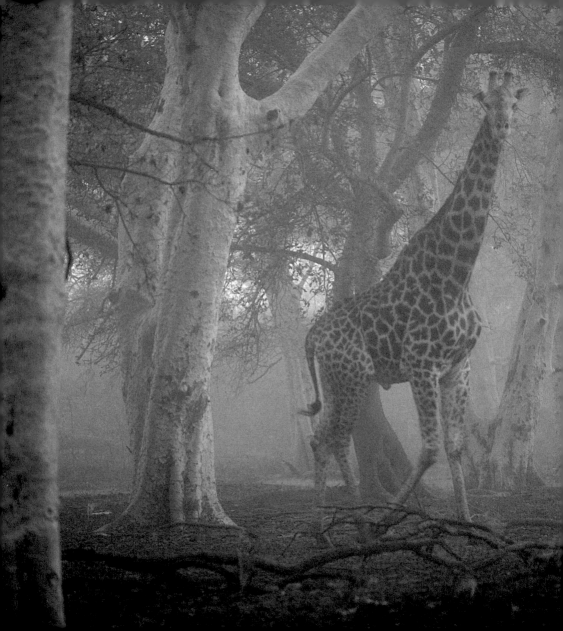

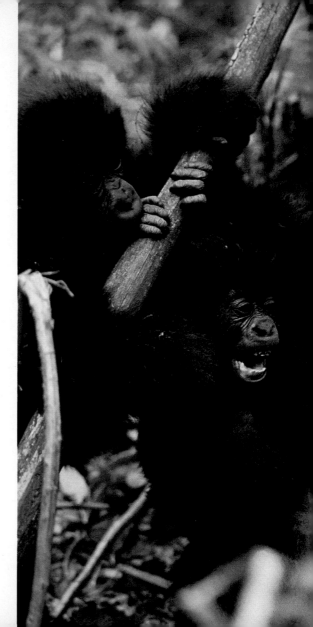

MICHAEL NICHOLS | 1995
Conservationists fear they are fighting a losing battle to save mountain gorillas such as these near Karisoke, Rwanda.

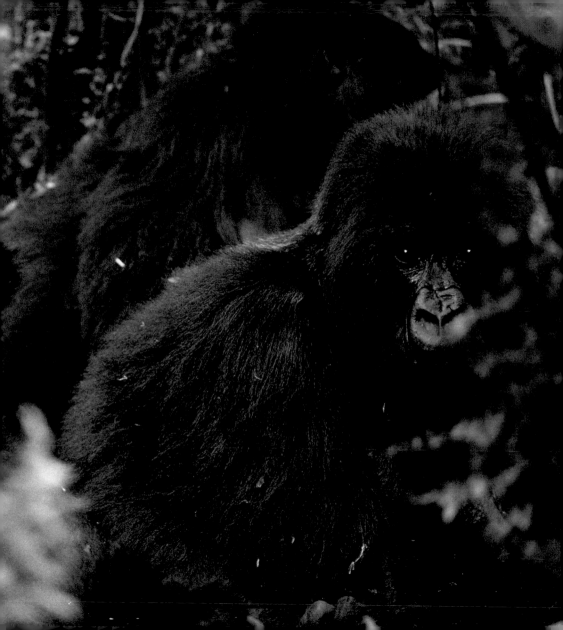

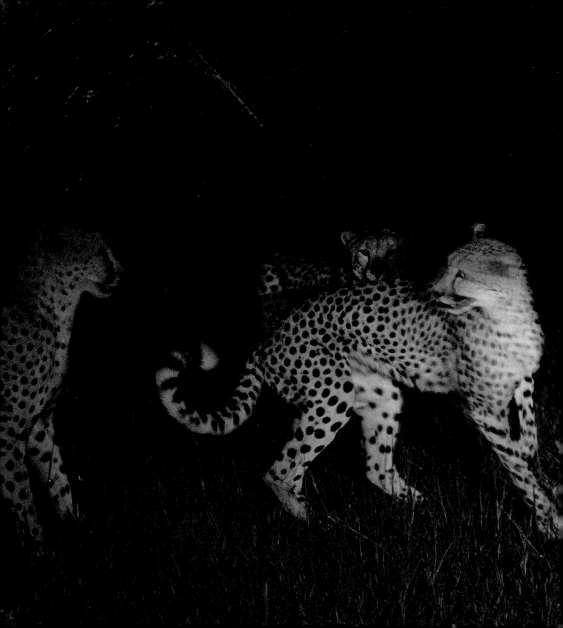

CHRIS JOHNS | 1999

Admired for their genetic hardiness but reviled as pesky predators, cheetahs in Namibia prowl under the cover of night.

AMERICAS

WONDERS OF THE NEW WORLD

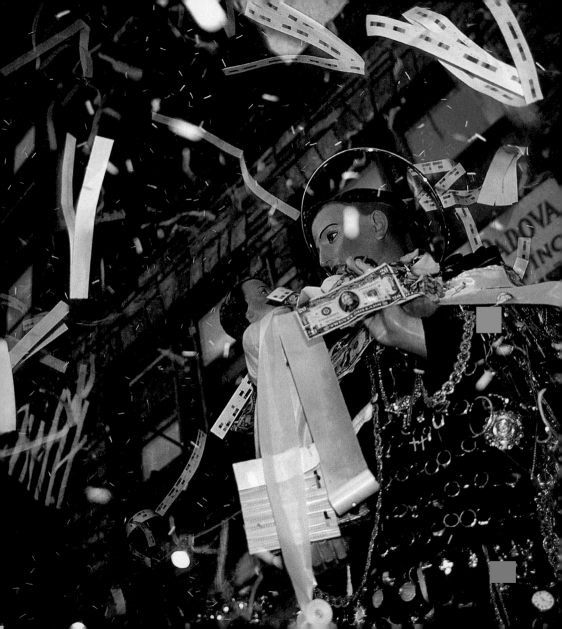

Americas

by Sam Abell

The greatest continuing story in the NATIONAL GEOGRAPHIC, a magazine renowned for foreign reporting, is the unfolding account of life here at home—in the Americas. This is the story the editors, writers, and photographers know best, and it is apparently what Geographic readers most want to see. Every issue includes at least one article about the United States. Beyond that, the most frequently covered countries are Canada, Mexico, and nations in Central and South America.

Ever since the magazine's early days, its photographers have been drawn to documenting the exploration and settlement of the Americas. This work has been so relentless that no scene or event seems to have been overlooked; some settings and some people have been photographed again and again.

On assignment for a story in Mexico, David Alan Harvey was traveling through a remote Maya village when he encountered a man he had photographed years before. The man was little changed, dressed in the same

PAGE 292: At a summer festival in Boston, Italian Americans honor St. Anthony, whose statue bears offerings for miracles.

traditional clothes that Harvey had first seen him wearing. Moreover, he still had the same bearing that had dignified the earlier portrait published in the GEOGRAPHIC. On the spot, Harvey pulled out a copy of the old issue, found the picture, and placed the open magazine in the man's hands. Then he posed him against the same worn turquoise wall and took another picture in the same light.

In the double portrait, the only visible differences are the subtle ones that arise from time's passing, and that fact says much about the GEOGRAPHIC's relationship to its subject matter and with its photographers, and readers. Time has been the greatest gift given to all three. It once wasn't uncommon for photographers to spend months in the field, and specialists could spend years with their subjects. David Alan Harvey's work on the cultures of the Caribbean and the Americas has gone on for 30 years.

A model for this way of working and living was established in the years after the Civil War, when men like William Henry Jackson made extensive photographic surveys of the American West. Before Jackson's work, which led to the creation of Yellowstone National Park, the only depictions of the Rocky Mountains were oral, written, or painted ones—often vivid accounts that could not always be fully believed. But Jackson's images were visually accurate records that could be trusted by all who saw them.

Following in Jackson's footsteps came a generation of photographers that included P.G. Gates, Carl J. Lomen, and Edward S. Curtis.

These men photographed native peoples who were holding on to traditional lifestyles, and their work, which extended into Canada and Alaska, was charged with urgency. Increasing numbers of settlers were pouring into the West in the aftermath of the excitement caused, in part, by Jackson's photography, and the age-old Native American ways of life were diminishing.

By the turn of the 20th century, settlement of the United States had become a continuing subject for the GEOGRAPHIC, with stories on cities and states in almost every issue. Still, some intrepid photographers pushed the work of exploration deep into the new century, particularly in South America.

In the tradition of Jackson and Curtis, photographers Loren McIntyre and Jesco von Puttkamer worked and lived in the remotest regions of Amazonia in the 1970s, '80s, and '90s. Pictures of the rain forests and rivers of Brazil were, like Jackson's photographs, made to manifest the beauty of untouched wilderness and thus speak to the need to preserve the environment. Images of forest dwellers were, like Curtis's photographs, records of traditional lifeways before native peoples were changed by contact with the modern world. McIntyre's portrait of a red-faced boy, on the cover of the October 1972 GEOGRAPHIC, has all the complexity and staying power of pictures made by Curtis a century earlier. Both photographers dignified their subjects and created portraits charged with poignancy, the kind that infuses images of individuals whose last days, we know, are drawing near.

Loren McIntyre's devotion to documenting the Amazonian wilderness resulted in more than landscape photography and portraiture. He also made memorable wildlife photographs, including a rare image of a fatal in-the-water encounter between a jaguar and a caiman. McIntyre capped his involvement with the Amazon by trekking into the highest elevations of the Andes to seek the true headwaters of the mightiest river in the Americas. His map work, on the ground and from the air, challenged the assumptions of science about the actual location of the river's source.

Over the years, several amazing finds and photographs have been made in the Andes and featured in the GEOGRAPHIC. Exploring Peru in 1911 and 1912, Hiram Bingham moved slowly over difficult terrain, photographing the unfolding scene with a variety of cameras, most notably one that produced panorama prints. The climax of the expedition was the discovery of Machu Picchu, a lost Inca city. Like Jackson's photographs of Yellowstone, Bingham's pictures of intricate stone architecture set among the misty towers of the Andes excited world interest and led to restoration and preservation of the site.

More discoveries were made in the Andes later in the century. Working at the highest elevations, anthropologist Johan Reinhard found ancient Inca mummies almost perfectly preserved by the cold, dry air. Subsequent photographs by Stephen Alvarez and Maria Stenzel again brought world attention to the Andes and the Inca culture.

But ancient sites and vanished cultures have not been the only focus of photographers at work in the Americas. With a mandate to include a U.S. story in every issue, the GEOGRAPHIC has provided almost continuous photographic coverage of American society. Yet even within this new and ever evolving culture, pockets of tradition and history have remained; photographer William Albert Allard found rich material in subjects like baseball, rodeos, the blues, the Amish, Hutterites, and William Faulkner.

Jodi Cobb's interest in urban culture resulted in photographic essays on two great North American metropolises, New York and Los Angeles, while various photographers over the decades have covered small-town life in a succession of state, regional, and ZipUSA stories.

So replete has been the GEOGRAPHIC's straight documentary photography of life in the Americas that by the end of the 20th century there was even room to imagine a place, then find and photograph it, which is what writer Garrison Keillor and photographer Richard Olsenius did for their "In Search of Lake Wobegon" story, in the December 2000 issue. Before their collaboration, the "lake" had existed only in Keillor's mind and writings. But, as Olsenius's work shows, aspects of this imaginary world could be found in actual life, in central Minnesota. To emphasize the link between the imaginary and the real, Olsenius used a large-format camera and black-and-white film. His approach thus united him across time with Jackson, Curtis, and other pioneers of photography in the Americas.

AMERICAS | SCAPES

Realms of diversity, the myriad landforms of the Americas range from the frigid barrens of the Canadian Arctic to the fecund, steaming Amazon Basin. North America's Great Plains mirror the immense grasslands of South America, and along both continents' western margins, still-active tectonic plates have thrust up rugged cordilleras. Preserves protect some of the most amazing landscapes, such as the eroded canyonlands of Utah and the geysers and mineral springs of Yellowstone, the world's first national park.

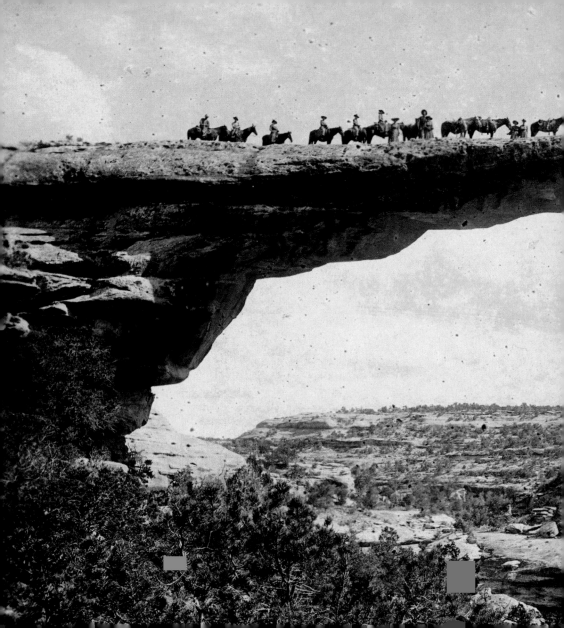

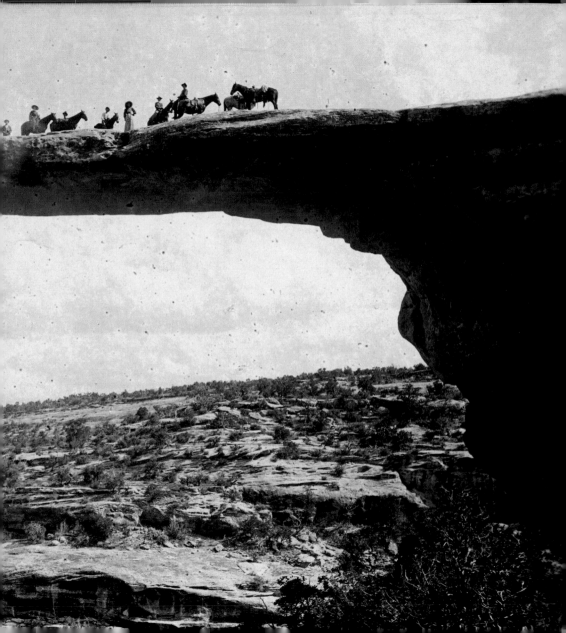

GEORGE STEINMETZ | 1998

PAGES 296-7: Billions of organisms flourish in the scalding-hot Grand Prismatic Spring at Yellowstone National Park.

CHARLES GOODMAN | 1910

PRECEDING PAGES: Edwin Natural Bridge, in San Juan County, Utah, rises nearly 100 feet and measures 194 feet long.

HIRAM BINGHAM | 1912

RIGHT: In 1911, explorer Hiram Bingham discovered the ancient Inca site of Machu Picchu, high in the Peruvian Andes. He took this photo in 1912, after his expedition had spent months removing dense overgrowth.

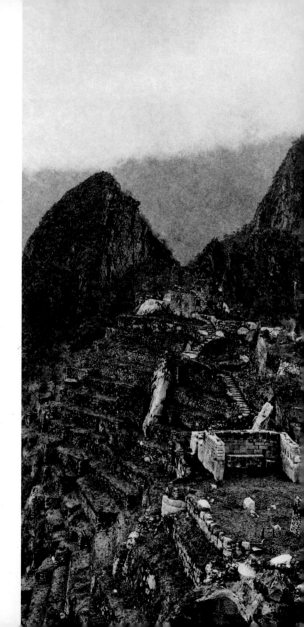

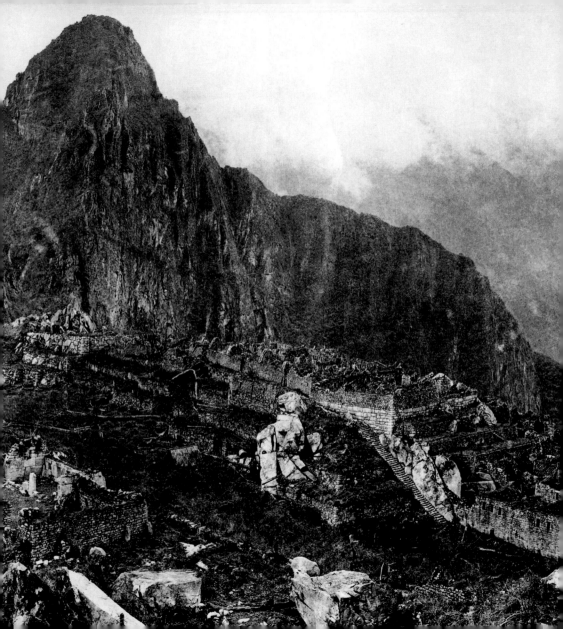

STUART FRANKLIN | 1994
Afternoon traffic in Buenos Aires, Argentina, streaks along the world's widest street.

JOEL SARTORE | 2001

Designed for grizzly bears and other wildlife, an overpass provides safe passage across a highway in Alberta, Canada.

MARIA STENZEL | 1996

FOLLOWING PAGES: In 1796, a Hudson Bay expedition made the first survey of these rapids on the Fond du Lac River, near the U.S.-Canadian border.

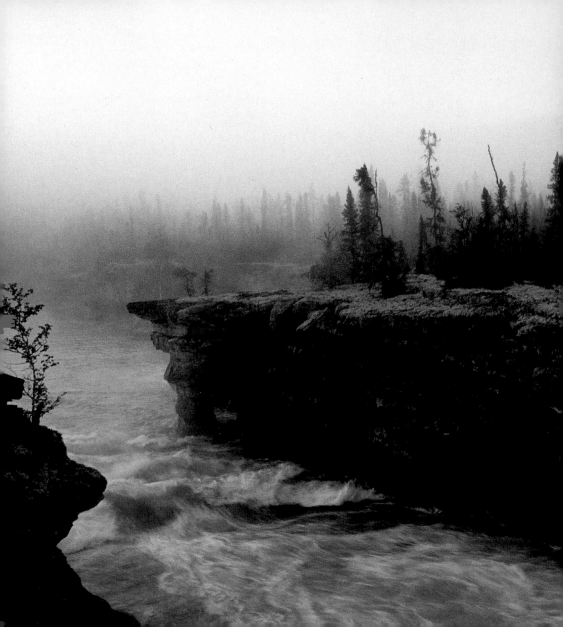

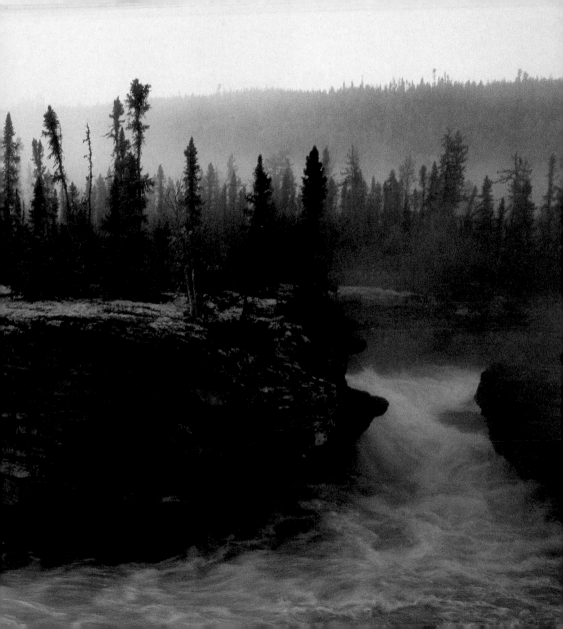

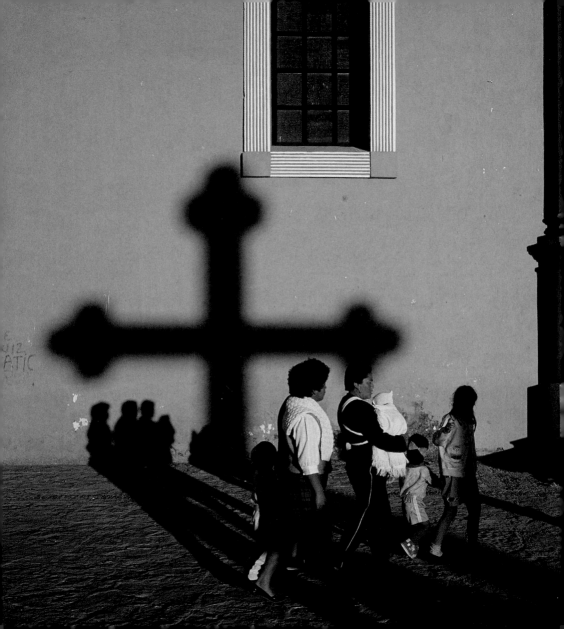

TOMASZ TOMASZEWSKI | 1996
A family comes to worship in the beautiful
but politically torn town of Chiapas, Mexico.

GORDON WILTSIE | 1994

Mere specks against the snow and ice, determined climbers approach the 6,550-foot summit of Gremlin's Cap in the Cordillera Sarmiento of southern Chile.

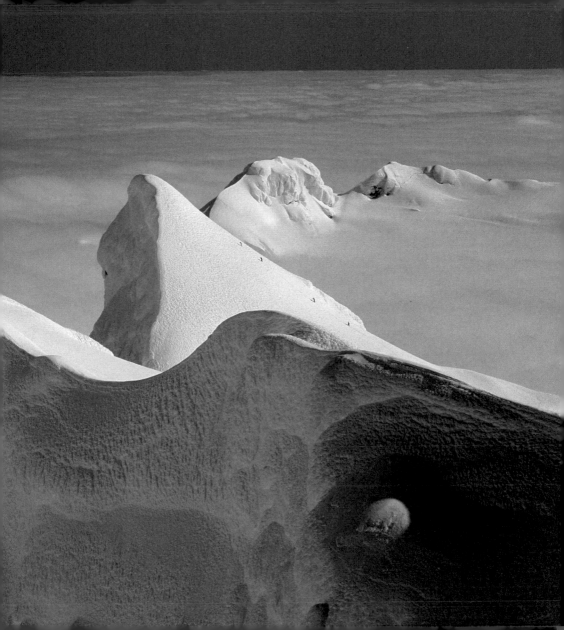

JODI COBB | 1990
Times Square, in New York City, has long
been a gaudy center of neon lights and
lively diversions.

AMERICAS | WOMEN

T he cultural pastiche of the Americas bears the imprint of waves of colonizers who swept over the New World from the 15th century onward— the Spanish, Portuguese, French, and English, whose languages are now spoken by the majority of the continents' 850 million inhabitants. In North America, a Boston matron's stylish fake-fur coat says as much about her milieu as a Canadian Eskimo's skin and fur garments say about hers. The glitter of Spain shines forth in the festive finery of Mexican dancers.

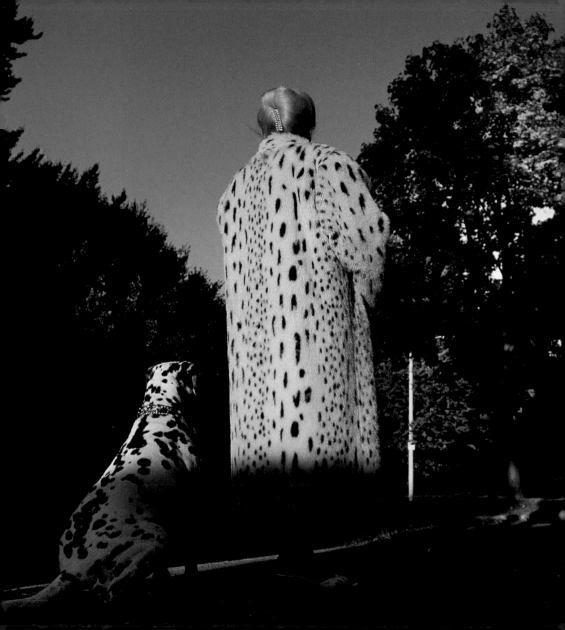

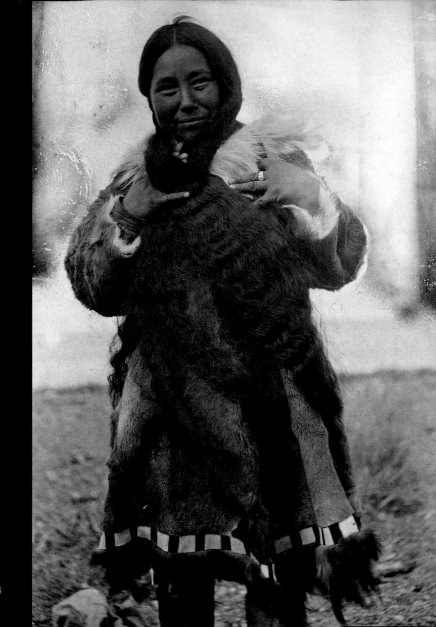

JOEL SARTORE | 1994
PAGES 314-15: A couple of "spots fans"—
one in fake fur—wear matching coats on
Beacon Street in Boston.

SISSE BRIMBERG | 1990
PRECEDING PAGES: As brilliant as Christmas
trees, dancers in Acapulco, Mexico, twirl in
sequined dresses inspired by the Orient.

**UNKNOWN
PHOTOGRAPHER | 1912**
OPPOSITE: This Eskimo woman's husband
accompanied explorer Vilhjalmur Stefans-
son on a journey in the Canadian Arctic.

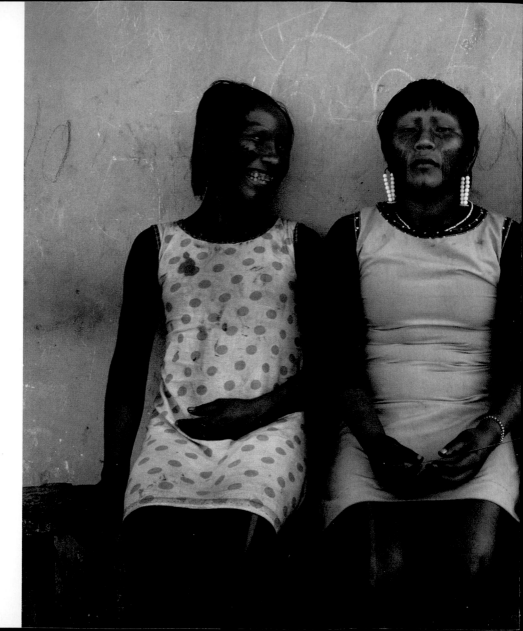

MIGUEL RIO BRANCO | 1984

In Brazil, Kayapo teenagers are all dressed up and ready to pick marriage partners.

HENRY W. HENSHAW | 1924

A pure-blooded Hawaiian girl wears native dress, a style handed down from generation to generation, and plays the ukulele—a small guitar popularized in Hawaii in the 1880s.

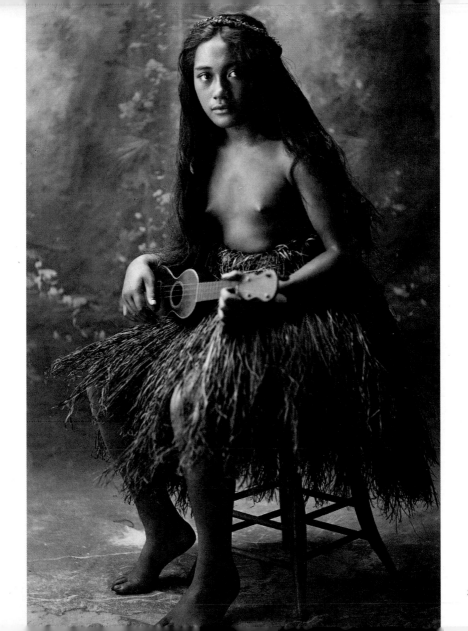

AMERICAS | WILDLIFE

A fierce predator, the gray wolf symbolizes the plight of many wild species. Once roaming nearly all of North America, it is now restricted to Canada, Alaska, and isolated parts of the western U.S. Similarly, the grizzly bear has been driven from much of its western North America habitat. Writing in the May 2001 NATIONAL GEOGRAPHIC, Douglas Chadwick noted that the jaguar's range, from Argentina to Mexico, is becoming threatened: "What was a broad, continuous range is getting thinner and beginning to tear like a rug trod by too many people."

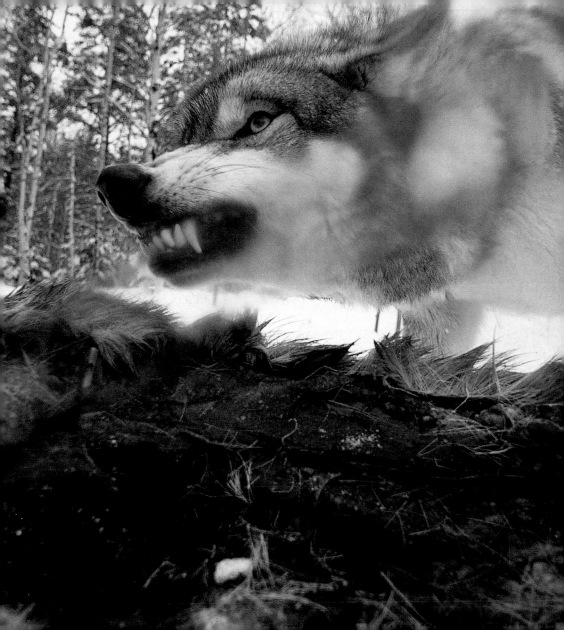

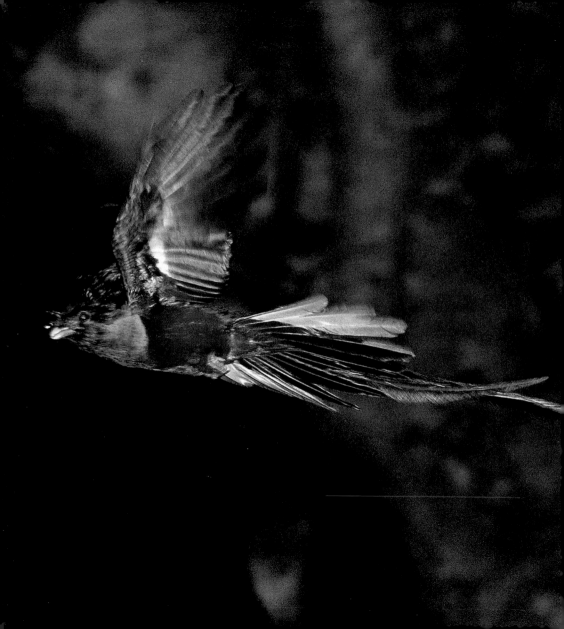

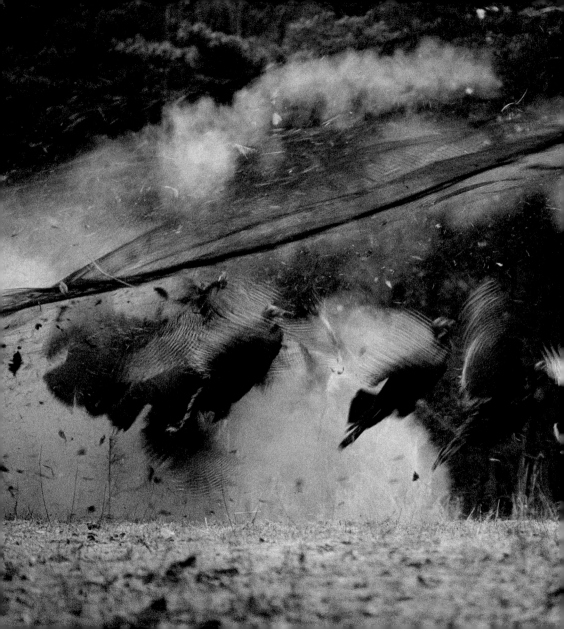

JOEL SARTORE | 1998

PAGES 324-5: A gray wolf savors a fresh kill; this species once was hunted nearly to extinction in the western United States.

STEVE WINTER | 1998

PRECEDING PAGES: In Guatemala, a brightly feathered quetzal looks for some of its favorite foods—small avocado-like fruits.

RAYMOND GEHMAN | 1992

LEFT: Flapping furiously, wild turkeys in Asheville, North Carolina, try to escape a net hurled over their heads; later, wildlife managers will relocate the birds to an area having few or no turkeys.

STEVE WINTER | 2001

A hidden camera captures a male jaguar
prowling his territory in Belize, site of the
world's first jaguar preserve.

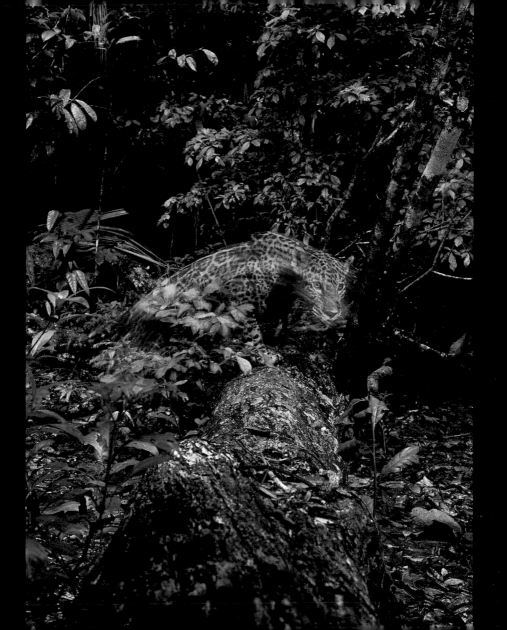

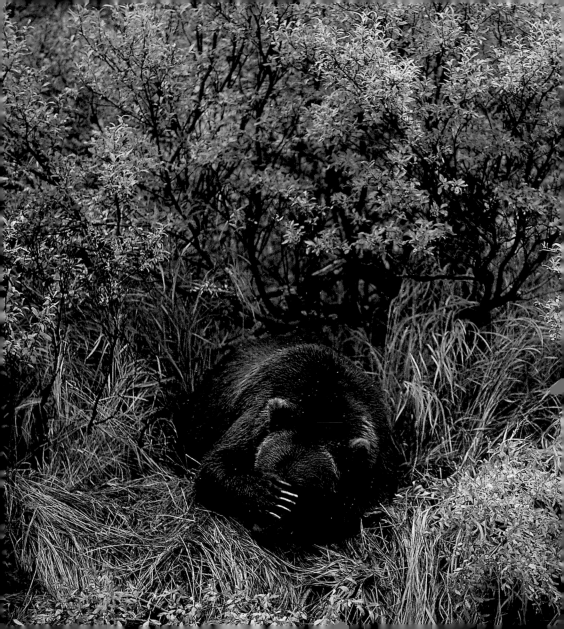

Safely bedded down, a brown bear takes a nap after fishing in the Katmai National Park and Preserve of southern Alaska.

SAM ABELL | 1984

Unique to North America, the pronghorn
is an unforgettable sight, whether racing
along at 55 miles an hour—only the cheetah
is faster on land—or quietly surveying the
surrounding territory.

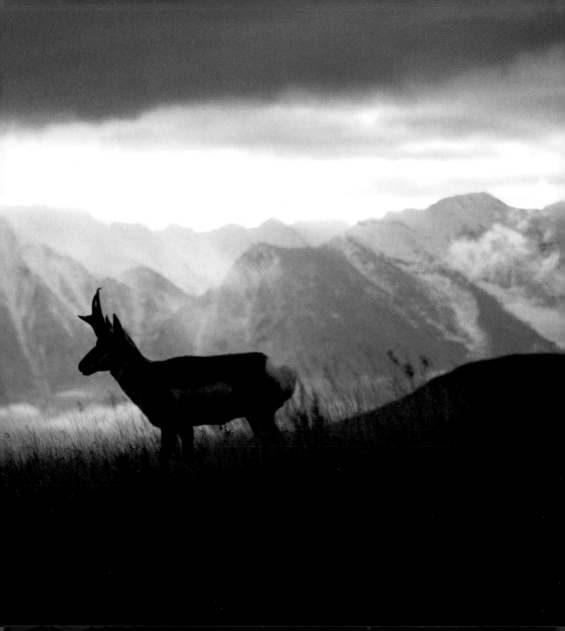

JIM BRANDENBURG | 1987
An arctic wolf leaps from ice raft to ice raft in the wilds of northern Canada.

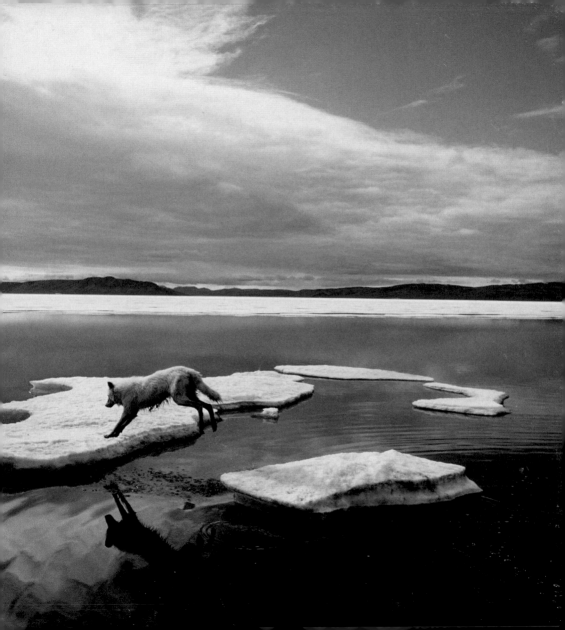

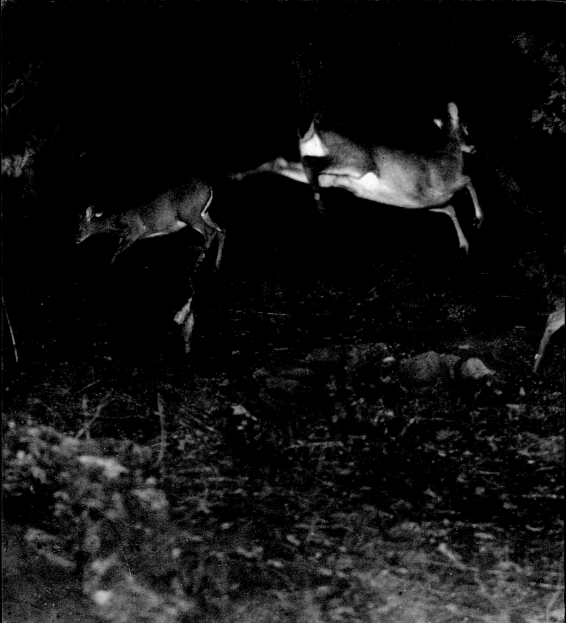

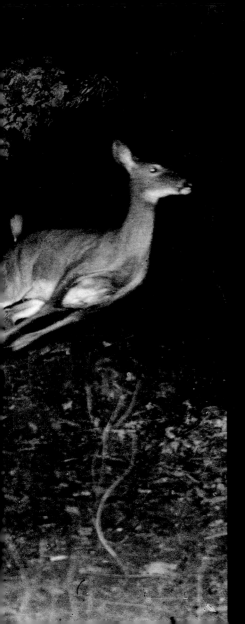

GEORGE SHIRAS III | **1921**
Illuminated by a flashlight, frightened deer
bound into the woods near Lake Superior.

MARK MOFFETT | 1996

Found in many parts of the Americas, the tarantula has a life span of more than two decades; each year this spider outgrows its skin and sheds it like a glove.

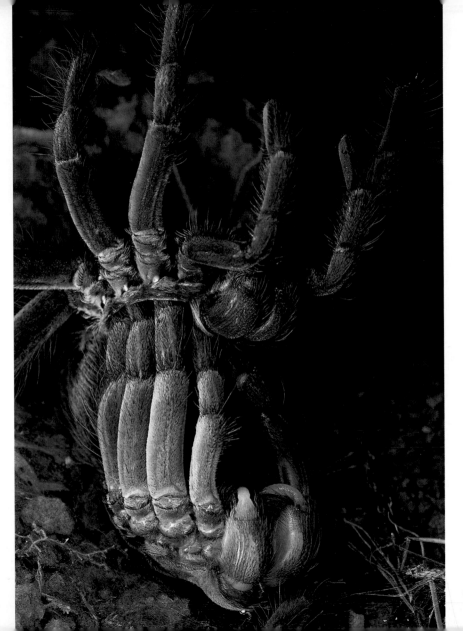

From the tranquil to the raucous, leisure pursuits add spice to life in the Americas. Spending time with family or friends is a favorite way to unwind—whether it be a lakeside reunion in Minnesota or ice-skating in a tree-studded park in Montreal. Throughout Latin America, holy days fill the calendar. During the Festival of the Virgin of Guadalupe in Mexico City, revelers don costumes that dazzle the eye. In contrast, at the Burning Man gathering in Nevada's Black Rock Desert, some participants' outfits boggle the mind.

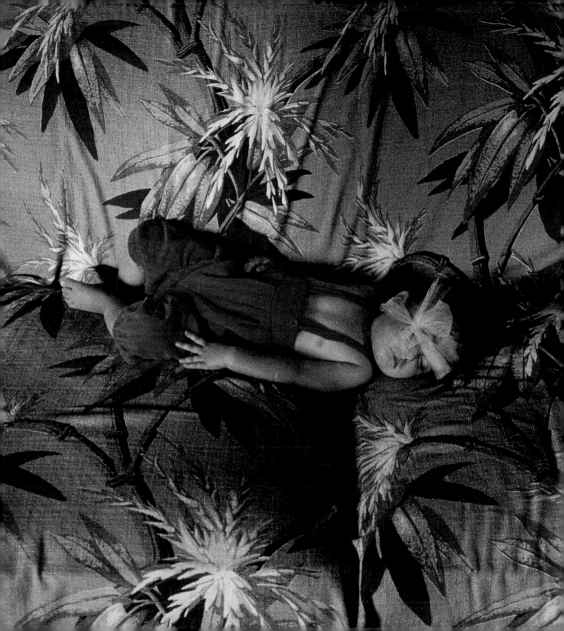

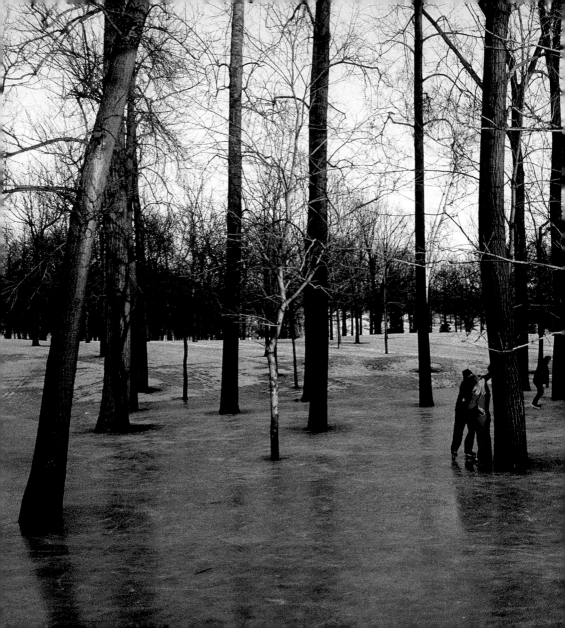

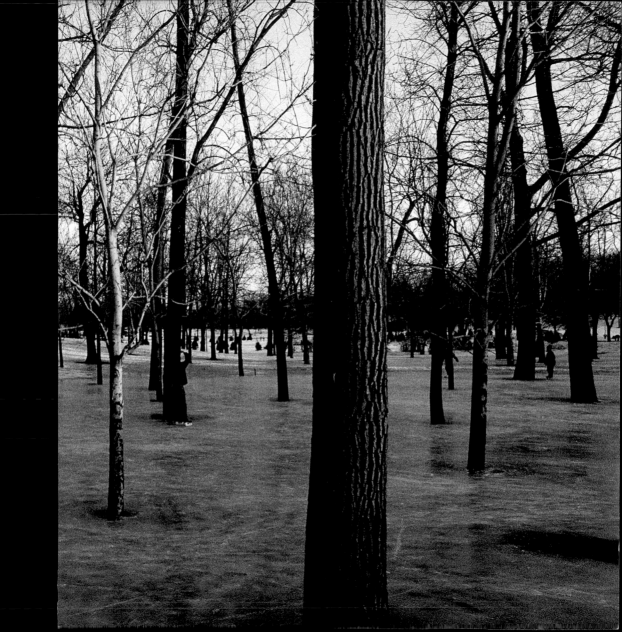

SAM ABELL | 2000

PAGES 342-3: In Seattle, Washington, an artist's baby sleeps while a party gets under way elsewhere in the house.

SISSE BRIMBERG | 1991

PRECEDING PAGES: A couple in Montreal, Canada, enjoys a quiet moment on Mount Royal Park's iced-over Beaver Lake.

STUART FRANKLIN | 1996

RIGHT: Celebrants at the Festival of the Virgin of Guadalupe in Mexico City mix traditional costumes and Roman Catholic images.

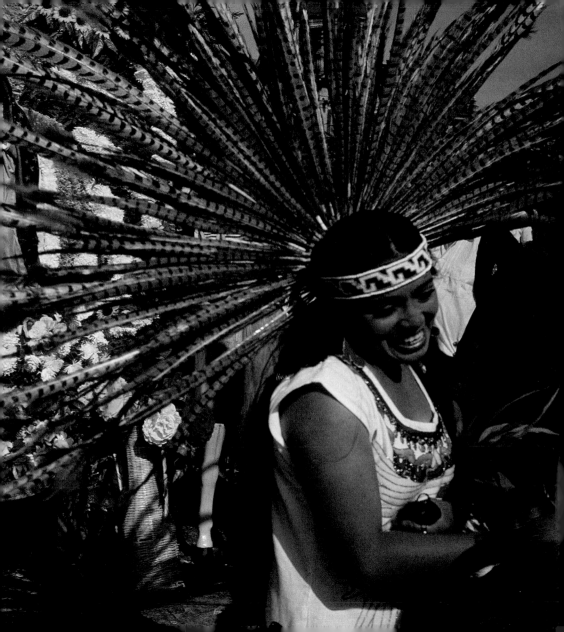

STUART FRANKLIN | 1994

With professional aplomb, a couple in Buenos Aires
performs the tango, the national dance of Argentina.

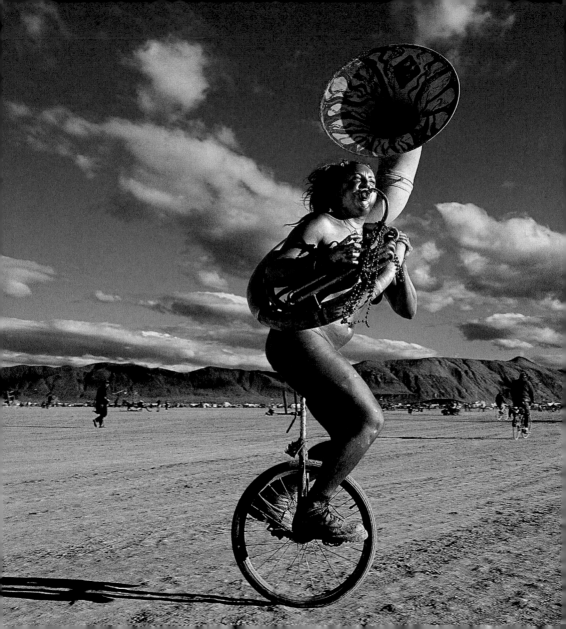

Expressing herself, a sousaphone player makes music at the annual Burning Man festival in Nevada's Black Rock Desert.

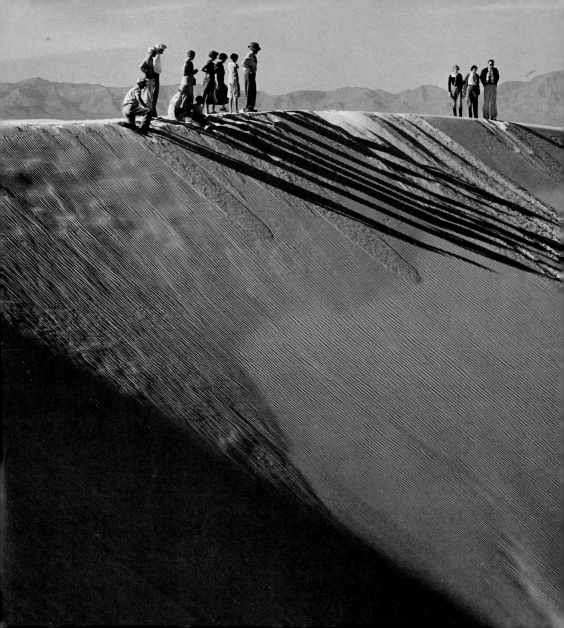

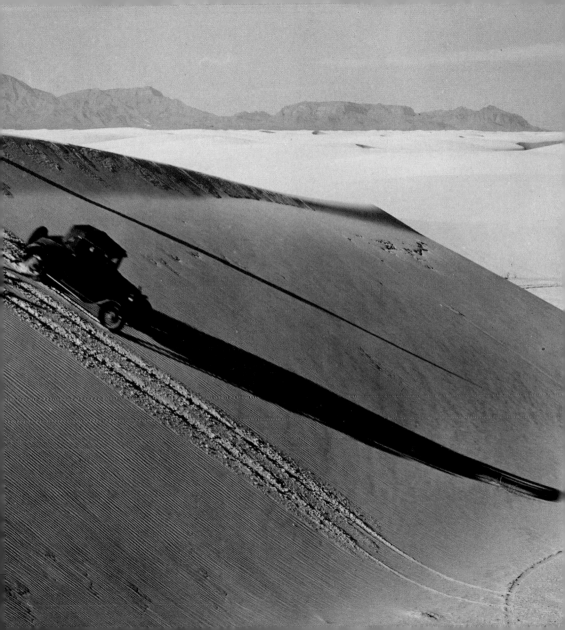

G.A. GRANT | 1935
PRECEDING PAGES: Thrill-seekers descend steep dunes at White Sands National Monument in New Mexico.

WILLIAM ALBERT ALLARD | 1991
RIGHT: Players compete for major-league positions at a Milwaukee Brewers training facility near Phoenix, Arizona.

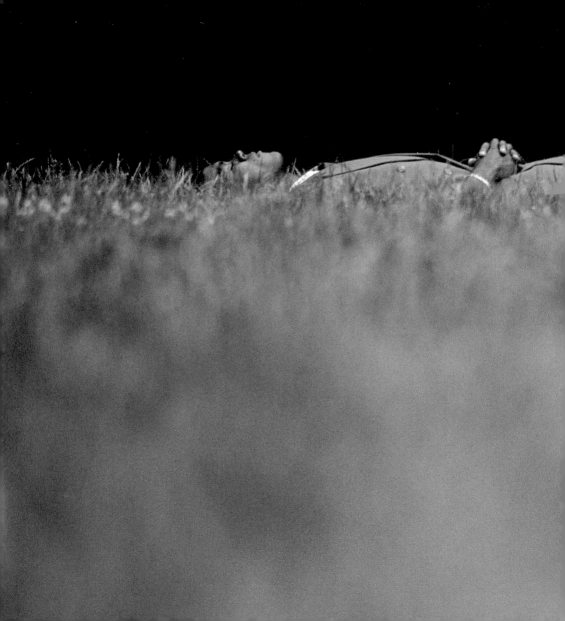

JOSE AZEL | 1993

PRECEDING PAGES: A trusting sleeper finds peace and privacy among the 843 acres of Central Park in New York City.

WILLIAM ALBERT ALLARD | 1999

RIGHT: Playing the blues—often called America's music—is a family affair in Clarksdale, Mississippi.

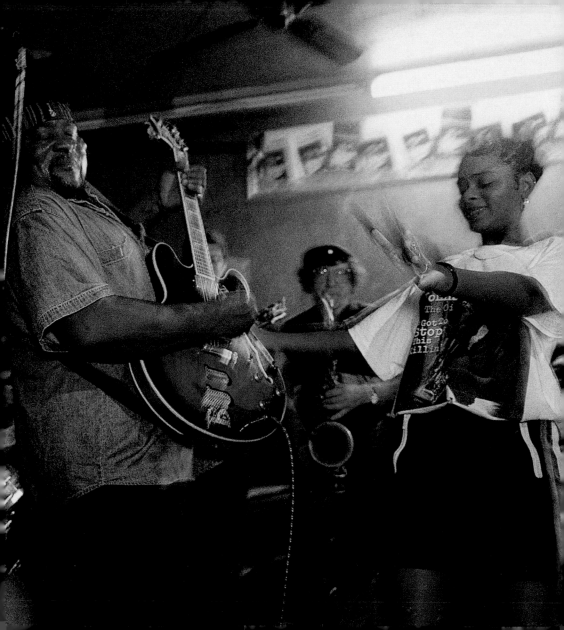

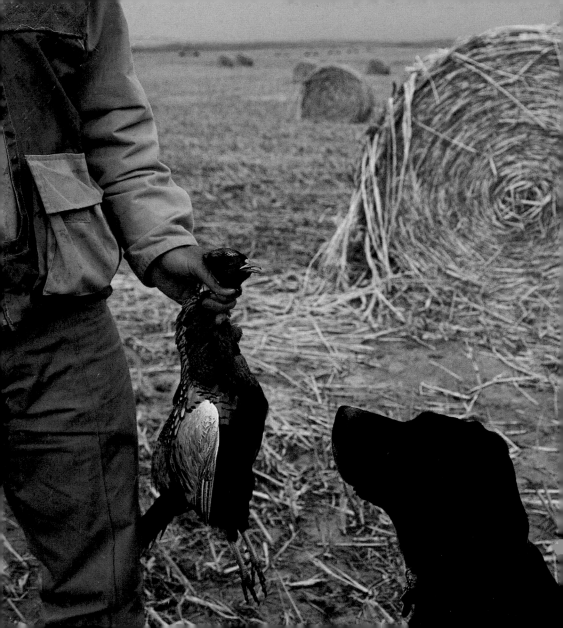

JOEL SARTORE | 1998
A hunter grasps a prized ring-necked
pheasant, bagged during a popular annual
shoot at Broken Bow, Nebraska.

RICHARD OLSENIUS | 2000

The seventh annual Lund family picnic, at Pelican Lake in central Minnesota, reunites up to 40 family members.

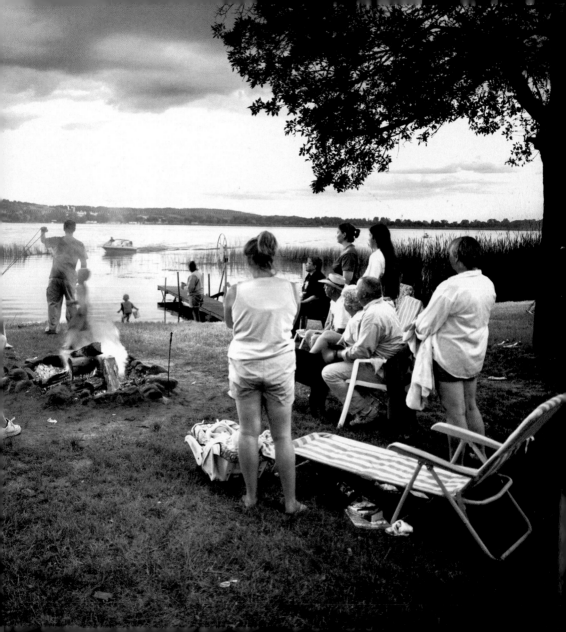

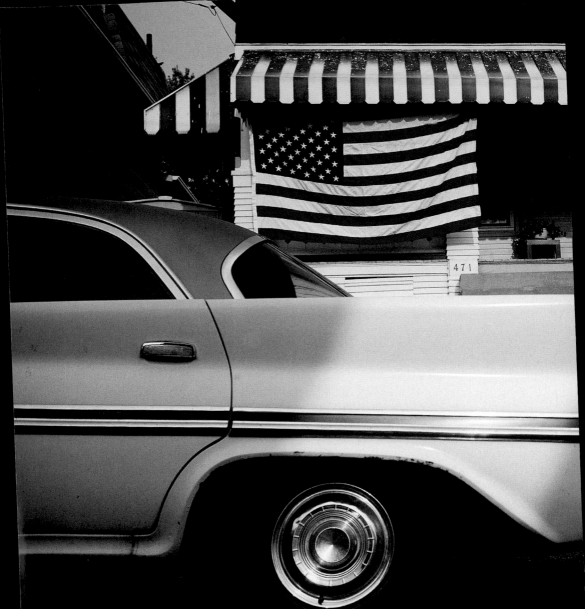

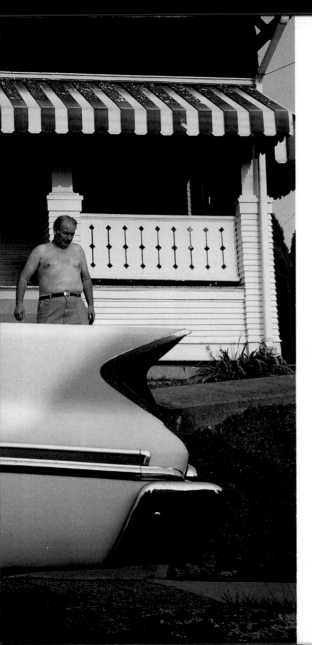

NATHAN BENN | 1991

With patriotic pride, a resident of a
blue-collar neighborhood in Pittsburgh,
Pennsylvania, displays a large U.S. flag
and a big American-made automobile.

SARAH LEEN | 2002

To play outside with his friends, a
14-year-old boy wears a protective
outfit designed by NASA; he suffers
from a rare condition that makes
exposure to sunlight intolerable.

T rades in the Americas often reflect the general economic disparity between north and south, with Canada and the United States far outstripping the Third World nations of Central and South America. Even so, Newfoundland dory fishermen lead no life of luxury. Writing about these hardy souls in the January 1974 NATIONAL GEOGRAPHIC, Gary Jennings said, "In these parts, any lazy good-for-nothing is called an 'angishore' (hangashore)—a man too spineless to leave the land and dare the sea."

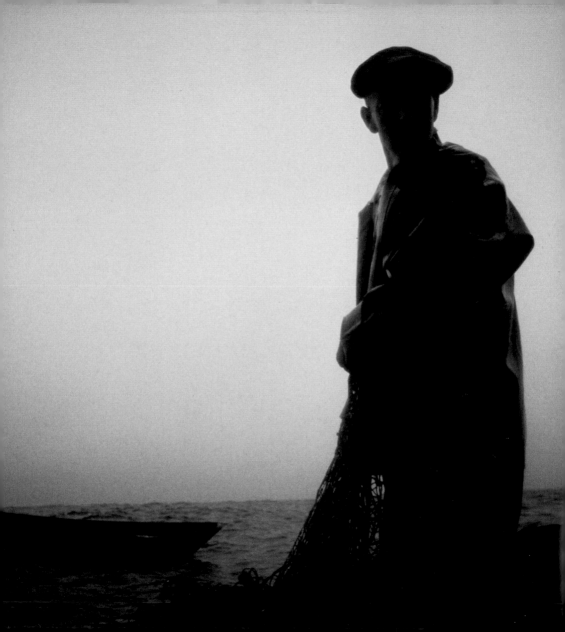

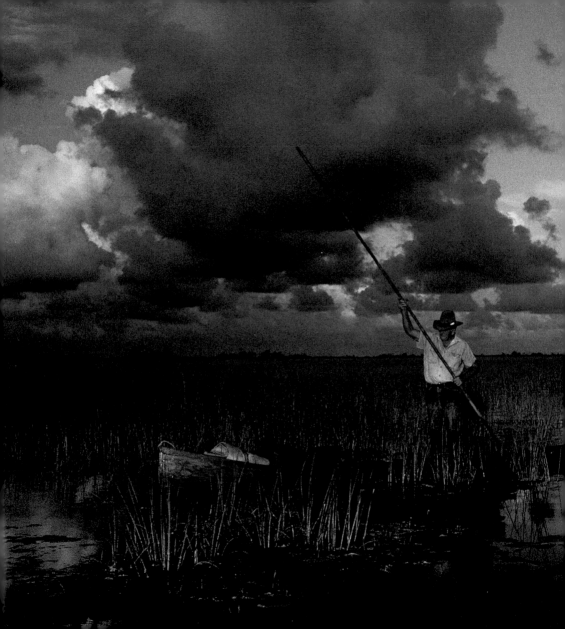

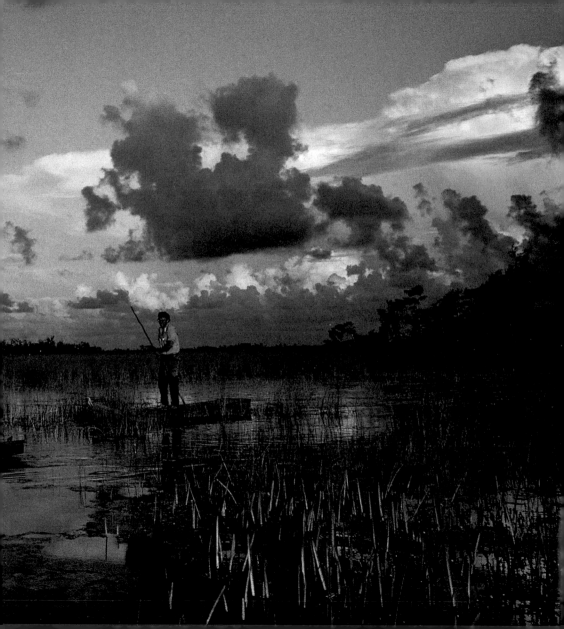

SAM ABELL | 1974

PAGES 368-9: Fishermen use nets to harvest the waters off Newfoundland.

CHRIS JOHNS | 1994

PRECEDING PAGES: Canoes based on Seminole Indian designs still ply the waters of the Florida Everglades.

O. LOUIS MAZZATENTA | 1980

RIGHT: In Paraguay, cowhands take a break on a bunkhouse porch.

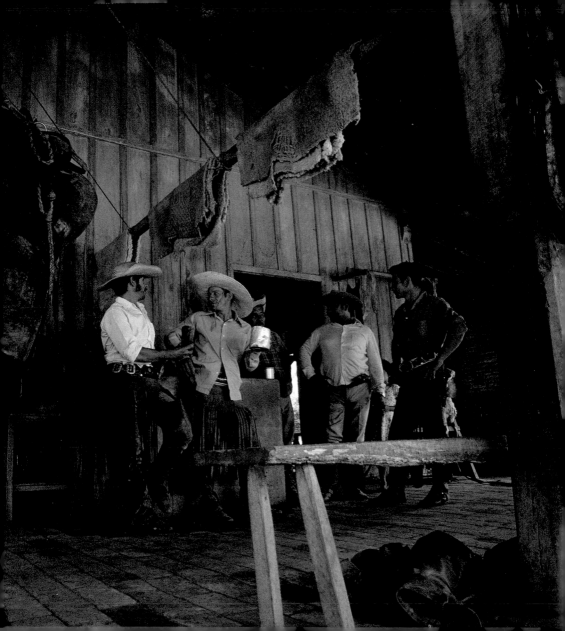

WILLIAM ALBERT ALLARD | 1982
In Lima, Peru, the Plaza de Acho—oldest bullring in the Americas—attracts matadors from Spain and Latin America.

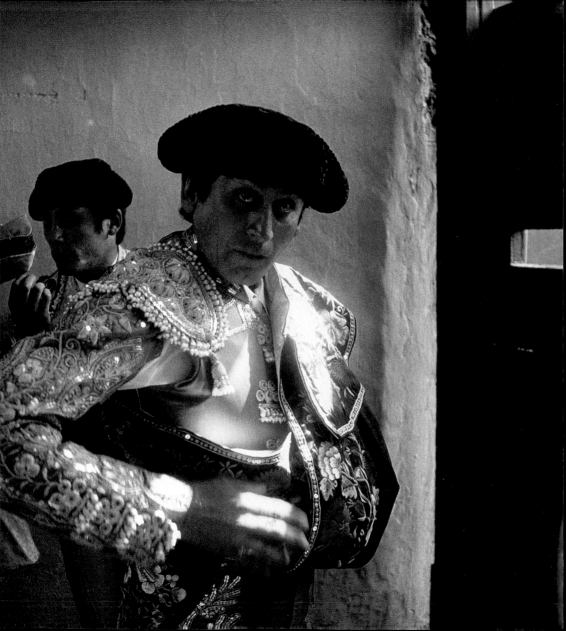

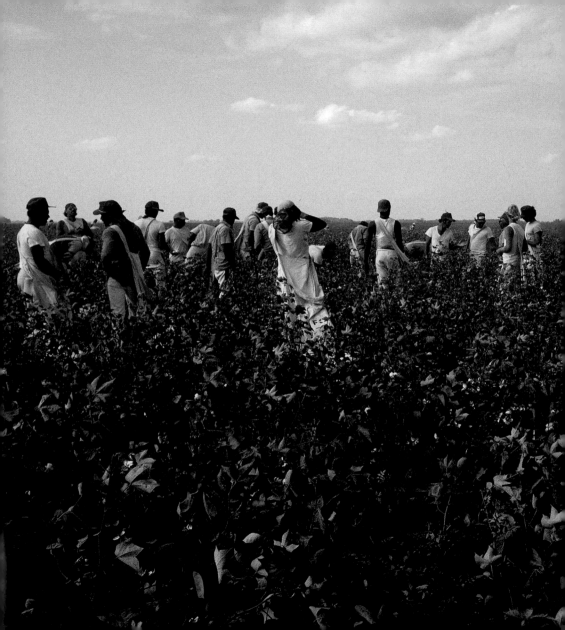

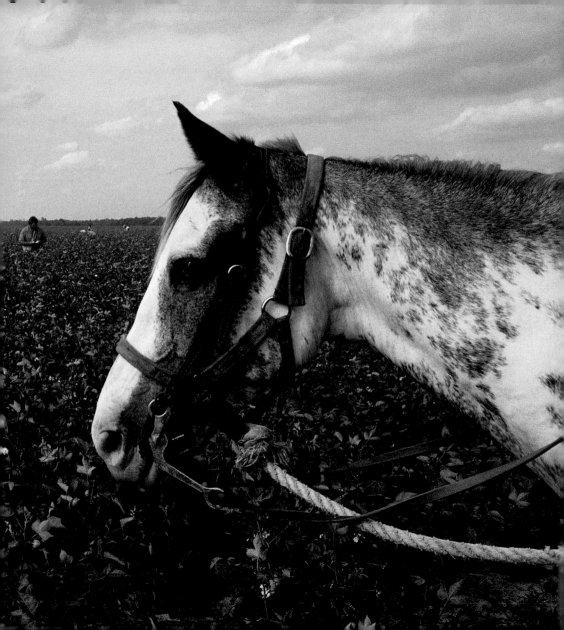

WILLIAM ALBERT ALLARD | 1989
PRECEDING PAGES: A mounted guard keeps close watch over inmates from the Mississippi State Penitentiary in Parchman.

JOEL SARTORE | 1993
RIGHT: For a 77-year-old orange picker in northern California, fruit is free for the taking and exercise is plentiful.

OCEANS
& ISLES

LANDS AND PEOPLE OF THE SEA

Oceans & Isles
by P.F. Kluge

Consider the images in this volume, and it's clear that NATIONAL GEOGRAPHIC photographers have visited many islands over many years—from Australia, the so-called island continent, to Iceland to tiny Pacific atolls. Photographers have also captured the many moods of the oceans, discovered spectacular underwater realms, and explored the shores of every continent. Through their pictures they have evoked the look and "feel" of such places, from the strange and wonderful to the familiar and commonplace.

For those of us who love islands, our feelings are often hard to defend and sometimes impossible to shake. We are drawn to these places, visiting and revisiting them, seeking new ones and returning to old ones; it's as if we are members of a secret order, a kind of freemasonry united in its love of small places. For nonmembers, this passion is difficult to grasp. Most of the world's land comprises continents, so continents are where most history is made, great nations rise and fall, and large cultures flourish and fade. Granted, powerhouse island nations like England and

PAGE 382: The palm-fringed sands of Bora Bora lie about
150 miles northwest of Tahiti in the Society Islands.

Japan have produced discoverers and conquerors and have won and lost empires. Yet, as islands go, they are rarities.

Most islands are much smaller, and to care about them is to risk being written off as marginal or minor league, someone who makes a meal out of appetizers. Call someone "continental" and you connote a suave and experienced manner, an easy presence anywhere in the world. "Insular," on the other hand, can call to mind unflattering synonyms like detached, isolated, unworldly, and illiberal. There's a small-town, small-time aspect to islands, which might cause you to beware of visiting too many or lingering too long.

Never mind. If you are an island-lover, nothing can stop you from picturing and planning another island trip, not even competing invitations to the most important places on the planet. You know something that other people have not yet discovered, and it is just as well. Insular or not, island people favor small over large, depth over breadth, the particular over the general. They are drawn or driven to the shores of islands, arriving as discoverers or shipwrecks, on purpose or by accident. Some are exiles, like the deposed Napoleon Bonaparte; others may be vacationing celebrities or fugitives from justice. Fictional characters, like Doctors Moreau and No, find islands to be the perfect settings for their villainy. But most island-lovers aren't movers and shakers and villains. They are thinkers, idlers, and—most of all—dreamers.

What does this dream of islands include? Part of it involves living in a small place, the smaller the better. A too-large island gets blurry and compromised. You want a place whose ground you can cover in a day or so; you can also find everything fairly easily, and the sea is rarely out of sight. An ocean view is crucial, for the sense of water all around reminds you of how far you have come and how distant you are from the rest of the world.

The more remote the island, the better. Forget Manhattan, Singapore, and Hong Kong; they are islands only in a technical sense. Forget offshore isles reachable by bridge or ferry; they are in the mainland's field of force. Fine and restful places they may be, but they cannot be taken seriously as islands if newspapers arrive on the same day they are published and visits are as short as a long weekend. Distance is essential. A faraway isle offers a chance to begin again, a kind of makeup exam for life's troubled students. It is a recycling plant for the used and empty, a witness protection program for people who have seen too much in other places.

There are all kinds of small islands, and generally they are known for only one thing—a natural feature, a certain activity, or a special product; they seem to be entitled to just one claim on the world's attention. We have shipwreck islands, as in *Robinson Crusoe* and *Gulliver's Travels*, *The Tempest* and *Lord of the Flies*. We have battleground islands like Iwo Jima, Midway, and Guadalcanal. We have islands that are volcanoes, atolls, deserts, tourist magnets, offshore banking centers, guano collection sites, prisons, fortresses, fishing spots, and fantasy worlds.

In a way, all islands are fantasylands before you get to them. The ultimate dream, of course, is an uninhabited isle, the kind of place you see in shipwreck cartoons. What books would you take to such a place? What music? What ideal companion?

Every time you come to an island, you feel as if you are discovering it for the first time. You are landing on some improbable dot and setting foot on a place that is lost—or so you like to think of it—in an endless sea. Stepping ashore, you repeat a ritual that goes back to Shakespeare's Prospero and Defoe's Crusoe, looking around and staking your claim. You are with Bougainville and Cook, coming upon Tahiti, or with Napoleon, catching your first sight of St. Helena. You measure the distance traveled and calculate the chance of return. Escape and exile are mingled together as you ponder the beginning of one life, the end of another.

The first taste of island life is heady stuff. Even on the first morning after your arrival, you can swallow a hook that will hold you forever. It's the infinite distance out to sea or the solid particularity of the ground you stand on. It's a certain heaviness in the air, especially on tropical isles. You may sense a languorous, velvety quality in the hour before sunrise, as well as at dusk, when the light goes from bright to mellow and a breeze comes in from the sea. It's the sea, too, with the regular advance and withdrawal of the tides becoming a pattern as important as the taking in and letting out of each breath. You

savor the wind, become a connoisseur of sunsets, and explore your island beach by beach. You ride or walk or sail around the whole thing and climb whatever hill or crag is called its highest peak. And every time you look out to sea, you can't forget the depths below, the drop off beyond the reef, and the life and death that are waiting there.

Your island world is finite and knowable— you get fascinated by local history and local characters—and your new life is good. But you have a couple of lessons left to learn. Number one is that your island usually has other people on it, some of whom have never lived anywhere else. Although they may extend a friendly welcome, you realize that they may never accept you as a full citizen.

If you learn the language, go fishing, play softball, or perhaps marry locally, you will become a familiar character who is tolerated and maybe even liked. But there's a limit, a point beyond which you won't matter. Be tasteful and generous as you can, and yet you still won't be considered an islander. You can read it in people's eyes and facial expressions, especially those of the old-timers, who have seen a parade of visitors come and go. The tide brings you in, and it will someday carry you out, they seem to say. You really can't blame the locals.

Harder to endure are your fellow expatriates. The long-timers watch you, amused by your beginner mistakes, your rookie enthusiasms. You watch them watching you, and you wonder

if you will end up like many of them: beery and complacent and provincial.

The second lesson you will learn is that islands change. More than 2,000 years ago, the Greek philosopher Heraclitus said, "It is impossible to step into the same river twice." The same holds true for islands. Think of them as adrift in a stream of time, at history's mercy. They are essentially passive places unable to control whoever or whatever arrives from across the sea: waves of missionaries, soldiers, businessmen, and tourists; foreign movies, music, and money. And islanders are often at the mercy of their own globe-trotting leaders. For every dream of islands coming in, there's an islander dreaming out.

Local dreams frequently involve development, and any action is deemed better than none at all. Thus you will see golf courses, garment factories, clear-cut forests, and resort beaches, as well as surrounding waters that are subleased to foreign fishing fleets. Usually the people doing the work are foreigners, as are the people who pay the foreign workers. The islanders generally function as middlemen, agents, and fronts. Offshore banking, casino gambling, and flags of convenience—it's hard to know what is not out of the question these days.

The island you love will eventually change; count on it. Islanders change, too. They travel more, watch a lot of television and movies, and dance to foreign tunes. Many of them attend colleges overseas, and those who return are unlikely to be impressed by foreigners seeking a paradise that never changes. Your dream of islands doesn't die; other dreams crowd it out.

Consider the handsome island of Saipan, in what is now the Commonwealth of the Northern Mariana Islands, and realize that what is said of it could be said of many other places. Call it a battleground island: In the summer of 1944, nearly 3,500 Americans and ten times as many Japanese perished along the sandy shores, on the jungle slopes, and in the countless limestone caves.

Saipan was still a battleground island in 1967, with the marks and scars of conquest never far from view. The shell-pocked, burned-off island had been sealed with tangan-tangan brush soon after World War II to halt erosion, so miles of brushy saplings had replaced coconut groves and sugar plantations. On the beaches, ruined pillboxes pointed across lagoons at rusting landing craft, impaled and resting on their roofs. Remnants of Japanese buildings and shacks cobbled together of used wood and metal served as homes for the Saipanese, who drove to work—government jobs, mostly—in war surplus jeeps that the U.S. forces had left behind.

Morbid as this may sound, Saipan was an easy place to fall in love with in the 1960s: It begged a newcomer to go exploring and get to know it. Villages were concentrated along a beach on the west side, which left miles of coastline open to solitary rambles. A rocky, forbidding shore lay on the far side of Saipan, and half a dozen secret beaches were guaranteed private and unforgettably fine. The deep interior of the island beckoned

hikers to obscure ridges, abandoned fortifications, and overgrown plantations that no one had visited for years. On the grounds of the plantations, tools lay rusting, toads colonized rainwater cisterns, and gardens had gone to seed.

Up and down Saipan's invasion beach, weekend barbecues abounded on a grassy shoulder just above the sand, in the shade of soft-needled pines. Try to picture marinated ribs and chicken, placed on a grill or a piece of corrugated roofing and doused with beer when flames licked too high. Imagine piles of saffron rice, beer by the case, conversations stretching past spectacular sunsets and into the extra-starry night. Think of war stories, peace stories, family feuds, island politics, and gossip. Imagine parties that might adjourn to a half-dozen roadhouses, where people whispered, argued, joked, and sang while jukeboxes that were time capsules offered "You Are My Sunshine" and other songs from the 1940s. How could you not fall in love with such a place? If you left it, how could you not dream of going back someday?

You return, you island dreamer, to a place that can break your heart: Saipan has become a Japanese Florida. Now lining the World War II invasion beach is a murderer's row of hotels. Roads, clogged with cars, have traffic lights, and they run past a host of duty-free shopping centers, tourist shops, franchise food outlets, and gaming parlors with hungry poker-playing machines. There are also garment factories and barracks that are filled with foreign workers. The island's population, mostly foreign-born, currently stands at about 70,000 and includes Filipinos, Bangladeshi farmers, Russian prostitutes, and Chinese merchants. All the newcomers have dreams, too—perhaps more dreams than a small island can accommodate.

If you look around Saipan, you can still find old friends, but they are fewer than before and seemingly more distant, even with each other. The once tight weave of life has loosened and begun to fray. More crowded and less intimate, the island is now more continental than insular. And what is true of Saipan may be true of Grand Cayman, Key West, Bora Bora, Maui, and any other island in the world. Some of the things that once captured you remain, but it is difficult to know if they would be enough to capture you again. One thing is certain, though: The sea and the tides, the sunrises and sunsets, and the chance to consider life in a small place—even if it's more complicated—are still powerful attractions. That should be enough to keep the dreamers coming.

OCEANS
& ISLES | SCAPES

The oceans' diadems, Earth's islands range in size from the continental landmass of Australia to smaller isles of volcanic origin, such as those of French Polynesia. Islands reflect the dual influences of the sea, which can both isolate species to a speck of land and also disseminate life. Scientists speculate that fruit from the baobab tree, for example, drifted from Madagascar across the Indian Ocean to Australia about 75 million years ago, resulting in the boab trees that flourish today on the island continent.

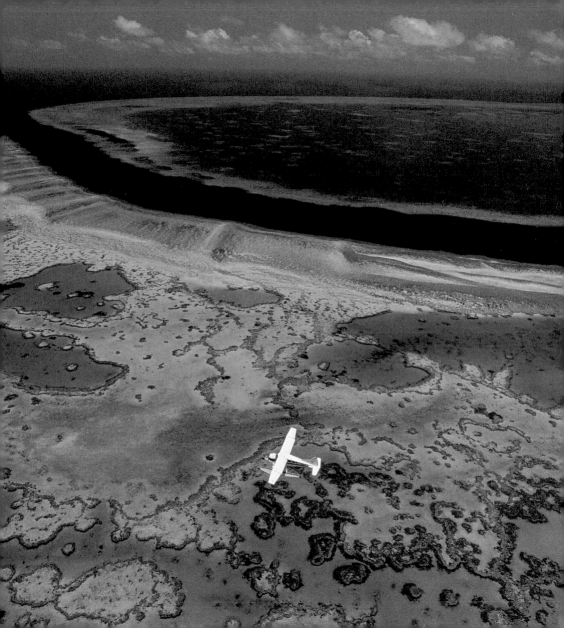

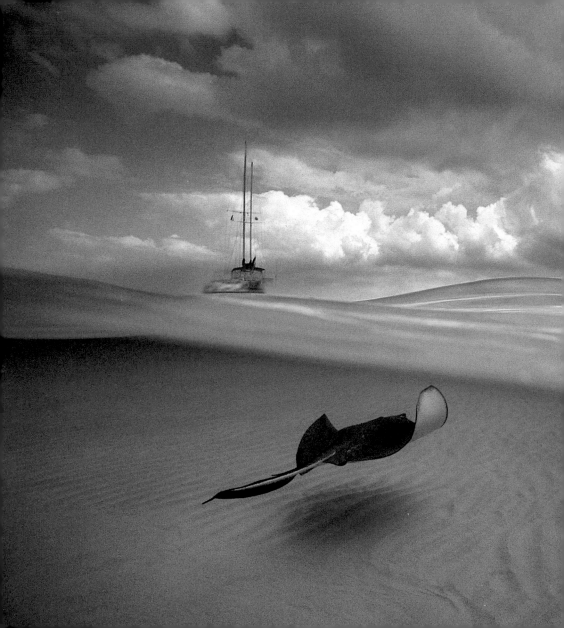

DAVID DOUBILET | 2001
PAGES 388-9: Australia's Great Barrier Reef—actually a group of more than 2,800 reefs—supports a diversity of species rivaled only by that of tropical rain forests.

HERBERT E. GREGORY | 1916
PRECEDING PAGES: Visitors marvel at a chasm seen from atop 4,070-foot Bald Mountain in south Queensland, Australia.

DAVID DOUBILET | 2000
LEFT: A stingray flaps its fins like wings in the sky-clear waters of North Sound, off Grand Cayman Island.

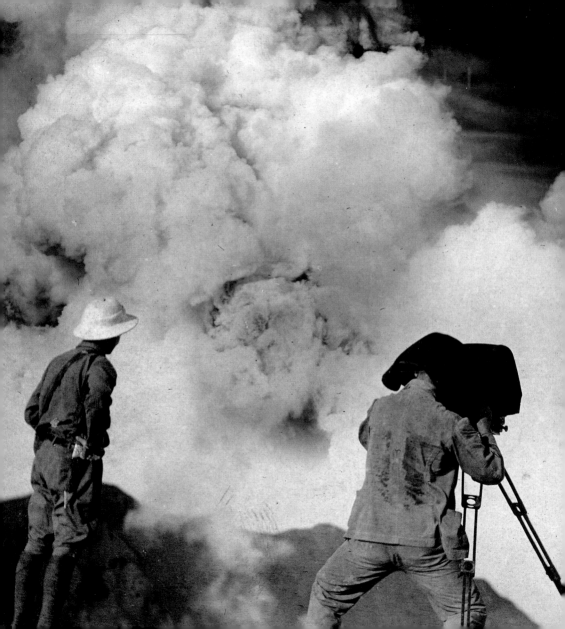

A photographer and geologist from the Philippine Bureau of Science get an up-close look at the erupting Taal Volcano.

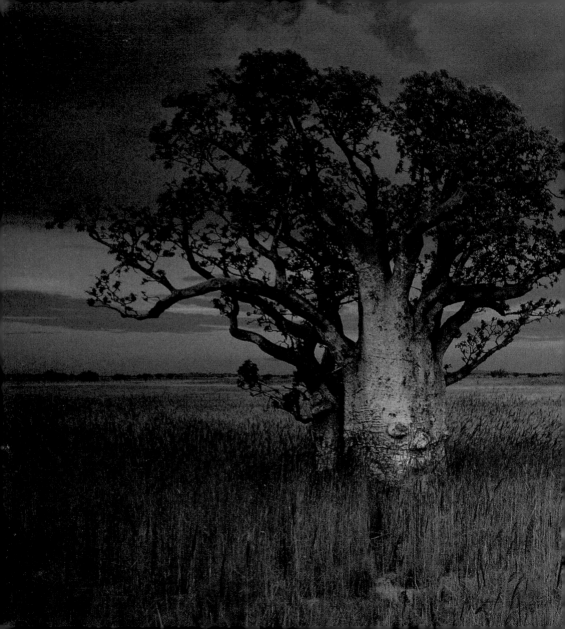

SAM ABELL | 1991

PRECEDING PAGES: Boab trees near Australia's
northwest coast may descend from plants
that took root there 75 million years ago.

DAVID DOUBILET | 2002

RIGHT: In False Bay at Cape Town, South
Africa, giant Atlantic kelp grow like tree
trunks in a garden of sea urchins.

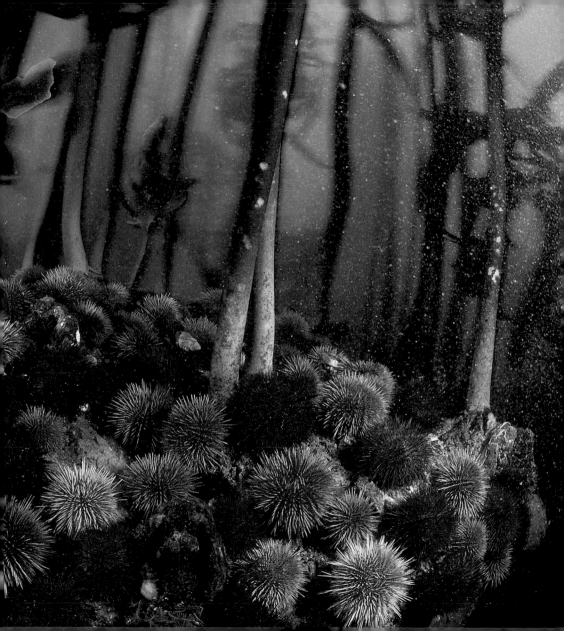

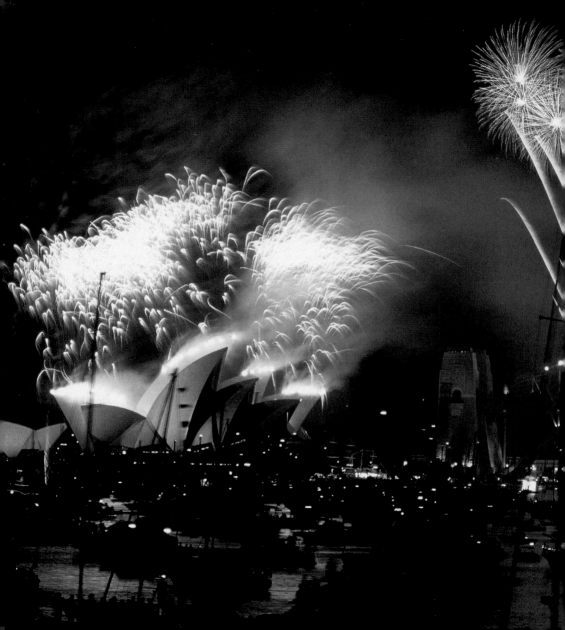

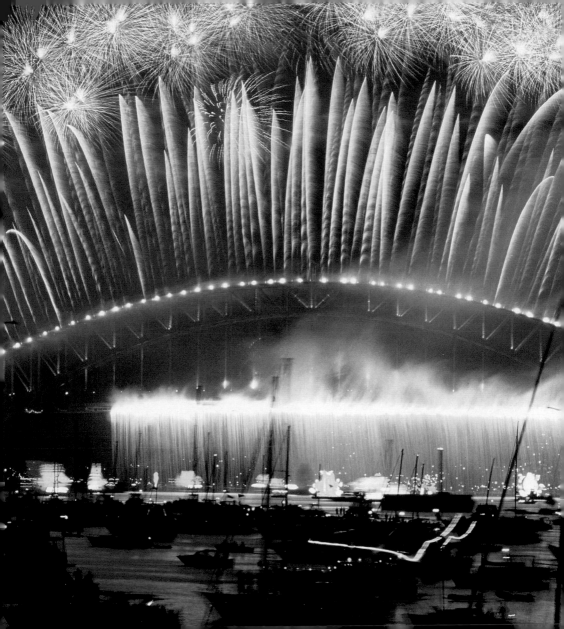

ANNIE GRIFFITHS BELT | 2000

PRECEDING PAGES: Australia welcomes
the New Year with a spectacular fireworks
display, lighting up Sydney Harbour and
the renowned Opera House.

CARY WOLINSKY | 1982

RIGHT: A runner's tracks add yet another
element to the sand-and-surf patterns on
Cottesloe Beach in Perth, Australia.

EMORY KRISTOF | 1991

Bearded in rust, the prow of R.M.S. *Titanic* rests two and a half miles below the surface of the North Atlantic.

FRANS LANTING | 2002

FOLLOWING PAGES: Bull kelp clings to the Snares Islands coastline, hiding sea lions that prey on Snares crested penguins.

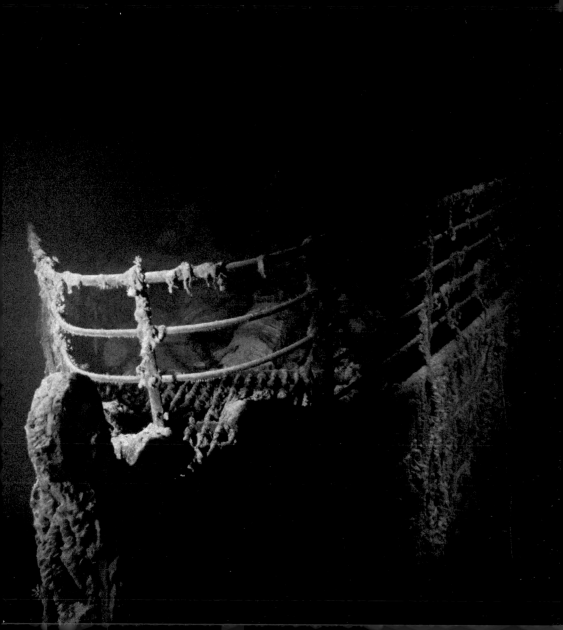

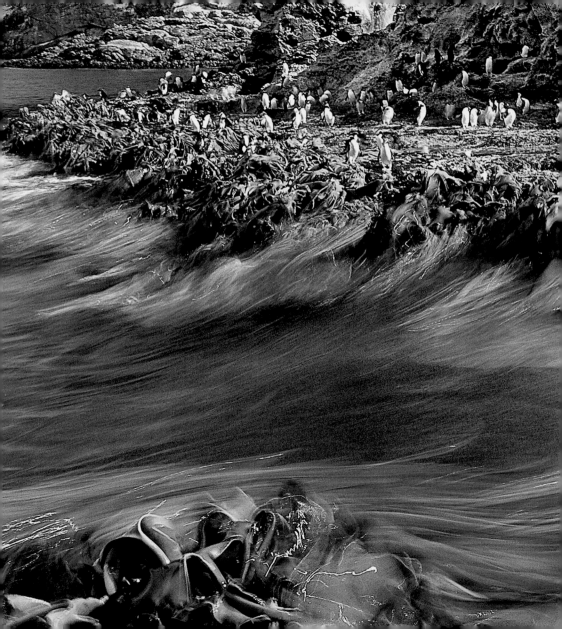

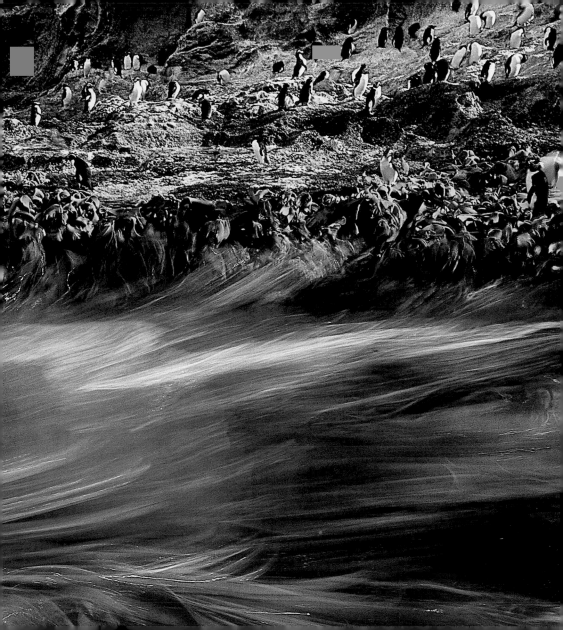

"The shallow, sunlit seas are the essence of life," says NATIONAL GEOGRAPHIC photographer-in-residence David Doubilet, one of the world's preeminent underwater photographers. "They are some of the most—if not the most—beautiful places on our planet." Home to myriad fascinating creatures, from tiny seahorses to mighty humpback whales, the seas also nurture land animals like the Snares crested penguins. This species nests in the lush forests of New Zealand's Snares Islands.

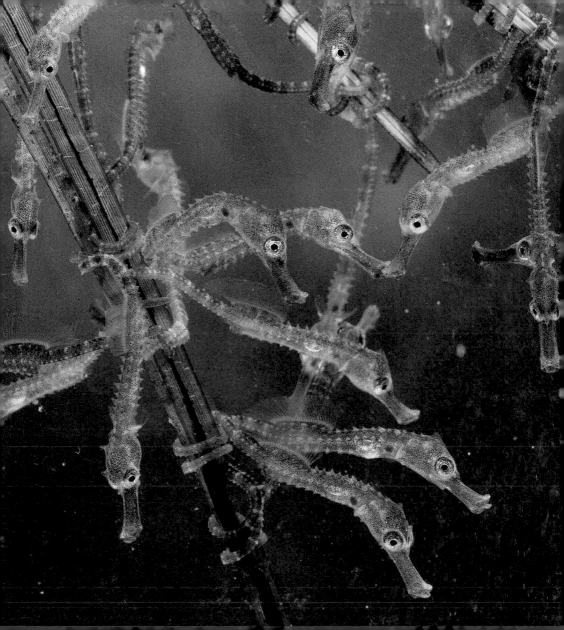

GEORGE GRALL | 1994

PAGES 408-409: Anchored to twigs and grasses by their tails, tiny sea horses drift with the currents in waters off Australia.

BILL CURTSINGER | 1994

OPPOSITE: A hatchling hurries away from its birth beach in Michoacán, Mexico, a major nesting site for black turtles.

DAVID DOUBILET | 2000

PRECEDING PAGES: Small fish seek safety amid the kinks, frills, and tentacles of jellyfish in the Tasman Sea.

FRANS LANTING | 2002

RIGHT: Like an amiable group of theater-goers, crested penguins queue up in the Snares Islands of New Zealand.

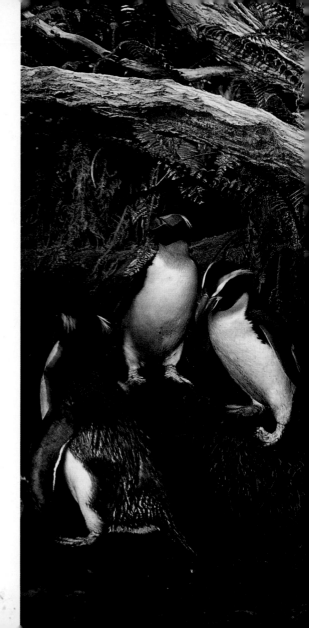

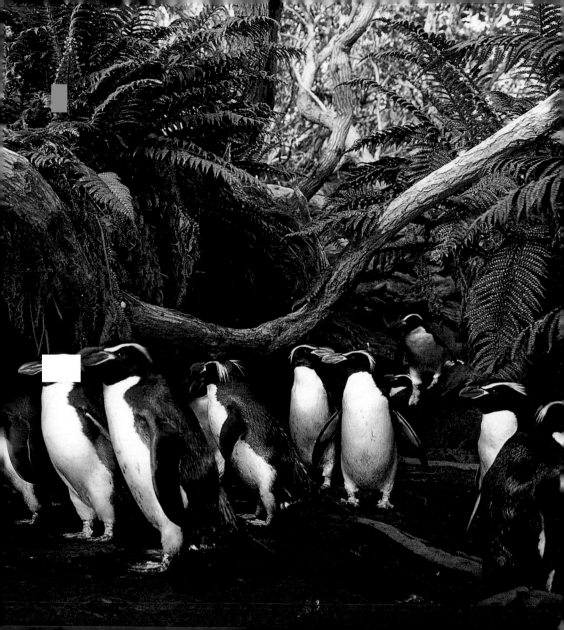

FLIP NICKLIN | 1998
Snorkelers surround a manta ray, a friendly
member of the shark family, in the Flower
Garden Banks of the Gulf of Mexico.

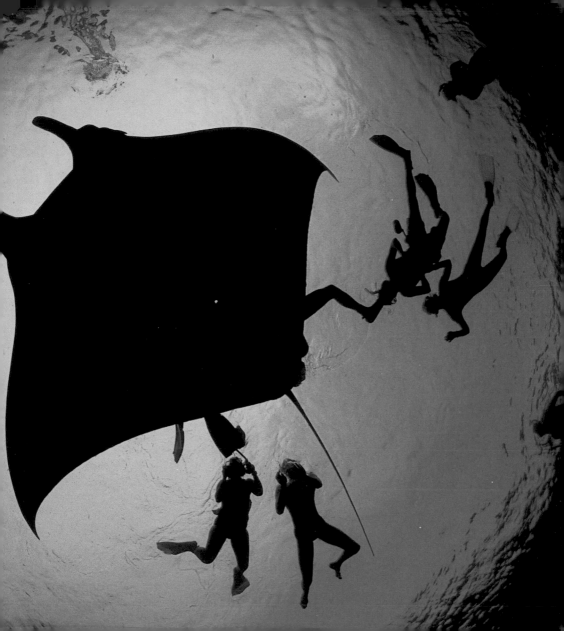

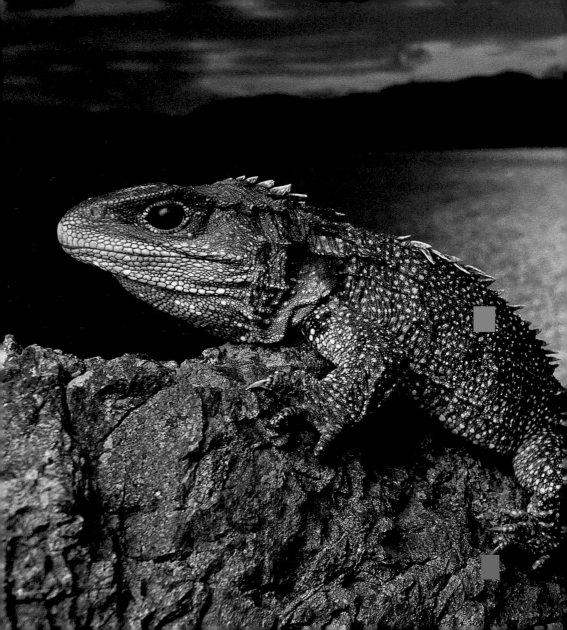

FRANS LANTING | 2002

The tuatara, whose name means "dorsal spine" in Maori, grows up to two and a half feet long and lives only in New Zealand.

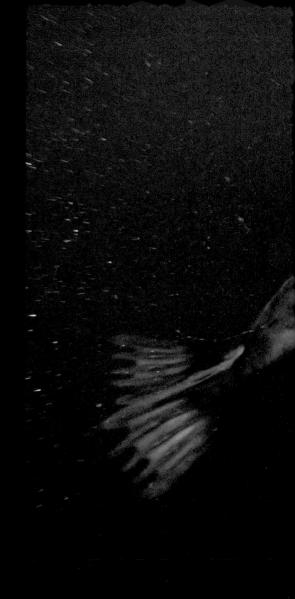

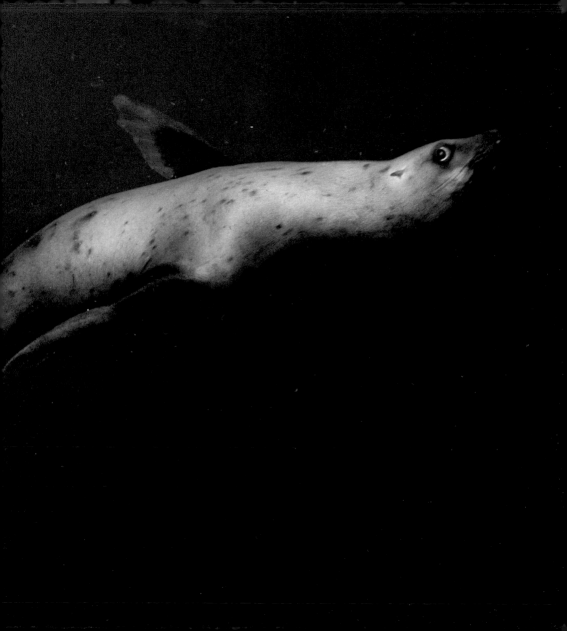

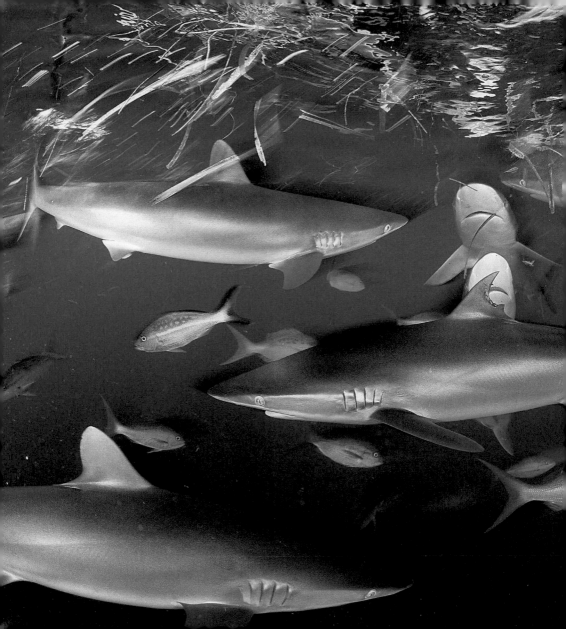

DAVID DOUBILET | 2002
Sharks and yellowtail snappers feed
on scraps tossed from a dive boat.

JAY DICKMAN | 1994

Hunting dogs in Papua New Guinea make
a meal of a northern cassowary, a flightless
bird they cornered and killed.

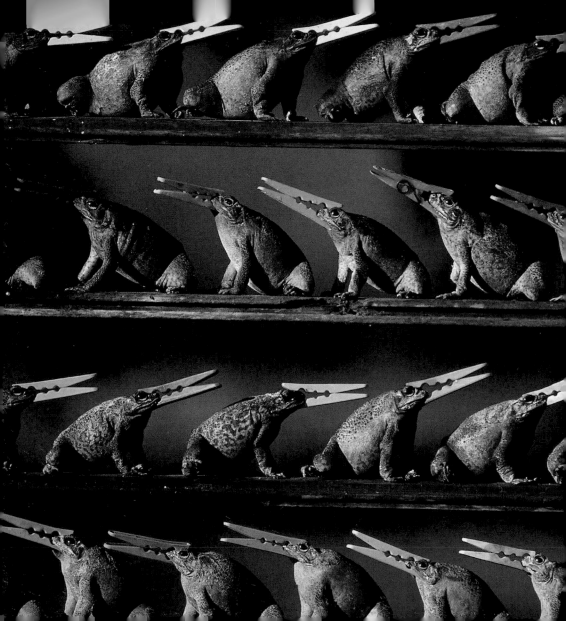

CARY WOLINSKY | 2000
Clothespins keep wet plaster in place while dead cane toads dry in a taxidermy shop in Queensland, Australia.

Near Stellwagen Bank, in the Atlantic off
Massachusetts Bay, a humpback whale may
eat as much as a ton of food in one day.

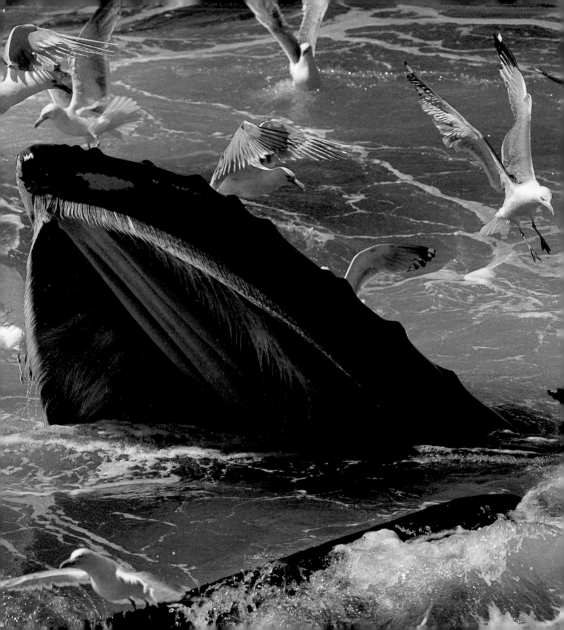

OCEANS & ISLES | TRADITIONS

Worlds unto themselves, isolated islands have often engendered unique traditions, from ecstatic carnival revelry to more ferocious practices. Describing an encounter with cannibals in the September 1929 NATIONAL GEOGRAPHIC, E.W. Brandes wrote, "Neolithic man has not vanished entirely. I found him…in the remote jungles of New Guinea and was mistaken for a god!" He termed the island a "strange land…of coconuts, cannibals, and sorcery." Other isles preserve more civilized traditions, like the friendly welcome visitors receive on Easter Island.

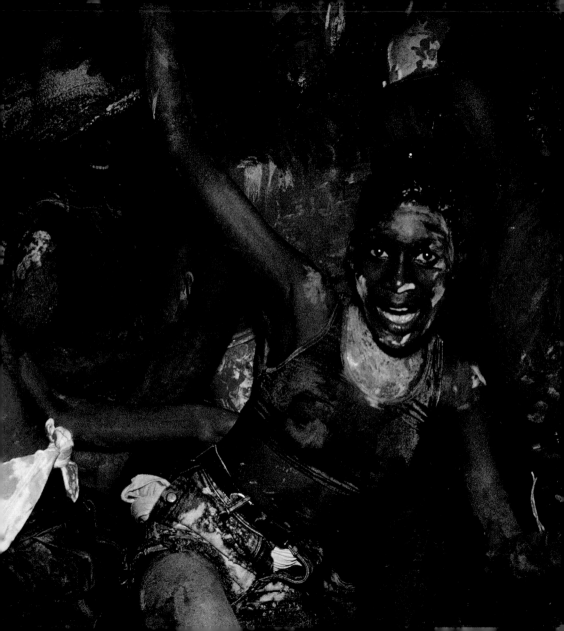

DAVID ALAN HARVEY | 1994
PRECEDING PAGES: Mud-streaked revelers dance the night away during Carnival in Port of Spain, Trinidad.

PENNY TWEEDIE | 1980
RIGHT: Aboriginal boys in Arnhem Land, Australia, wait for a circumcision ceremony to begin. Their white face paint signifies potency, death, and rebirth.

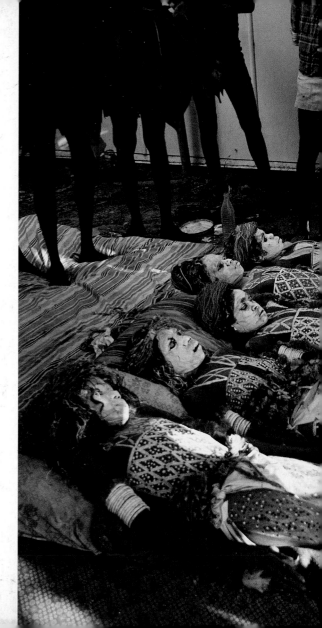

F.J. KIRSCHBAUM | 1929

Cannibals undergo bloody and dangerous
tribal initiation rites near the Sepik River in
Papua New Guinea.

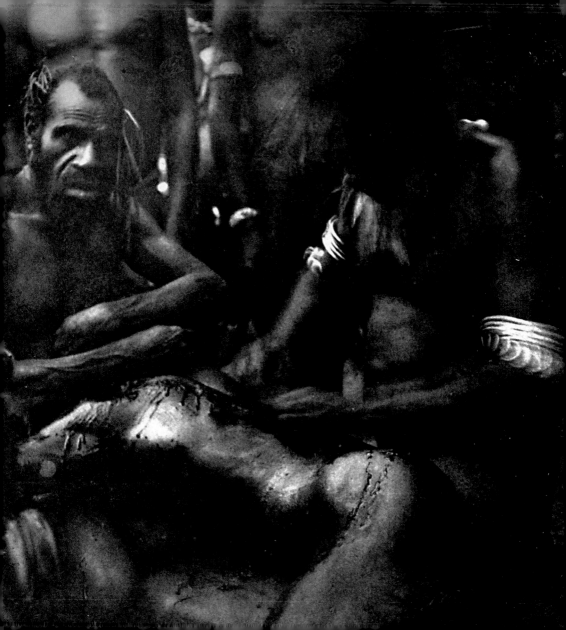

BOB SACHA | 1993

Easter Islanders
get ready to extend a warm Polynesian
greeting to recently arrived visitors.

CAPT. FRANK HURLEY | 1927

OPPOSITE: In Urama, Papua New Guinea,
tribal elders wear goblin masks to perform
certain ceremonial functions.

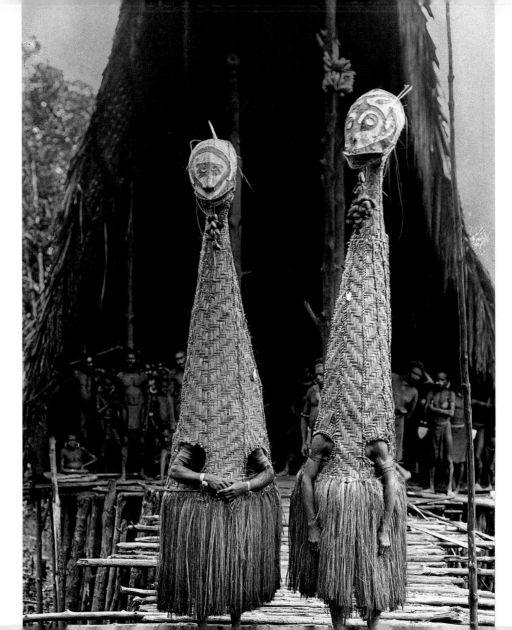

OCEANS & ISLES | RECREATION

I slands have long conjured up notions of escape. For French Postimpressionist painter Paul Gauguin, Tahiti in the 19th century held the magic to inspire his art. Today's dreamers will often settle for a week on a crowded beach in some sunny "paradise." Vacationers' demands for island getaways have distorted the economies and cultures of many islands, although for others, tourist dollars have actually helped resurrect neglected traditions, such as live performances of traditional songs and dances.

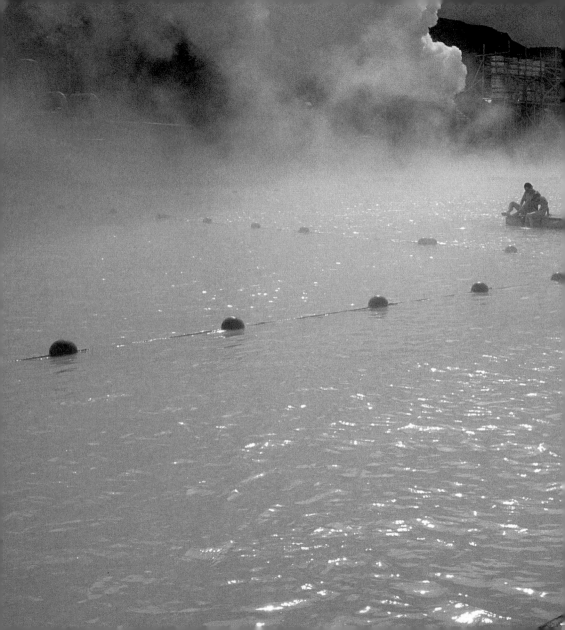

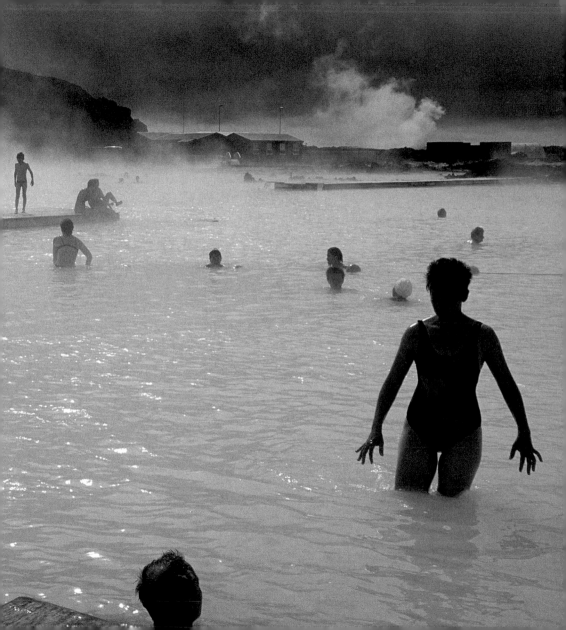

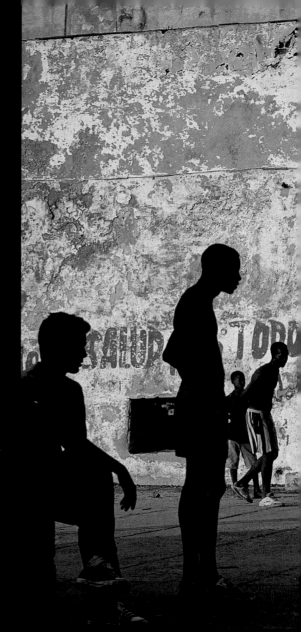

ANNIE GRIFFITHS BELT | 2000
PAGES 440-41: Sunbathers on Bondi Beach in Sydney, Australia, bask in the warmth of a Southern Hemisphere Christmas.

SISSE BRIMBERG | 2000
PRECEDING PAGES: Despite the chilly air, bathers in Iceland keep warm in a thermal spring dubbed the Blue Lagoon.

DAVID ALAN HARVEY | 1999
RIGHT: Havana residents play a pickup game of baseball—one of Cuba's most popular American imports.

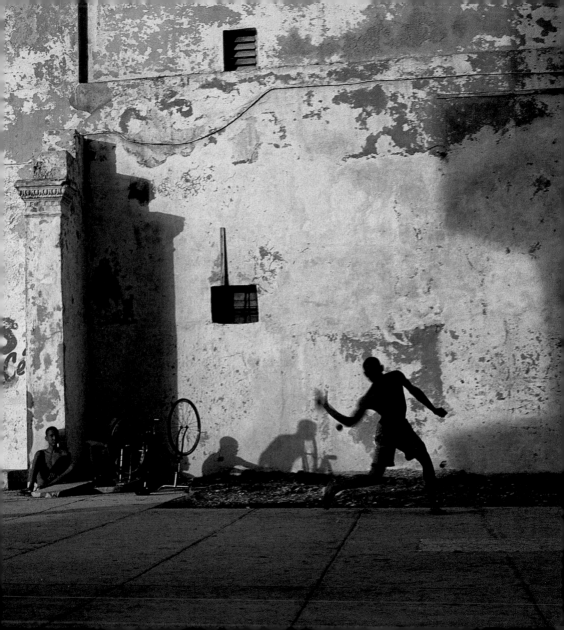

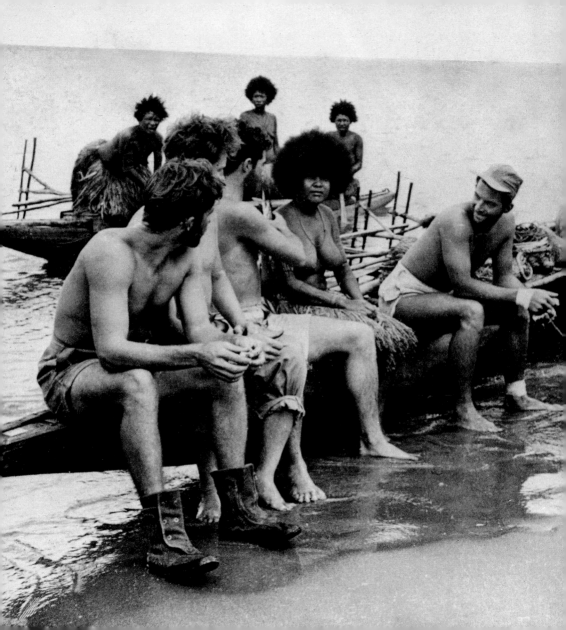

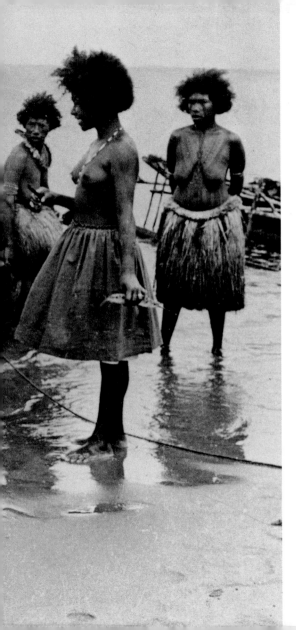

JOE MCNALLY | 2000
PRECEDING PAGES: Off the Kona coast of Hawaii, elite swimmers compete in the 2.4-mile leg of the 1999 Ironman Triathlon.

INTERNATIONAL NEWS | 1943
LEFT: World War II fliers enjoy local company while they wait for their damaged aircraft to be repaired.

JODI COBB | 1997
FOLLOWING PAGES: High and dry, a French tourist gets carried ashore after an outrigger cruise in Tahiti.

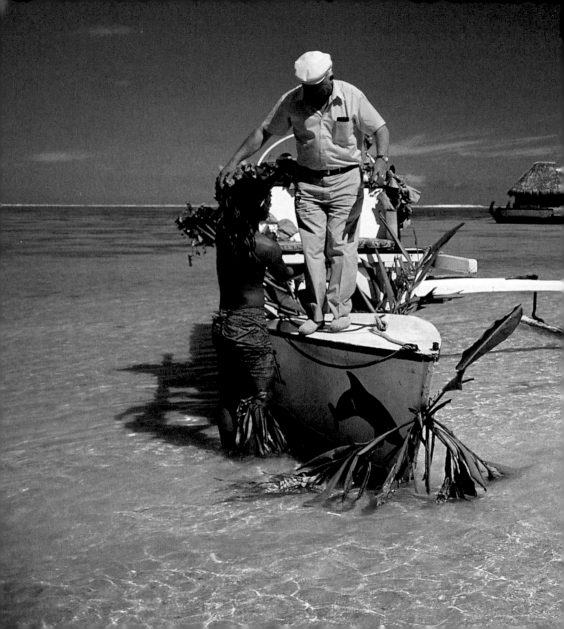

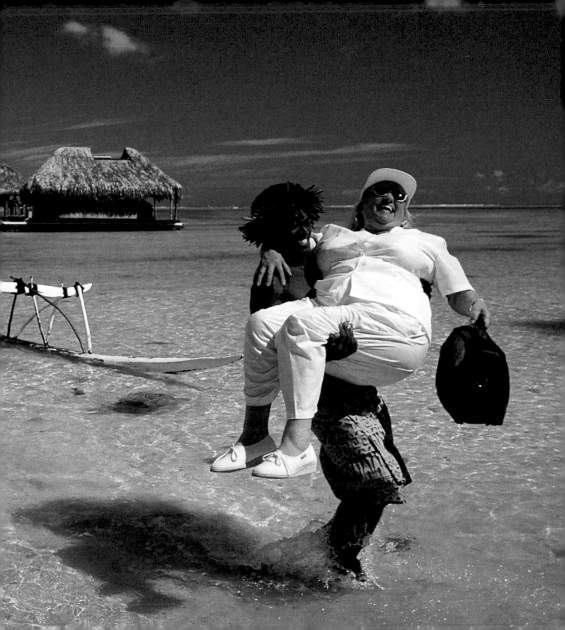

UNIVERSE

TO THE PLANETS AND BEYOND

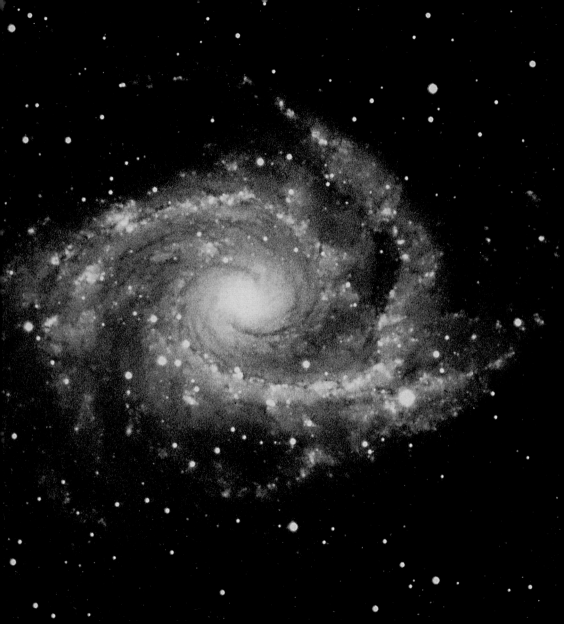

Universe

by Nathan Myhrvold

Millions of years ago our ancestors gazed beyond the lurking dangers of the African savanna and looked up at the night sky to see the stars and planets above them. Strictly speaking, this wasn't a very practical thing to do, for they always had to be on guard against marauding hyenas and scores of other potential threats. Still, the sky held the same irresistible fascination for our forebears as it does for us today: Earth is where we live, but space has always been home for our imagination.

Throughout history, humankind has been drawn to space. Its inky blackness was not an empty place for our ancestors; instead, it was a canvas for their myths and a stage on which their gods held forth. The cosmos wasn't a remote or distant place either; it was as close as their stories and as real as their understanding of the world.

Every culture has a creation myth that tries to explain where the stars come from. For the Navajo, the Milky Way was formed when Coyote stole a piece of bread from the First Man and First Woman, scattering

ANGLO-AUSTRALIAN OBSERVATORY/DAVID MALIN | 2000
PAGE 454: Whirling millions of light-years from Earth, Galaxy NGC 2997
resembles our own spiral galaxy—the Milky Way.

crumbs across the sky. The priests of Samoa knew our home galaxy as the belly of Riiki the Great Eel, who lay across the sky after helping Nareau lift the heavens from the sea. Other legends are equally charming; a particularly common theme among Native American tribes is that meteors are in fact feces of the stars. As quaint as these stories may seem, they are not far removed from some of the traditions of larger cultures. The term "Milky Way" comes from a Greek myth in which Hera, queen of the Olympian gods, sprays her breast milk across the sky, thus creating the broad band of light we see in the heavens.

Artists who created spectacular cave paintings in France 15,000 to 17,000 years ago certainly were among the starstruck. On a cave wall at Lascaux, just above the magnificent paintings of animals, is what most scholars agree is a drawing of the Pleiades—a tight cluster of stars in the northern sky. Hundreds of feet from any view of the sky, in a dark cave illuminated by the flicker of oil lamps, an intrepid man or woman created the first pictorial art—and the first recorded astronomical image.

The same fascination with the heavens led the Anasazi people of ancient New Mexico to construct the great kiva of Casa Rinconada at Chaco Canyon. Astronomy was very important to the Anasazi, and the kiva is thought to be a physical model of the Anasazi cosmos. The shape matches the sky, and its axis is oriented nearly perfectly to true north, deviating by less than a degree. The precision of the ancient builders can easily be seen in a nighttime photograph, which captures star trails centered over the kiva.

Near Casa Rinconada is the famous "sun dagger," which was featured in the November 1982 and June 1990 issues of NATIONAL GEOGRAPHIC magazine. A narrow slit in slabs of rock atop a mesa casts a beam of light from the sun. The resulting dagger of light makes its way across a rock wall on which is carved a spiral petroglyph—forming not only a clock but a calendar that marks the position of the sun between each solstice.

For many years, the solar connection was thought to be the entire story. But then a NATIONAL GEOGRAPHIC photographer noticed more grooves carved on the rock wall. These additional carvings have been found to serve another function: When the full moon reaches its maximum northern extent, a beam of moonlight illuminates the upper groove; when the moon is in its most southerly position, 9.3 years later, it illuminates the lower groove. Astronomers know this as the 18.6-year Metonic cycle. How many centuries did the people of Chaco look to the heavens to figure this out? Measured against the average Stone Age life expectancy, just one cycle was half a lifetime. Many generations must have cooperated in the endeavor, passing along the details as oral tradition.

Early astronomers had only their eyes and minds as tools. Instruments were, at best, about measuring angles, not seeing the heavens with greater clarity. Galileo was the first astronomer

to use a telescope, and his work transformed astronomy into a science of images. The telescope was a great step, but it was limited by two things: the sensitivity of human eyes and the fact that only one person at a time could use it. Photography removed these constraints, capturing light too faint for eyes alone to see and letting astronomers share distant views with the world. The images in this book are testaments to the power of photography.

Today we map the heavens with great observatories that mimic the shape and orientation of Casa Rinconada. The state of the art in optical telescopes is epitomized by the Keck Observatory, in Hawaii, and the Starfire optical range, in New Mexico, both pictured in this chapter. These facilities use a technique called adaptive optics, seen in action in the Starfire photo. Rather than just passively observing, they shine powerful lasers upward to probe for turbulence in the atmosphere. The turbulence can be compensated for, thus yielding a clearer picture.

Visible light isn't our only means of looking skyward: The heavens fairly hum with microwaves and radio emissions. A few hundred miles from Starfire and Casa Rinconada is the Very Large Array (VLA) radio telescope. One of the premier radio telescopes in the world, the VLA comprises 27 giant dishes, each about the same diameter as the great kiva. The array is scattered across 21 miles so that data from distant dishes can be combined into a virtual instrument of great power resolution. A hemisphere away, the Molonglo radio telescope in Australia uses sheer size—it is nearly a mile long—to boost its power.

A top modern telescope in the Keck or VLA class can easily cost a hundred million dollars and require a decade or more to design and construct. Even so, in relative terms this is just a drop in the bucket compared with the resources 11th-century Chacoans put into the great kiva.

The drive to understand the cosmos is part emotional and part rational, and over time the mythological aspects of the sky have taken a back seat to what we now recognize as science. Today astronomy is one of the "pure" sciences, but it once was driven by practical applications. Few things mattered more to agricultural societies than their ability to predict the seasons of the year.

The ancient Egyptians settled on a 365-day year, probably by 4228 B.C. The Chinese got to the value of 365.2502 by 104 B.C. (today the value is known to be 365.2429). Meanwhile in the Americas, the Maya independently calculated the length of the year as 365.2420 days, a remarkably accurate figure given their relative lack of technology. Humankind's desire to master the movements of the heavens inspired the birth and evolution of mathematics. In fact, the calculations made by the Maya drove them to create a concept so basic that it is hard to believe it was a major innovation: They invented "zero."

Reeling off the length of a year to several decimal places makes this enterprise seem like a dry and nerdy task, but that hardly conveys its

importance and its difficulty. Planting crops at the wrong time could ruin harvests and starve thousands. If the value for the length of the year is off by one percent, then in just eight years dates are wrong by one month. In fifty years, the calendar is six months out of date. Achieving accuracy wasn't easy for the ancients, who had to make tens of thousands of observations—and without the aid of modern technology. Many lifetimes of work by Stone Age astronomers and mathematicians lay behind their calculations, which have to rank among the most outstanding intellectual achievements of all time.

The invention of astronomy and mathematics started a wave of intellectual change that gained momentum with each new discovery. In 585 B.C., Thales of Miletus, in what is now Turkey, was the first person to predict a solar eclipse. Today, we confidently and routinely forecast eclipses, but we are still struck by the wonder of these spectacular phenomena. We are fascinated and amazed; the ancients were terrified. Taming an eclipse by understanding its cause and predicting its date and time was another milestone in our intellectual conquest of the cosmos.

One might think that the increasing understanding of what we now call outer space would have lessened its emotional impact on us, but that isn't how things have turned out. The cosmos has long been a cornerstone of cultural beliefs, and it will not yield its position easily. As new knowledge has threatened old beliefs, violent reactions have often occurred.

In the early 17th century, Galileo was arrested, tortured, and forced to recant by church officials—because he popularized an astronomical theory by Copernicus. Giordano Bruno, a Galileo contemporary, wasn't so lucky. Bruno supported the Copernican theory and went even further, suggesting that the "innumerable" stars each contained Earthlike worlds that were inhabited by intelligent beings. Today, we would recognize him as a kindred spirit to Carl Sagan, but in Renaissance Rome the Inquisition held a different view. Bruno was taken to the Piazza Campo di Fiore, tied to a stake, and burned alive.

What made an astronomical theory important enough to warrant killing someone? The answer is that space, despite its physical distance, has never been far from our hearts and minds. Humans, and by extension the planet Earth, were once thought to be the center of the universe. But Copernicus and his followers said no, the universe is a messy and dynamic place, and Earth is a bit player that revolves around the sun. Faith in an immutable cosmos was thought to be the bedrock of society itself. If people could challenge these divine truths, where would it all lead? Arguments about planetary orbits and life on other worlds weren't arcane issues of science; they were matters of life and death.

As crazy as it sounds, we are not that different today. We would never think of condemning a person to burn at the stake in the name of astronomy. Yet when astronauts go into space, they voluntarily risk this very fate. We may not kill over space, but we are willing to die for it.

This book's stunning photograph of the space shuttle *Columbia,* taking off at dawn, captures both the majesty of the accomplishment and the potential danger for astronauts, who must sit atop 500,000 gallons of rocket fuel. Four years after the photo was taken, a similar launch of the shuttle's sister ship *Challenger* turned into a pyre for her crew, as Apollo 1 had years before. Ultimately, after 28 successful missions in space, a terrible fate also befell *Columbia*, which exploded during reentry in 2003.

The very real risk of a flaming death is only part of the price. Years of training are also required. Gut-wrenching training flights simulate weightlessness, and hours spent underwater let astronauts practice working in space. Painstaking work and drudgery are necessary preludes to the glamorous and risky time spent off our planet.

Is the exploration of space important enough to warrant this price? "Yes" is the answer that we have given as a society, but this response is too easy for us to give, because we will never have to pay the ultimate price ourselves. The astronauts are in a better position to judge, and their answer is clear. The promise of the cosmos is more than worth the sweat and blood it requires.

The sacrifices willingly made by astronauts have yielded a rich bounty, some of it shown in the pages of this book. We no longer think of the moon as a spot of light hitting grooves on a rock in New Mexico; we think of it as a world of mountains and craters where Gene Cernan and others have gone exploring in lunar rovers. Jupiter isn't just a bright speck in the night sky. A photo from a NASA probe shows the planet's Great Red Spot as a turbulent riot of color. Venus has also revealed itself to spacecraft in ways it never could to observers on the ground.

Besides showing us the wonders of the universe, these images and the quest to obtain them reflect powerfully on ourselves. It has often been argued that the most important thing the Apollo program brought back to Earth wasn't a moon rock; instead, it was the photograph of Earth rising above the moon. This image and its kin graphically gave the human race an entirely new perspective on our world—both literally and psychologically. Indeed, the truths we have learned about the universe are more beautiful, terrifying, and challenging than any myth. In that difference lies the contribution that these images make to our civilization.

Copernicus started our slippery slide away from the center of the universe to a more mundane but realistic place in the cosmos. The earthrise photo graphically marks the end of the line, showing Earth as a small but precious oasis in a vast universe. Some people once killed to try to stop this idea; then others risked their lives to explore its truth. The next challenge is for humanity to drive the lesson home and see our new appreciation reflected in our stewardship of a small, finite, and fragile Earth.

UNIVERSE | BEYOND EARTH

After viewing Earth from the moon, Apollo 17 astronaut Harrison H. Schmitt observed, "That fragile piece of blue with its ancient rafts of life will continue to be man's home as he journeys ever farther in the solar system." And so we have gone farther since those words appeared in the September 1973 NATIONAL GEOGRAPHIC, although now we often use surrogates in our explorations. Voyagers I and II captured brilliant images of the outer planets, and the Hubble Space Telescope amazes us with breathtaking views of deep space.

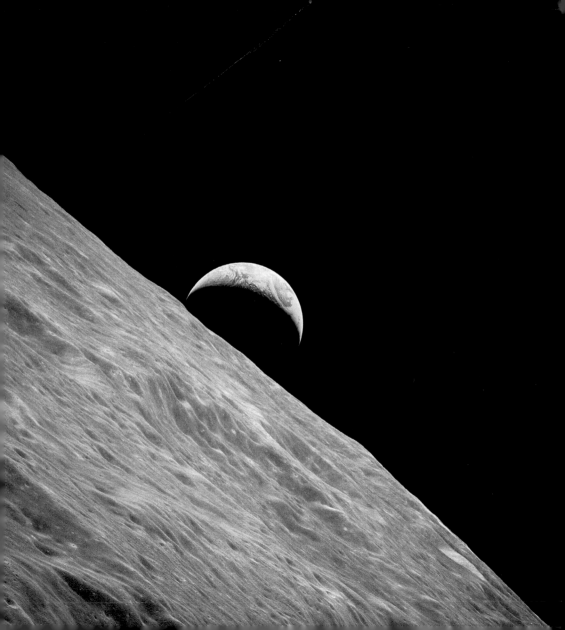

NASA | 1973

PAGES 460-61: Apollo 17 astronauts, in orbit around the moon, photographed a crescent Earth rising in the lunar sky.

NASA | 1996

OPPOSITE: Astronauts aboard the space shuttle *Discovery* observed a massive volcanic eruption in Papua New Guinea.

ANGLO-AUSTRALIAN
OBSERVATORY/DAVID
MALIN | 1995
Scattered stars amid the Orion
nebula illuminate an evolving cloud
of gas and dust.

DAVID P. ANDERSON/SOUTHERN METHODIST UNIVERSITY | 1993

Venus—a brilliant light in Earth's morning and evening skies—presents a craggy face to the orbiting Magellan spacecraft.

NASA | 1980
Familiar to generations of Jupiter-watchers, the Great Red Spot continues to swirl in the gas giant's atmosphere.

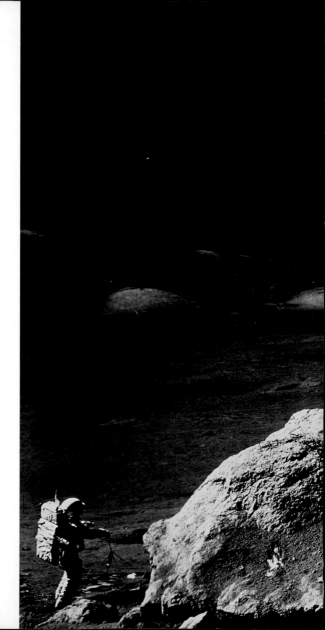

An Apollo 17 astronaut examines enormous lunar boulders resting in a crater at the Taurus-Littrow landing site.

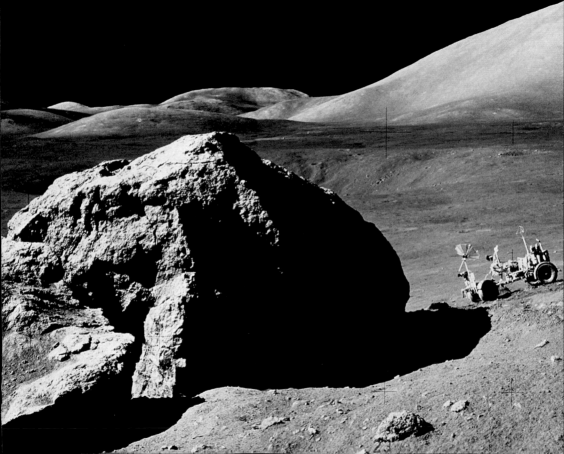

Mankind's long-held dream of shedding its earthly shackles took centuries to realize. Leonardo da Vinci sketched plans for a flying machine around 1500, but it was 1903 before the Wright brothers completed the first sustained powered flight—at Kill Devil Hills near Kitty Hawk, North Carolina. In the past century, the hardware of flight has leapfrogged from fragile winged craft to rockets such as the powerful boosters that hurl the space shuttle into orbit, a liftoff that astronaut John W. Young likened to "riding a fast elevator."

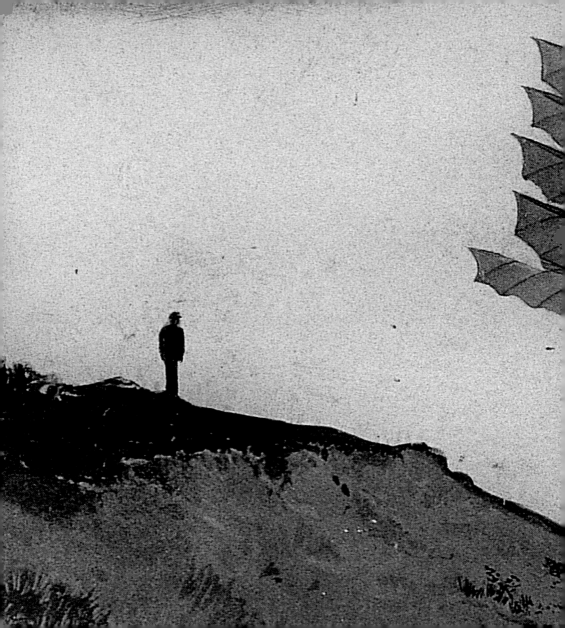

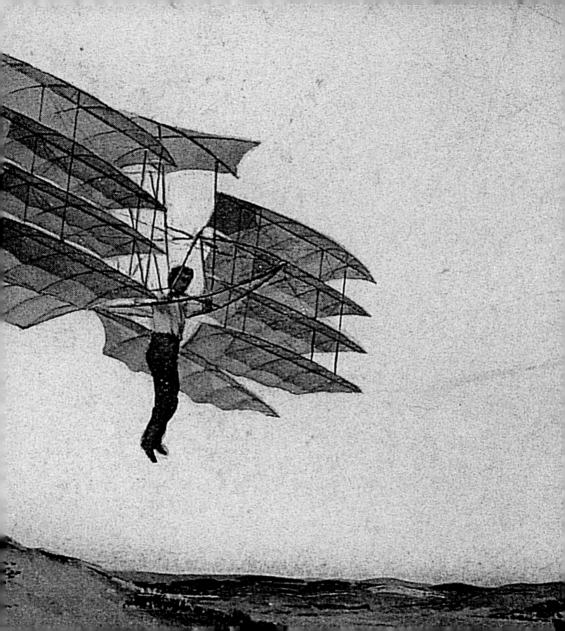

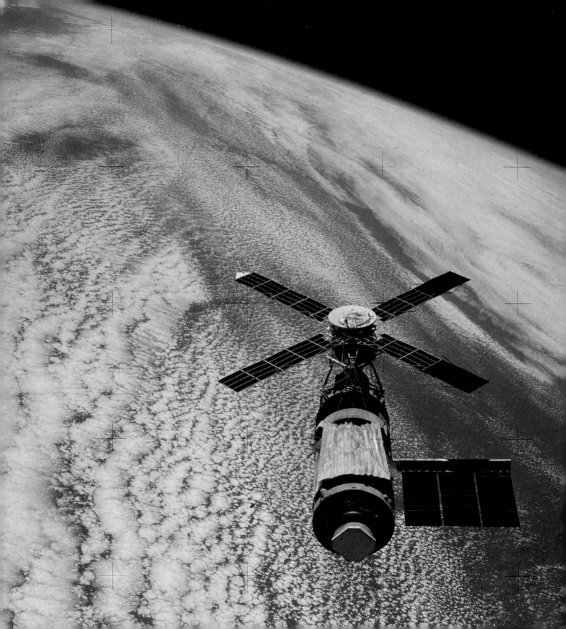

WIDE WORLD PHOTOS | 1960

PAGES 474-5: Two would-be space travelers experience weightlessness aboard a Convair C-131 transport aircraft.

GILBERT H. GROSVENOR | 1907

PRECEDING PAGES: Octave Chanute, a 19th-century American aviation pioneer, designed the multiwinged Katydid glider.

NASA | 1974

LEFT: Skylab, the United States' first manned orbiting laboratory, amassed a wealth of information about the universe.

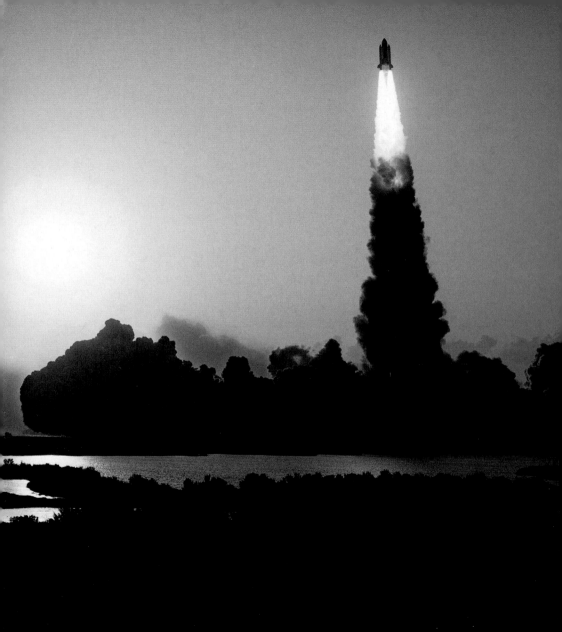

JON SCHNEEBERGER | 1982
The space shuttle *Columbia* lifts off
from the Kennedy Space Center in
Cape Canaveral, Florida.

UNIVERSE | WORK

To meet the challenge of working in the weightless, airless void of space, astronauts train on Earth in sophisticated simulators. During their missions they make use of equipment their predecessors would have marveled at, from onboard computers to satellites and tracking telescopes. Capt. Albert W. Stevens, reporting in the January 1936 NATIONAL GEOGRAPHIC on his historic balloon ascent into the stratosphere, described his airship as "a somewhat messy, crumpled, wrinkled pile of fabric" before it was inflated.

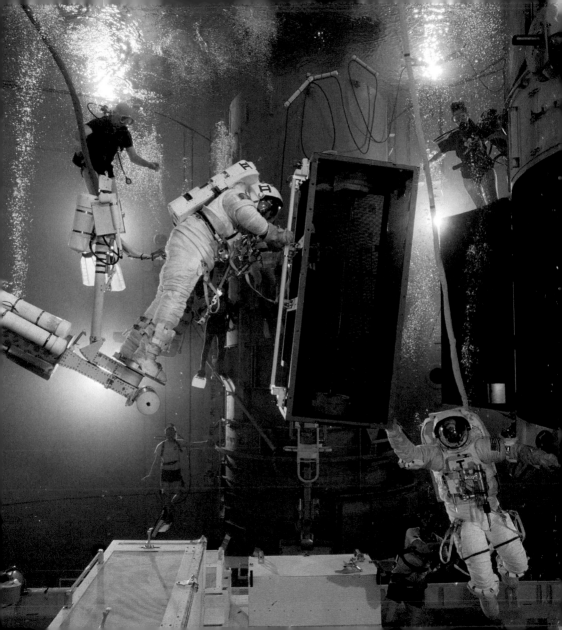

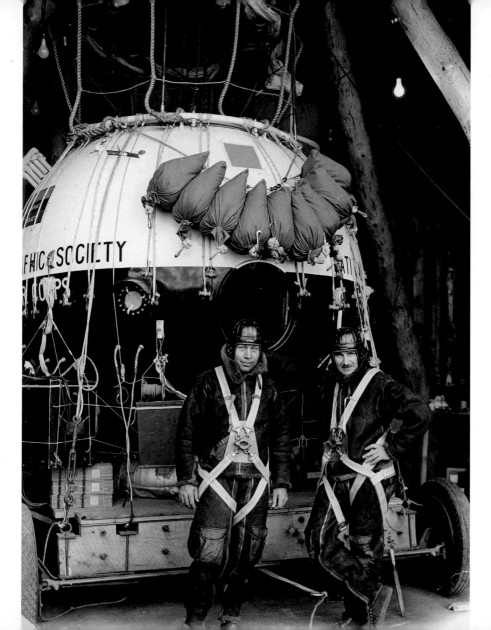

ROGER H. RESSMEYER | 1994

PRECEDING PAGES: Before their mission
to repair the Hubble Space Telescope,
astronauts practiced underwater in NASA's
1.3-million-gallon simulator tank.

RICHARD H. STEWART | 1935

OPPOSITE: In the world's largest balloon,
Captains Albert W. Stevens (right) and
Orvil A. Anderson made a record-breaking
ascent into the stratosphere in 1935.

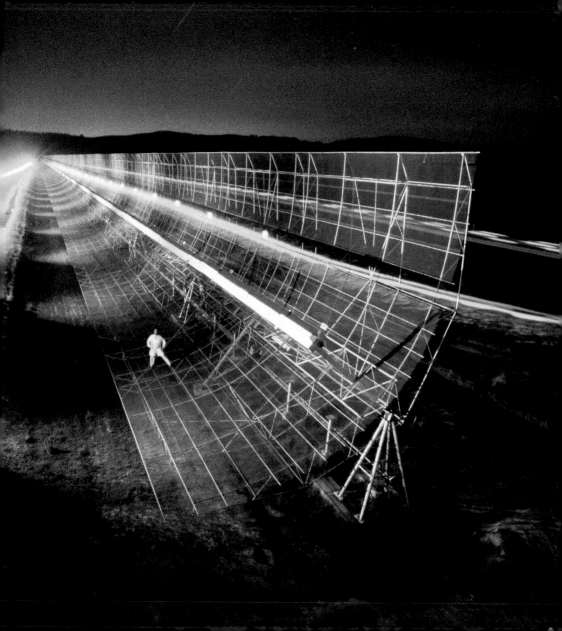

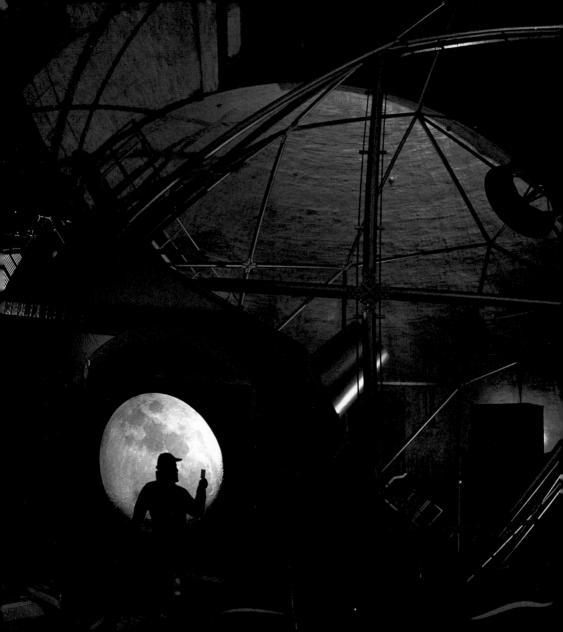

Through the ages, humans have gazed toward the heavens, searching and wondering. Since the invention of the radio telescope in 1937, we have also been listening to the universe. In an article about America's ancient skywatchers in the March 1990 NATIONAL GEOGRAPHIC, John B. Carlson told of the striking astronomical achievements of the Inca, Maya, Anasazi, and other indigenous peoples, for whom "astronomy was not a science.... Rather, the movements of the sun and moon were the journeys of gods personified."

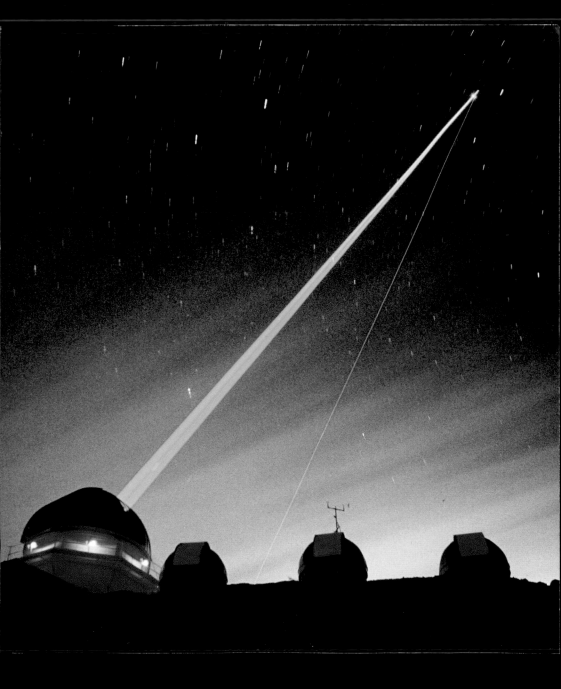

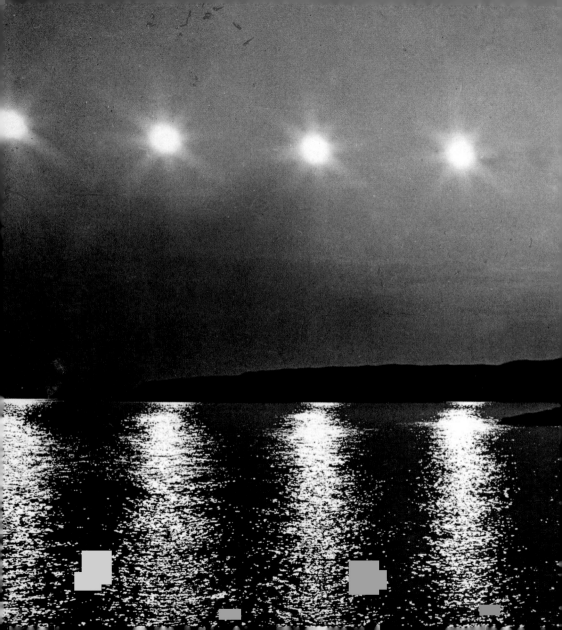

ROGER H. RESSMEYER | 1994
PAGES 490-91: At Starfire Optical Range in New Mexico, lasers measure the distortion of starlight by the atmosphere.

DONALD B. MACMILLAN | 1925
PRECEDING PAGES: Eight exposures on the same photographic plate, made at 20-minute intervals, capture the midnight sun over Littleton Island near Greenland.

WIDE WORLD PHOTOS | 1932
OPPOSITE: Protecting their eyes with crude shades, a crowd watches an eclipse from atop the Empire State Building in New York.

BOB SACHA | 1990

In Chaco Canyon, New Mexico, the great
kiva of Casa Rinconada symbolized the
cosmos for its 11th-century Anasazi builders.

JERRY LODRIGUSS | 1997

FOLLOWING PAGES: A celestial dazzler, Comet
Hale-Bopp delights earthbound observers
in Arizona's Sonoran Desert.

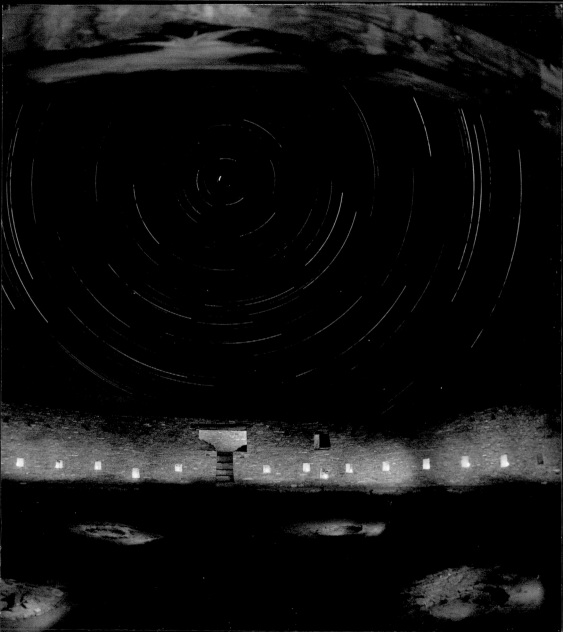

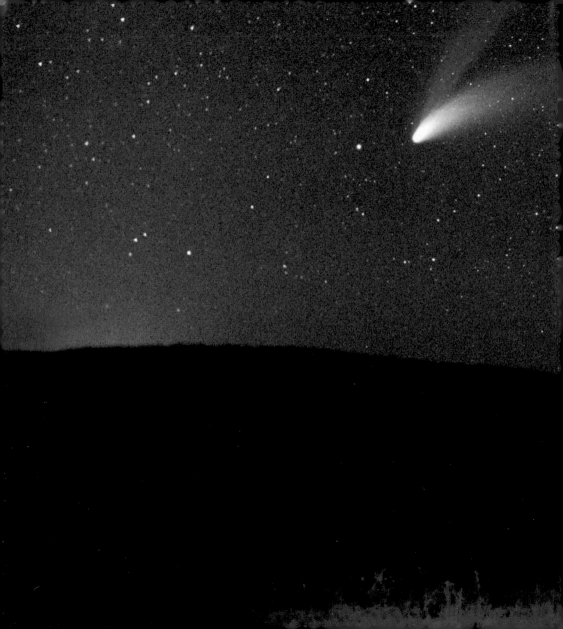

Notes on Authors

Sam Abell's words and photographs have appeared in more than 20 National Geographic articles and books, including *Lewis & Clark: Voyage of Discovery*.

Raphael Kadushin, Humanities Editor at the University of Wisconsin Press, is a contributor to *Bon Appetit* and *National Geographic Traveler* magazines.

P.F. Kluge, a professor and writer-in-residence at Kenyon College, has written for many national magazines, including *Life*, *Smithsonian*, and *Rolling Stone*.

Douglas Bennett Lee, a freelance writer and filmmaker, has lived intermittently in Africa since the GEOGRAPHIC sent him on assignment to Botswana in 1988.

Paul Martin, Executive Editor of *National Geographic Traveler*, has edited or written more than a dozen National Geographic books, and his numerous magazine writing assignments have taken him around the world.

Daisann McLane writes the "Real Travel" column for *National Geographic Traveler* and the "Frugal Traveler" column for the *New York Times*.

Nathan Myhrvold, cofounder and managing director of Intellectual Ventures, has published scientific papers in several journals and contributed stories to *Fortune*, *Time*, and *National Geographic Traveler*.

Notes on Photographers

Carl E. Akeley (1864-1926), one of the first Americans to explore East Africa, became an advocate for protecting mountain gorillas.

William Albert Allard has been a photographer for NATIONAL GEOGRAPHIC for over 35 years; his focus has included Sicily, the Provence region of France, and Peru.

Alexandra Avakian has traveled throughout Africa and the Caribbean. An assignment to cover Gaza was her first for NATIONAL GEOGRAPHIC.

Jose Azel is a regular contributor to NATIONAL GEOGRAPHIC magazine and to many other publications in the U.S. and abroad.

Bruno Barbey, a Morocco-born photojournalist and author, has exhibited extensively in galleries in France and around the world.

Carol Beckwith has written three books on Africa and has made films about the continent for the National Geographic Society.

Annie Griffiths Belt has traveled to such places as Baja California, England, Jerusalem, Australia, and the Pacific on her assignments for the National Geographic Society.

Nathan Benn is the former director of Magnum Photos, a photographer cooperative with more than a million prints and transparencies.

Hiram Bingham (1875-1956) chronicled his 1911 discovery of Machu Picchu, a lost Inca city in Peru, in the pages of NATIONAL GEOGRAPHIC.

James P. Blair joined the NATIONAL GEOGRAPHIC staff in 1962 and over the years covered many countries and topics for the magazine.

Ira Block has worked on GEOGRAPHIC assignments for more than 25 years and is noted for shooting rare archaeological relics from around the world.

Jim Brandenburg, a NATIONAL GEOGRAPHIC photographer since 1978, is noted for having the most photographs ever published in one magazine feature (November 1997).

Sisse Brimberg has contributed to more than 25 stories, including articles on the life of Hans Christian Andersen and the culture of the Vikings.

Horace Bristol was a leading documentary photographer in the 1940s.

W. Douglas Burden proposed in 1926 that the Museum of Natural History make an expedition to Komodo Island in search of the world's largest lizard.

Esha Chiocchio, a former Peace Corps volunteer in West Africa, focuses mainly on the peoples of developing nations.

Jodi Cobb's assignments as a NATIONAL GEOGRAPHIC staff photographer have taken her to China, Japan, the West Bank, Saudi Arabia, and Polynesia.

Bill Curtsinger's expert work in the underwater realm has been published in textbooks, encyclopedias, and 30 NATIONAL GEOGRAPHIC articles.

A.W. Cutler photographed Wales for a NATIONAL GEOGRAPHIC story in 1923.

Bruce Dale has covered 75 countries as a GEOGRAPHIC STAFF photographer.

Jay Dickman has traveled to nearly 50 countries on GEOGRAPHIC assignments.

David Doubilet's extraordinary underwater photographs have been featured in the NATIONAL GEOGRAPHIC for nearly 30 years.

Melissa Farlow has used her camera from the Okefenokee Swamp to the American Midwest; photographing people is her greatest joy.

Angela Fisher has exhibited photographs around the world and collaborated with photographer Carol Beckwith on the book *African Ark*.

Stuart Franklin photographed the November 1995 NATIONAL GEOGRAPHIC story on Oxford; his work appeared in earlier stories on Shanghai and Buenos Aires.

Raymond Gehman photographed *Exploring Canada's Spectacular National Parks* (1998), a book in the National Geographic Park Profiles series.

Charles Goodman (1843-1912) photographed the American West in 1888.

George Grall is noted for natural history images; his expertise with camera equipment has produced remarkable photos above and below the water.

Herbert Gregory (1900-1944) was a geologist whose work stretched from the Colorado Plateau to Peru, New Zealand, Tahiti, Australia, and Hawaii.

David Alan Harvey's photographs have been published in more than 30 NATIONAL GEOGRAPHIC articles—four in 1994 alone.

Frank Hurley was a photographer on the Shackleton expedition of 1914-16.

Mitsuaki Iwago is a wildlife photographer whose images help to stress the need for conservation.

Chris Johns joined the NATIONAL GEOGRAPHIC staff in 1995; some of his works are held in the collections of Bill Gates and Nelson Mandela.

Lynn Johnson covered the Olympics for NATIONAL GEOGRAPHIC.

Ed Kashi has worked in more than 50 countries and photographed several stories on the Middle East for NATIONAL GEOGRAPHIC magazine.

Karen Kasmauski has been with NATIONAL GEOGRAPHIC since 1984, covering such subjects as viruses, radiation, Japanese women, and Appalachia.

Robb Kendrick is known for his "socially provocative and beautiful images."

Michael Kirtley has interviewed leaders around the world; he also works to protest human rights abuses against Muslim minorities.

Mattias Klum specializes in natural history and cultural subjects. His many expeditions include recent trips to Malaysia, Thailand, and India.

Emory Kristof, a NATIONAL GEOGRAPHIC contributing photographer-in-residence, has received high acclaim for his underwater exploration efforts.

Tim Laman has a Ph.D. in Biology from Harvard. He photographs wildlife to further conservation efforts.

Frans Lanting is a great chronicler of nature. The GEOGRAPHIC commissioned him to search for white rhinos in Africa and bonobos in the Congo Basin.

John Launois's photos of the Tasaday tribe in the Philippines, published in a 1971 GEOGRAPHIC, documented tribal life before loggers invaded.

Sarah Leen has worked with NATIONAL GEOGRAPHIC since 1988.

Danny Lehman's photos have appeared in *National Geographic's Driving Guides to America* and in stories on San Antonio and New Orleans.

Lehnert and Landrock operated a photography studio in Cairo in the early 1900s. Today most of their plates are in a Lausanne museum.

Jerry Lodriguss studied astrophotography and used his camera to capture images of nebulae and solar eclipses—as well as basketball.

Gerd Ludwig covered changes in the former Soviet Union for the GEOGRAPHIC.

Donald B. MacMillan made more than 30 expeditions to the Arctic.

David Malin is a professor of scientific photography in Melbourne, Australia.

O. Louis Mazzatenta was a writer, editor, and photographer at the NATIONAL GEOGRAPHIC for more than 30 years.

Steve McCurry has traveled extensively in Asia and the Middle East, looking to catch "the unguarded moments—the essential soul—in the human condition."

Donald McLeish (1879-1950) supplied NATIONAL GEOGRAPHIC with photos taken in Europe, North Africa, and the Middle East between 1915 and World War II.

Joe McNally has worked on the Geographic's Masters of Contemporary Photography Series and on numerous "Day in the Life" projects.

Mark Moffett is a scientist who photographs ants, spiders, and frogs.

Michael "Nick" Nichols' interest in wild animals was inspired by Jane Goodall and Dian Fossey. He has been published frequently in the GEOGRAPHIC.

Flip Nicklin is a noted underwater photographer who has contributed to NATIONAL GEOGRAPHIC magazine for more than 20 years.

Richard Olsenius's photographs illustrate "In Search of Lake Wobegon," an article in the December 2000 NATIONAL GEOGRAPHIC.

Randy Olson's photos have illustrated numerous projects for the National Geographic Society, including a recent book on county fairs.

Charles O'Rear's work includes photographs for a series of books on wineries in California's Napa Valley.

Herbert Ponting (1870-1935) is known for his 1911 coverage of Capt. Robert F. Scott's expedition to the South Pole.

Larry C. Price has worked for various news groups and won the Pulitzer Prize for his photographs of Angola and El Salvador.

Roger Ressmeyer is a renowned photojournalist and science photographer.

Reza has been a Middle East correspondent for *Time* and *Newsweek* and has completed many photographic assignments for the NATIONAL GEOGRAPHIC.

Miguel Rio Branco focuses on Gypsies and other minority groups.

Joseph Rock was a leader of the NATIONAL GEOGRAPHIC Society's expedition to Yunan-Sichuan from 1927 to 1930.

Bob Sacha has circled the globe, photographing NATIONAL GEOGRAPHIC stories for more than 18 years.

Joel Sartore has covered Hurricane Andrew's aftermath, Northern California, eagles, and "America's Third Coast" for NATIONAL GEOGRAPHIC.

Jon Schneeberger, a former GEOGRAPHIC illustrations editor, was a consultant for the GeoCam designed and tested at Goddard Space Flight Center.

Ernest B. Schoedsack (1893-1979) began his photographic career in the Signal Corps; he later helped film motion pictures, notably *King Kong* in 1933.

George Shiras III was a wildlife photography pioneer. Gilbert Grosvenor published 74 of Shiras' pictures in the July 1906 NATIONAL GEOGRAPHIC.

James L. Stanfield has photographed subjects "from rats to Pope John Paul II" in more than 65 assignments for the NATIONAL GEOGRAPHIC.

George Steinmetz is best known for photos with science and exploration themes; topics have included the Sahara, obscure cultures, and robotics.

Maria Stenzel began her career with the NATIONAL GEOGRAPHIC in 1991 and has covered regions such as the Antarctic and the Catskill Mountains.

Lida and Miso Suchy captured scenes from the Carpathian Mountains and documented the fierce survival of the Hutsui people.

Tomasz Tomaszewski has contributed to NATIONAL GEOGRAPHIC articles on El Salvador and the St. Lawrence Seaway.

Penny Tweedie has photographed major events in more than 60 countries, including the 1971 Pakistan civil war and the 1973 Yom Kippur war in Israel.

Alex Webb's photographs have appeared in NATIONAL GEOGRAPHIC stories on Paraguay, Amazon, and Florida.

Maynard Owen Williams was among a select group of reporters allowed into Tutankhamun's tomb after it was discovered in 1922.

Gordon Wiltsie has spent more than 25 years photographing expeditions to the far reaches of the world.

Steve Winter's assignments as a NATIONAL GEOGRAPHIC photographer have included capturing remarkable images of animals and rain forests on film.

Cary Wolinsky's work can be seen in "Silk, the Queen of Textiles," "Sichuan: Where China Changes Course," and other GEOGRAPHIC stories.

Michael S. Yamashita, a NATIONAL GEOGRAPHIC contributor since 1979, was the first photographer to trace the Mekong River from its source to its mouth.

Acknowledgments

We are indebted to the National Geographic Image Collection and Image Sales staff, especially Susan E. Riggs, Paula Allen, Bill Bonner, Brian Drouin, Taranjit Kaur, Lisa Mungovan, Hillary Murphy, Paul L. Petty, Leonie Rubiano-Moncada, Ricky Sarno, Anne Wain, and Sanjeewa Wickrameskera. For her support throughout the project, we extend deep thanks to Tracey Blanton. We also appreciate the assistance of Tom Craig, Andrew Jaecks, Masako Jennings, Ming Liu, Eduardo Rubiano, Patrick Sweigart, Philip Tinios, and others at the National Geographic Photographic and Digital Imaging Lab. Finally, we thank our colleagues in National Geographic's International Licensing and Alliances, especially Robert Hernandez, Declan Moore, and Howard Payne, for their support and involvement in this project.

THROUGH THE LENS
NATIONAL GEOGRAPHIC GREATEST PHOTOGRAPHS

Essays by Sam Abell, Raphael Kadushin, P.F. Kluge, Douglas B. Lee, Paul Martin, Daisann McLane, and Nathan P. Myhrvold

Published by the National Geographic Society

John M. Fahey, Jr., President and Chief Executive Officer
Gilbert M. Grosvenor, Chairman of the Board
Tim T. Kelly, President, Global Media Group
John Q. Griffin, Executive Vice President;
 President, Publishing
Nina D. Hoffman, Executive Vice President;
 President, Book Publishing Group

Prepared by the Book Division

Kevin Mulroy, Senior Vice President and Publisher
Leah Bendavid-Val, Director of Photography Publishing
 and Illustrations
Marianne R. Koszorus, Director of Design
Barbara Brownell Grogan, Executive Editor
Elizabeth Newhouse, Director of Travel Publishing
Carl Mehler, Director of Maps

Staff for This Book

Leah Bendavid-Val, Editor
Carolinda E. Averitt, Text Editor
Vickie Donovan, Illustrations Editor
Peggy Archambault, Art Director
Linda Johansson, Designer
Marnie Benney, Project Manager
Anne Moffett, Writer-Researcher
Meredith C. Wilcox, Illustrations Assistant
Mike Horenstein, Production Project Manager
Flora Battle Davis, Rights Researcher
Natasha K. Scripture, Coordinator-Researcher
Ted Tucker, Design Intern

Jennifer A. Thornton, Managing Editor
R. Gary Colbert, Production Director

Manufacturing and Quality Management

Christopher A. Liedel, Chief Financial Officer
Phillip L. Schlosser, Vice President
Chris Brown, Technical Director
Nicole Elliott, Manager
Monika D. Lynde, Manager
Rachel Faulise, Manager

The National Geographic Society is one of the world's largest nonprofit scientific and educational organizations. Founded in 1888 to "increase and diffuse geographic knowledge," the Society works to inspire people to care about the planet. It reaches more than 325 million people worldwide each month through its official journal, National Geographic, and other magazines; National Geographic Channel; television documentaries; music; radio; films; books; DVDs; maps; exhibitions; school publishing programs; interactive media; and merchandise. National Geographic has funded more than 9,000 scientific research, conservation and exploration projects and supports an education program combating geographic illiteracy. For more information, visit nationalgeographic.com.

For more information, please call 1-800-NGS LINE (647-5463) or write to the following address:

National Geographic Society
1145 17th Street N.W.
Washington, D.C. 20036-4688 U.S.A.

Visit us online at www.nationalgeographic.com

For information about special discounts for bulk purchases, please contact National Geographic Books Special Sales: ngspecsales@ngs.org

For rights or permissions inquiries, please contact National Geographic Books Subsidiary Rights: ngbookrights@ngs.org

ISBN: 978-1-4262-0526-2

The Library of Congress has cataloged the 2003 edition as follows
Through the lens / by the Editors of National Geographic.
 p. cm.
 ISBN 0-7922-6164-X
 1. Travel photography. 2. Documentary photography. 3. National
Geographic Society (U.S.)--Photograph collections. I. National
Geographic Society (U.S.) II. National geographic.
 TR790.T47 2003
 770--dc21 2003002237

Printed in China

11/PPS/2